WEDDING AND PORTRAIT PHOTOGRAPHERS'

LEGAL HANDBOOK

Norman Phillips *and*
Christopher S. Nudo, Esq.

AMHERST MEDIA, INC. ■ BUFFALO, NY

Published by:
Amherst Media, Inc.
P.O. Box 586
Buffalo, N.Y. 14226
Fax: 716-874-4508
www.AmherstMedia.com

Publisher: Craig Alesse
Senior Editor/Production Manager: Michelle Perkins
Assistant Editor: Barbara A. Lynch-Johnt

ISBN: 1-58428-148-0
Library of Congress
Card Catalog Number: 2004101350

Printed in Korea.
10 9 8 7 6 5 4 3 2 1

DISADISCLAIMER

The contracts and agreements that we have drafted for this book are drafted with the State of Illinois law as our jurisdiction. We recommend that you seek counsel from a lawyer where you transact business to ensure that our contracts and agreements conform to your state law and any local ordinances that may apply. Further, I do not hold myself out, nor do I represent that I have any authority to practice law outside of the State of Illinois. Nothing in this book should be construed as my attempt to practice law outside of my licensed jurisdiction and thus be interpreted as the unauthorized practice of law.

No attorney–client relationship can be construed due to your use of these agreements and contracts and no claim can be asserted against the authors of this book based upon a loss or a claim that you have suffered or may suffer in the future. This book is merely a reference to assist you in protecting your rights as a photographer.

This book is a tool, and as with any good tool it works most efficiently when it is used in its proper context. With the majority of the work done for you, you still have the responsibility to use these contracts and agreements in their proper context. An agreement or contract that is used in an inappropriate manner is no better (and at times worse) than using no agreement or contract at all.

Finally, no matter how skillfully an agreement or contract is drafted, it does not protect a party from misrepresentation or fraud. All of these agreements and contracts assume that both parties are dealing in good faith and with the full intention to agree with one another.

We hope that you enjoy our book and, more importantly, that you use it to enhance your business.

—*Christopher S. Nudo, Attorney at Law*

TABLE OF CONTENTS

SECTION 5—WORKING WITH OTHERS

SECTION 6—STOCK AND FINE ART PHOTOGRAPHY

SECTION 7—LECTURING AND PUBLISHING

FOREWORD

The legal relationship between professional photographers and their clients has forever been an area of serious neglect. Those who have ventured into professional photography have been drawn in by the magic of creating images with a press of a button. However, few have the business foresight to appreciate that they are offering a service that may, in many cases (especially wedding, bar mitzvah, and other once-in-a-lifetime special events), result in situations that can be contentious and potentially litigious. We operate in a legal system that encourages frivolous suits that can result in ruinous expenses to defend.

There are no definitive statistics to indicate how many professional photographers employ a contract between themselves and their clients. What we do know is that very few use contracts that offer even a modicum of protection against potential lawsuits. The well-published form contracts on the market are nothing more than an acknowledgment of a deposit toward a vaguely described service to be provided. Remarkably, in an era in which unscrupulous lawyers will encourage a lawsuit at the drop of a hat, members of the public will sign such a contract that offers them no more protection than it offers the photographer.

This book has come about because I have always been something of an amateur student of the law. In my own business, I have endeavored to be correct in my language when writing releases, contracts, estimates, quotes, etc. From time to time I have also requested my attorney, Christopher S. Nudo, to review these documents. When doing so in 2001, he went well beyond a review. He thoroughly researched many other contracts, including those recommended by leading professional photographers' associations. He also researched books on legal issues in professional photography. What he discovered was that most of them were not worth the paper they were printed on and that some had serious flaws. He suggested that, other than my own contract, there was not one that he could recommend. Even so, we added several elements to make it more appropriate for the modern era.

As a result of this research, we discussed numerous aspects of the law. We quickly realized that there is an enormous potential for legal problems in photography and that there was inadequate advice available—so we collaborated in this book.

Wedding and Portrait Photographers' Legal Handbook covers a wide area of protection for the photographer, as well as offering the degree of warranty for the client that must be seen as fair and reasonable. If you are a professional photographer, you will learn about situations that you might have been confronted with previously or that you may be confronted with in the future—and you'll discover how you can protect yourself. Many of the issues addressed here apply to both studio operations and also to freelance photographers who offer their services to the public or to studios seeking assistance.

I hope that this book will give you the tools and advice you need to create a thriving professional photography business without threat of legal suit.

—*Norman Phillips*

INTRODUCTION

Traditionally, photographers have been free spirits. As a result, many take assignments without a thought as to their obligations or to their client's obligations to them. But be aware: we live in a litigious society and there are those who, at the drop of a hat, are prepared to take you to court. Because it often costs less than litigation, most cases are settled out of court—even when the defendant has an adequate defense. Still, legal suits are costly and often times even crippling.

Unlike going into a store and purchasing an item from the shelf where the terms of business are well established and consumer-protection laws apply, accepting an assignment or commission to produce images for a specific or general purpose has very different connotations. This is especially true if the job is time- or location-restricted, such as a wedding, bar mitzvah, or any other event that cannot be restaged (or where restaging would involve great expense). Equally, a family commissioning a portrait at Thanksgiving when members are coming to town from far and wide might consider negligence or carelessness an issue worthy of legal recourse. Even a family of three or four who invest in time at the beauty parlor and the purchase of coordinating attire for a once-a-year portrait session could be encouraged to seek redress should the photographer not live up to the client's expectations. Apart from the potential for litigation there is also the need to ensure that there are no misunderstandings between the client and the photographer.

In this book, we will discuss potential problems and recommend solutions and protections. We recommend that you use the documents included in the following text as a basis for customizing your own contracts. It is strongly recommended that you also utilize the professional services of an attorney to review them.

A word of caution with regard to digital capture. The rapid advance of digital and other related technol-

> ## TO DOWNLOAD CONTRACTS
>
> All of the forms and contracts described in the following chapters are available as a free download from the publisher's website. Just go to www.AmherstMedia.com/downloads.htm, click on the title of this book, and enter the password PN1796. If you feel the need to modify the language of these contracts, we recommend that you refer to your state laws, since they may differ with those of Illinois, the state laws to which the recommended documents have been applied. Each state may have laws that make certain paragraphs in our documents either limited or unusable. However, the recommended documents are generally a sound and reliable foundation.

ogy may require slight modifications in the documents advocated in this book. It is important that we apply good sense with regard to changes in the tools made available both to us as professionals and to the consumer. Keeping abreast of these changes will enable us to ensure that our legal documents and public statements we make when we provide requested information are up to date and that they properly protect our interests as well as offer fair terms to existing and prospective clients.

Within our legal documents, the language used was specific, intentional, and, we believe, important; we make no apologies for what may appear complex. In the legal world, there is no such thing as user-friendly language. User-friendly language may make a signer happier, but such language may well undermine the value of the entire contract. You cannot afford to have an agreement or contract that is open to interpretation; such a situation, ultimately, results in there being no contract at all.

1. EVENT PHOTOGRAPHY CONTRACT

Imagine the following scenario and consider all the potential issues (indicated in italics) that should have sounded an alarm for the photographer. As we discuss the recommended contract we will address the issues referred to. The numbers that follow the italicized sections refer to the appropriate clause in the model event contract, with exception that the banner heading of the contract is referred to as the "general heading." Let's look at the scenario.

THE MAKINGS OF A LAWSUIT

A party planner introduces a photographer to a couple who say they are planning a medieval wedding with all the period trappings. There is the promise of knights in shining armor, a falconer and a falcon—all the makings of a spectacular event. They have also arranged for press and TV coverage. It is truly a storybook event. *The opportunity for the photographer to obtain stunning images with which to promote his work and gain wide exposure in the media is too much to resist* (10).

The couple is impressed by the photographer's work and they want to sign a contract (general heading). The photographer, believing that this wedding provides a once-in-a-lifetime opportunity, also wants the contract. The initial problem is that *the photographer's fees and prices are in excess of the couple's budget* (general heading). Because the photographer sincerely believes this is a job he can benefit from *he waives his personal fee of $500* (general heading), and at the request of the couple he *grants them ownership of the proofs* (3a) in the contract. He then breaks another of his rules and accepts *partial payment of the initial payment* (1) as the couple confess they do not have the funds immediately available for the full amount and promise to pay the balance when they receive their next paycheck, which they do.

As the event date approaches, the couple *changes both the venue for the ceremony and the reception, which later proves to be a significant issue* (4). However, the *required planning session* (21) takes place and the photographer also attends the wedding rehearsal.

The rehearsal, also attended by a representative of the party planner, provides little insight as far as the ceremony and procedures are concerned. *All that the photographer gleans from the rehearsal is the layout of the venue and where he will place supplementary lighting during the ceremony* (5).

On the day of the wedding, the photographer and two assistants arrive early and set up studio lighting in a foyer as agreed. *It is noted that the foyer is the only access to the wedding ceremony location. The groom arrives 15 minutes late* (4), not necessarily unusual. However, the photographer is shocked to see that he is in morning dress and not in medieval costume. Nonetheless, as a true professional he goes about his work as he would in any other surprising situation.

Imagine the following scenario and consider all the potential issues that should have sounded an alarm for the photographer.

Next, the best man, also in morning dress, arrives and a little later the knights in full costume arrive. *Photography is sporadic as the subjects of the event arrive late* (4 and 7). No one is keeping to the agreed schedule. *The bride is already 40 minutes late* (4 and 7). With the guests arriving, *it is now not practical to use the foyer*

as there is not enough time for the planned portraits. Therefore, the lights are relocated for the ceremony (7). The assistants reposition the lights and meter them before *the bride arrives a full 50 minutes late, less than 10 minutes before the ceremony is due to start* (4 and 7), attired in a modern gown, not a medieval bridal gown.

The entire plan is completely ruined. Worse, *only 48 of the 250 guests attend, leaving over 200 empty seats* (4 and 7). *There is not one representative of the press or any other media in attendance. The falcon fails to perform as planned, and the anticipated shot is not possible* (7). After the ceremony, *the planned images of the wedding party and family become an exercise in futility as the two assistants endeavor to gather the appropriate subjects* (4). Apparently no one is very interested in cooperating. The light is rapidly failing and causing exposures of ½ second. *Planned and customary shots are missed, but the photographer thinks that what is not possible at the chosen location can be made up at the reception* (7).

None of the knights appear at the reception, and only half of those at the ceremony are in attendance (7). The room for the reception is set with 20 tables and less than half have anyone seated. *It is not possible to make up the missing photographs* (7).

> The suit further alleges that not meeting these requests represented a breach of contract and that the photographer was negligent.

This was, from the photographer's perception, a plan that had gone seriously wrong. After the couple picks up the proofs and expresses their displeasure, the party planner calls and *asks if the photographer would agree to take additional photographs on another date to make up for those that were missed, and he readily agrees. The couple goes to the photographer's studio to take additional shots but fails to bring all that they need to accomplish the reshoot* (7). *Apparently, they want a host of trappings from the ceremony photographed—things that do not fall into the area of wedding photography* (21). Attempts are made to *arrange a reshoot of some of the missing shots, but none of the photographer's offers are accepted* (5). Ultimately, arrangements are made for a session at the ceremony venue. With two assistants and all the appropriate equipment, the photographer arrives

at the location—a 40-minute drive—only to learn from the staff at the venue that *the couple has canceled without telling the photographer*. It is to be noted that *the contract specifies that the photographer is to provide a finished album of 80 prints* (general heading).

There are a great many issues in this scenario that we will deal with a little later, but here's the rest of the story. Several months later the studio receives a demand from the couple's attorneys for $5,800 to meet the alleged costs of restaging the wedding so as to enable them to obtain the shots they claim the photographer failed to take.

The studio replies with the details as set out above and draws attention to the terms of the contract. Nothing is heard again for more than 12 months. The photographer and his studio are then presented with a suit in the amount of $130,000 plus punitive damages. The plaintiffs sue the studio and the photographer both jointly and separately. Attorneys for the defendant describe the suit as gold digging, a description of a suit that has less than genuine merit and seeks to obtain monetary reward with little apparent danger of any real cost to the plaintiff.

The suit alleges that the photographer falsely claimed to be a PPA (Professional Photographers of America) Master Photographer and therefore fraudulently caused the plaintiffs to sign a contract. The suit further alleges that the photographs taken were faulty, that many of the couple's requests were not met, and that not meeting these requests represented a breach of contract and that the photographer was negligent.

The suit provides a list of over *1,200 requested photographs* (7 and 21) that the couple alleges they had presented to the photographer prior to the wedding, and that they allege was part of the contract. Part of the claim is based on charges of $66,000 to commission a digital artist to re-create the images they were missing. It is also alleged that the photographer was carrying faulty and inadequate equipment. Additionally, the suit alleges that the photographer failed to carry out the couple's wishes at the studio session.

For such a suit to go forward the plaintiffs are required to obtain an expert witness to support their case. In this case, they initially obtain the services of a PPA Master Photographer who is also an accredited PPA National Judge. After reviewing the proofs, his

three-page assessment does not support their case, and only two paragraphs of his assessment are included in their submission to the court. This expert witness states that the contract specified that the commitment was for an album of 80 prints and that there were more than enough images (480) to produce a beautiful album. He states that the photography was more than adequate—and generally well above average.

Because this qualified expert does not agree to demands to support their case, the plaintiffs then search the Internet for anyone with some credibility who will agree to do so for an appropriate fee. They ultimately find a photographer with four years of professional experience, then drop the original expert witness—someone with infinitely superior experience and expertise in wedding photography. According to the information available, the new expert witness agrees to act in order to enhance his resume. (We need to be aware that there are always people seeking to advance their own careers at the expense of others, and our contracts need to protect us from them.)

Ultimately, the studio and photographer settle the case out of court by mediation and with no admission of liability. The photographer and the studio each have a total costs in excess of $18,000, for a grand total in excess of $36,000. Of this sum, only $10,500 goes to the plaintiffs. The rest is used for attorney and mediation fees. The plaintiffs also win possession of the proofs, negatives, and copyright. It is also likely that the plaintiffs will be required to meet some of the costs of the legal insurance program that represented them.

CREATING AN EVENT CONTRACT

What we have just reviewed is as bizarre a case as any we are likely to hear about. Reviewing the studio contract, we found that there were a number of areas that could have been covered to prevent the lawsuit. Below, we have drafted a contract that will protect the photographer and offer the client reasonable and acceptable protection against palpable negligence and carelessness.

Keep in mind that any contract that will stand up in court must be fair, reasonable, and lawful. A judge is unlikely to uphold a contract that blatantly prevents the signer from reasonable redress in the event that the photographer fails to live up to his obligations as stated in the contract. Therefore, the contract must clearly set out the photographer's obligations as well as the limitations that may be placed on him and may prevent him from otherwise fulfilling those obligations

Let us start at the beginning, with the general heading. As you read the following sections, remember that the wording of a contract must be clear and unambiguous so that there is no opportunity to misinterpret or misconstrue what is agreed. There must be no vague statements or implications. What is stated should not need an interpreter, such as a judge in a court of law.

General Heading. The general heading, as shown below, should be personalized, clearly stating whom the

EVENT PHOTOGRAPHY CONTRACT

AGREEMENT/CONTRACT between John Doe Photography Incorporated (the "Studio"), located at _____ _____ (or other locations as may apply) and _____ (the "Client"), resident at _____ (telephone [home] _____ [office] _____), for the provision of photography and related services on the occasion of a _____.Date(s): _____ Days: _____ Services and photography to be provided: _____.

The Assigned photographer is _____ the charges for which total $_____ to be paid in two (2) equal and nonrefundable amounts of $ _____, the first to be paid at the date of this agreement, which is acknowledged as a retainer. The second payment shall be paid no later than thirty (30) days prior to commencement of photography and not later than (date) _____. The above stated charges are inclusive of $ _____ assigned attendance fees, subject to Clause 8, and are paid at the date of the contract. Payments made on this contract by charge card and charged back shall be made good by cash, check, or money order within seven (7) days. The following paragraphs shall, with the foregoing, form the body of this contract/agreement and shall not be amended.

The general heading of the event photography contract.

contract is between and their respective recognized addresses. The name of the assigned photographer should also be incorporated.

Immediately following this information there must be a clear and indisputable statement of what the photographer is contracting to provide and on what dates. In our example, this information would be: client name, client address, client phone number, the written date of the assignment, the day of the week of the assignment (this allows cross-matching the date in case of error), and a clear description of the service to be provided. It is also recommended that a copy of your current price list be stapled to the original contract so that there will be no dispute at a later date as to what charges (other than those within the contract) will be applied at the time of an order that does not fall within the terms of the contract. If the relevant information will take up more space than the preprinted contract will permit, it may be laid out on a separate sheet of paper and attached to the contract. If this is done, both parties should initial it. In the space on the contract where this information would normally be stated, instead insert "see attached." This clause should also state the agreed charges to be applied as well as the dates on which these charges are to be paid.

You will note that this general heading describes the initial payment as a nonrefundable retainer rather than a deposit. When a photographer contracts to photograph a wedding (or other event) and assigns the date and time to the client, that date becomes unavailable for any other purpose. A *deposit* is not a warranty for the loss of an assignment, because it is refundable if no service is provided. If a client cancels and you try to hold a deposit, she may go to court and ask for it to be returned—and the court will almost certainly rule in her favor. A *retainer*, on the other hand, is a warranty that the studio/photographer will be properly compensated for exclusively assigning the date and time stipulated in the contract. Therefore, if a payment is intended to reserve your time for a specific period, it should be referred to as a non-refundable retainer.

It is reasonable to state in a subsequent clause that, in the event the client cancels, the retainer may be refunded if the studio/photographer is able to acquire another assignment of a similar value for that date and time. If a new assignment cannot be obtained, it is sug-gested that, in order to foster goodwill, the forfeited retainer fee be used against other services to be provided outside premium time. This does not, however, need to be included within the contract. Such a gesture would be offered at the time of cancellation and at the discretion of the photographer.

The final section of the contract's general heading refers to the clauses that follow and that shall not be amended. The reasoning behind this stipulation is that the designed contract meets the needs of the contractor and offers protection to the client that, if amended, would undermine the credibility of the contract as a whole and might also cause a need to amend additional clauses. Amending a single clause (or more than one clause) may well create a legal tangle.

The numbered clauses that follow spell out the rights, privileges and limitations, and avenues of recourse open to both parties. We will take them one by one, referring to the issues that have been numbered in the case previously discussed.

You may find that some paragraphs in the body of this contract exceed your needs or do not apply to the way you operate your business. They have been included so that they will not have to be created should they be relevant. The fact that a paragraph may not appear to be applicable does not require you to remove it. Before removing any paragraph that you feel is not applicable, we suggest you consult with your attorney. Remember that what may initially appear irrelevant may become extremely important at a later date.

We would suggest that it is better to not agree to work with a client whose ability to fulfill your contract's terms is in doubt.

Clause 1. In the previously described case, the prospective clients entered into a contract that was beyond their means, and they had insufficient funds to meet the required down payment. While it is not our intention to advise you as to how you should conduct your business, we would suggest that it is better to not agree to work with a client whose ability to fulfill your contract's terms is in doubt. Additionally, disregarding your terms of business as laid out in your contract undermines the integrity of the contract.

1. PAYMENTS. This contract is valid only on payment of the first payment as specified above.

2. FAILURE. Failure by the Client to make the second and final payment as scheduled may be deemed a cancellation of this agreement, and the Studio shall be relieved of all obligations herein.

3a. PROOFS. Client agrees that all proofs (in whatever form the Studio designates) remain the property of the Studio unless otherwise provided above. Any proofs not returned according to the terms herein are chargeable at $10 each. Invoices or statements requiring payment for unreturned proofs will be paid within thirty (30) days. Proofs may not be part of any minimum order stated above or coverage fees and are loaned to the Client for a period of 45 days, after which they shall be returned together with any and all orders. Any extension of such period is at the discretion of the Studio. In the event that the Client fails to return the proofs and fails to place an order, an order-processing fee of $100 will be assessed for each thirty (30) day delay. Subsequent orders shall be subject to a 15 percent (15%) surcharge. The Client is responsible for payment of all orders by the Client, even if ordered by a third party, and the Studio is not obligated to accept separate orders from third parties or to provide separate billing of individual orders, and to do so is a courtesy to the Client.

3b. When proofs are provided in the agreed media (i.e. paper or electronic media), they shall be picked up no later than fourteen (14) days after notification that they are ready for pick up, and any balance due shall be paid at time of pick up. The Studio shall endeavor to make proofs available within twenty-one (21) days after photography.

Clauses 1–3b of the event photography contract.

Clause 2. Clause 2 deals with the possibility that the client may wish to delay making the second payment referred to in the general heading of the contract. This may be due to monetary issues or for other reasons that may undermine the integrity of the contract. In this contract, the second payment is due 30 days prior to photography. While a minor delay due to scheduling problems may be tolerated, any delay that suggests the client may default may be deemed a cancellation. It is assumed that the contractor would remind the client in good time that this second payment is due. When this is ignored, it raises a red flag. This clause would have prevented the couple in our example from failing to pay their second installment.

Clause 3a. This clause ensures there is no misunderstanding as to who owns the proofs, regardless of how they are presented. In our example case, the photographer released the proofs to the client in the contract. This led to the client allegedly presenting a list of 1,200 requested photographs. The client clearly viewed the ownership of the proofs as reason to have everything in sight photographed. It is recommended that this clause not be amended. Instead, if you wish to vest ownership to the client, it should be subject to a minimum order or a fee and only after all orders have been completed and paid for.

For the studio/photographer to efficiently organize production and control the scheduling of orders, it is important that the timeline for the return of the proofs, in whatever form, is clearly stated. To be effective, the penalties that may be used in the event of noncompliance must be spelled out. This provides the photographer with some options that may be applied. If the penalties seem harsh, it's because they are designed to deter certain behavior. You have full discretion to apply the penalties as circumstances warrant. Because the possible sanctions are separated, this allows the contractor to negotiate reasonable cooperation with the client instead of applying one sweeping option.

You will note that in Clause 16, it is stated that if the contractor fails to apply any of the individual sanctions, he does not waive his right to decide to apply them at a later date. In the case we discussed earlier, the studio did not invoice the proofs as provided in the contract. This was a serious omission on his part. The no-waiver clause would have been a useful tool in defending the suit, because it would have been clear that one omission did not void the other provisions of the contract.

Clause 3b. Clause 3b ensures that proofs are collected in a timely manner and advises the client as to when they will be ready. However, as it stresses that the studio will "endeavor" to make them ready within 21 days, it is not a guarantee. Good business practice requires that a contractor have adequate time to perform a service and create goodwill by completing a service

4. COOPERATION. The Studio and the Client shall cooperate and agree to all schedules and arrangements for services to be provided including, but not limited to, arriving promptly for scheduled photography as agreed at a planning meeting. Changes to scheduled times shall be authorized prior to the scheduled photography session. The Client agrees to meet with Studio representative(s) at least thirty (30) days prior to photography, at the initial planning meeting. The Studio shall endeavor to meet all reasonable the Client expectations, however there are circumstances where certain images are not possible and the Studio makes no express or implied warranty for providing specific images. When the Client or others referred to in the schedule are more than ten (10) minutes late, the Studio shall not be liable for omissions of requested photographs that may otherwise be feasible if the client had arrived at the appointed time.

5. CAMERAS AND LIGHTING. Any and all cameras and related lighting, including video, shall be under the direction of the Studio, and the Client shall advise any and all users or providers of services of this clause. Notwithstanding the foregoing, the Studio will seek to cooperate with the contracted videographer in order to meet the needs and expectations of the Client. In the event of a conflict between the photographer, the videographer, and/or any guest or member of the wedding party, the Client hereby expressly grants resolving authority to the photographer. If the videographer, guest or member of the wedding party continues to be in conflict after being advised by the photographer, then the client releases the photographer from all images not taken due to the conflict. Photography or videography by any person or persons other than the Studio during formal sessions is not permitted.

6. CANCELATION. Should the Client cancel the assignment date or cancel this agreement, the Studio shall retain all deposits, unless the Studio is able to secure an assignment for a comparable fee for the date canceled, at which time deposits shall be returned in full. The Studio shall not cancel unless serious illness or other such physical handicap shall render the Studio incapable of carrying out its obligations. The Studio having made every endeavor to obtain the services of a qualified and competent substitute, all deposits held by the Studio shall be returned to the Client, as the Client's sole remedy.

7. LIABILITY. The Studio shall not be liable for omissions caused by failure of the Client to maintain all agreed schedules or caused by delays due to inaccurate information provided by the Client. The Studio shall not be liable for failures or faults in the manufacture or processing of materials or other causes that may reasonably be deemed beyond the control of the Studio. In the event such circumstances prevent the Studio from performing its obligations or delivering the agreed product or service, the Client's sole remedy shall be the refund of any deposits, as a Limitation on Damages as set forth in Clause 20. Omissions or failure to produce specific images that may be discussed or proposed at a planning session shall not void this agreement and/or shall not result in compensation to the Client by the Studio.

Clauses 4–7 of the event photography contract.

ahead of guaranteed schedules. The contract provides the client with reasonable expectations and incorporates a fiduciary obligation by the photographer to live up to the spirit of the contract.

Clause 4. Regardless of how well-planned a special event is, there are many elements that can go wrong. As a result, schedules can be significantly disrupted and prevent planned photographs from being taken. Nevertheless, a planning meeting prior to photography is essential and an enormous advantage to all concerned. At such a meeting, critical information about locations, logistics, names, and details about those who will be part of the wedding ceremony and/or celebration, as well as a proposed schedule for the photography can be coordinated.

At this planning meeting, both the client and photographer should discuss the possibility of certain images to be created and where they may be made. In our contract, we are careful to state that, while every endeavor will be made to meet all client expectations, there is no warranty given or implied. The creation of these images is not part of the signed contract, and their discussion at the planning meeting is for informational purposes only.

Clause 4 requires the client to meet 30 days prior to photography for a planning session. Photographers who fail to meet with clients prior to photography to create a prospective schedule may well leave themselves exposed to criticism, if not litigation. Despite the best of intentions of both the client and photographer,

schedules, delivery of flowers, traffic holdups, and many other things may well prevent certain expectations from being realized.

Peculiarly, many clients think that photographers are capable of minor miracles and fail to realize that some requests become unrealistic or impractical when the schedule is, for whatever reason, disrupted. This clause covers all these eventualities. It is, in effect, a disclaimer of liability when the client fails to keep to an agreed schedule or fails to cooperate in the creation of proposed images. This was a serious problem in our case example. In fact, should such a breakdown of the agreed schedule occur and prevent the photographer(s) from producing what would have otherwise been possible, it should be noted and the client advised in writing as soon as possible after photography. Had the contractor in our case example done so, he would have significantly forestalled—or perhaps even prevented—the suit.

Clause 5. It is not uncommon for photographers and videographers to find themselves in conflict during coverage of an event. Even guests and members of the wedding party can sometimes become a nuisance during formal sessions. This clause provides the photographer with contractual authority when situations arise that could prevent him from creating the images that will be his copyright as well as his sales potential. Incorporating this clause into the contract, and making sure that the client advises all relevant parties, prevents situations that would otherwise become difficult and embarrassing.

Clause 6. Clause 6 covers the potential of client cancellation and what happens to payments made by the client in such an event. Additionally, in the event he is unable to fulfill his obligations, this clause limits the photographer's liability to the return of all monies received under the terms of the contract. If this is not included within the contract it may lead to a suit for compensation and possible damages. At the same time, the clause requires the contractor to make every endeavor to arrange alternative and acceptable coverage for the client.

Such circumstances occurred immediately after the horror of September 11, 2001, when a number of photographers were stranded and unable to get to contracted events because of canceled flights. Because I was stranded in London, my second photographer was assigned to substitute for me. Such situations are relatively rare, but every photographer for wedding photography needs to plan for such eventualities.

Clause 7. This clause is one of the most important in the contract. Limiting liability in the contract prevents a client from seeking unreasonable compensation and damages in the event of a breakdown in service and delivery of product. Had the photographer in the case discussed earlier had such a clause in his contract there would never have been a lawsuit. You will recall that, in that lawsuit, there were all kinds of assertions made about what was to have been provided; including this clause would have eliminated any doubt about the photographer's obligations.

Additionally, this clause deals with the issue of misleading or inaccurate information—of which there was plenty in the case referred to. Inaccurate information can lead to problems. You may be told it takes only 15 minutes to get from the bride's home to the church, when in fact it takes 30 minutes. It might be that you are given inaccurate directions and no allowance is made for traffic problems caused by road work, etc.

Had the photographer in the case discussed earlier had such a clause in his contract there would never have been a lawsuit.

Also, this clause covers the outsourcing of services that many photographers employ. This includes the transit of film and prints, processing of negatives, handling of digital files, etc.—services that are overwhelmingly contracted out to professional laboratories.

There have been numerous cases in which there has been an attempt to void an entire contract because of a failure to perform one or more elements of the contract. Here we cover the issue of omission of specific images. If, for instance, the photographer failed to photograph the bride and her mother together, for whatever reason, this clause would prevent the studio/photographer from being in breach of contract. However, this clause would *not* prevent the photographer from being in breach of contract if he failed, in general, to perform reasonably within the spirit of the contract.

In the case we discussed, there were a host of reasons why the photographer was unable to deliver on

some elements of the contract—none of which were his fault. But, because his contract did not limit his liability in such circumstances, the clients (with the aid of an expert witness) were able to make a damaging argument against him.

Clause 8. Clause 8 covers the studio in the event that the assigned photographer for this contract is indisposed and it is necessary to replace him or her. This could be the case when the assigned photographer, who was an employee of the studio, subsequently leaves to work elsewhere and there is ample time for the client to seek a photographer of his choice rather than accept a substitute the studio offers. However, in the case that the replacement is one that is necessary at the last moment, when there is not adequate time for the client to seek an alternative, the studio may replace the assigned photographer in order to honor the contract.

The clause also provides that the studio will adjust the paid fees if the replacement photographer is deemed not to be of the same level of quality as the originally assigned photographer.

Additionally, if the client disapproves of the newly assigned photographer, the contract is canceled, and all paid fees are returned to the client. While this is unlikely to occur, the client needs assurance that, in the event that their first choice of photographer is not available, they have the option of canceling without monetary loss.

We need to educate the public that copying professional images is a form of theft and advise them of the legal consequences of doing so.

Clause 9. In Clause 9, we make it clear that this contract provides for the exclusivity of the photography to the contractor. This prevents the client or his or her representatives from employing the services of another professional. We have heard of an instance where the groom's parents hired another photographer because they did not want to pay the prices charged by the photographer contracted by the bride's parents. In the event that another photographer was used to produce images for sale, the contractor would have grounds for a suit to recover lost sales. If another professional were contracted, the client would be in breach of contract.

This clause obligates the client to ensure that this does not happen.

Here we also limit the opportunity of others to take advantage of the photographer's skills in posing and grouping our subjects. The photographer should provide information to the client that he can distribute to the family and guests to advise them of the photographer's protocol when photographing the event.

This clause also provides the right of the studio and/or photographer to use images created at this event for the purpose of promoting his business, as indicated in Clause 10.

Additionally, this clause deals with copyright. This is an ongoing issue between professional photographers and the public. While there is a genuine effort by most copy stations to prevent consumers from copying professional images, there is also emerging potential for copying via computer software. We clearly need to educate the public that copying professional images is a form of theft and we need to advise them of the costs and legal consequences of doing so. This clause also states the right of the contractor to monetary compensation for each illegally produced image at 10 times the contractor's published rate. We will deal with this issue in more detail in chapter 12.

Obviously, proving that images have been copied is a separate issue, but when we know this has occurred, we should seek the appropriate compensation. In one incident when we learned of such infringement, I wrote to the client and advised her of the required compensation as published in our brochure. I also suggested that there were potential statutory damages which I was seeking. The client's husband was an attorney and he immediately called to find out what I was seeking. Within two days, his check was received in the mail. In Clause 20 we provide recourse for infringement of copyright by making it a breach of contract.

Often, clients and prospective clients ask about the retention of the negatives or recording media. Some photographers will retain the negatives (which require considerable storage space over the life of a business) for a specified period and then either dispose of them or offer them to the client. In this clause, we propose that the studio *may* retain these materials indefinitely but also may limit this retention to only those images from which there have been orders for prints.

8. ASSIGNED PHOTOGRAPHER. The Studio reserves the right to replace the assigned photographer as necessary, such as in the event of an emergency, in order to honor this agreement. The Client, subject to time permitting, shall be advised accordingly and has the right to approve or disapprove such change in assignment. On approval, any appropriate adjustment of paid fees will be made. In the event the Client disapproves, this contract shall be deemed canceled and all monies paid to the Studio by the Client shall be returned to the Client.

9. EXCLUSIVITY AND COPYRIGHT. The Studio is the exclusive photographer providing photographs for sale for this occasion, and all rights for use of the negative or electronic media used for recording images and reproductions therefrom is reserved by the Studio. The Studio shall not object to other photography at this event inasmuch as it does not hinder or impede the Studio in meeting its obligations in this contract, but such other photographs shall not be taken of subject(s) arranged and posed by the Studio. All Copyrights are reserved, and unauthorized copies or scanning made by the Client or his/her representatives or with his/her consent is chargeable at ten (10) times the listed charges of such prints by the Studio. The Client acknowledges that unauthorized scanning or copying of images is unlawful and subject to statutory prosecution. Release of negative or electronic materials to the Client, his or her heirs, or duly appointed assigns shall be subject to the payment of a fee of $2,000, plus any assessed taxes, and shall be delivered only after the Studio has made such reproductions it may require as specified in Clause 10. The Studio may retain all recording materials indefinitely but may limit such retention to those from which the Client has placed orders.

10. USE OF IMAGES. The Studio may use reproductions of images from negatives or electronic media in full or in part for display, promoting and advertising the Studio, teaching and lecturing, and illustration of related or unrelated articles as may be published. The Client releases the studio from any right in the image that the Client may claim through it, and the Studio has an expressed right to use the image as stated above.

11. ORDERS AND DELIVERY. Any orders for prints and services in excess of those contracted are subject to a deposit of 50 percent (50%) at time of order and prior to commencement of work, with the balance due on completion. Finished prints will not be released without payment in full. The Studio will endeavor to complete all orders within sixteen (16) weeks. The Client acknowledges that some phases of production are dependent on suppliers and outside contractors and may be subject to delay. The Client agrees to collect finished work and pay all balances within twenty-one (21) days.

Clauses 8–11 of the event photography contract.

The inclusion of this provision gives the photographer options and at the same time provides the client with guidance as to the studio's policy instead of leaving the issue open and subject to dispute at a later date.

Clause 10. In order to advance our business we need to show our work, and one of the problems that may occur is not having a release for the use of images for advertising and promotion. If we had to obtain a release from the client every time we wanted to use an image, we would be spending a considerable amount of time obtaining releases. When a client is approached for such a release, there might also have to be a trade-off of some sort or other in order to get a signature. Therefore, Clause 10 provides us with the automatic right to use the images for promoting our business without the need for individual releases.

In my studio, I have found that the overwhelming majority of clients are flattered to have their images on display. Many look forward to seeing their images in our reception area or in our ads. When these are included in books or articles, they are keen to have a copy and feel honored they have been included. However, we should still be sensitive; when we learn that a client may be uncomfortable with such prints on display, we should not use them and agree to delete the clause.

Clause 11. It is important that projected delivery times and payment processes be specific and clearly stated in order to avoid potential problems. Obviously, having stated these in writing, it is important to live up to them. At the same time, we should also be alert to delays and provide information to the client as needed so that we avoid breakdowns in customer service. The wording in Clause 11 provides the pertinent information, but you may wish to amend the timelines to suit your own policy. It is also reasonable to advise the client in writing of the anticipated time needed to complete

their order. Most clients want to know this at the time of a contract and receive the same assurance when they place their order.

Collecting money once the goods have left the premises can be difficult, and often the goodwill that existed previously can be undermined when there are uncollected balances. In this clause, the client agrees to collect and pay for all completed orders within 21 days. The contract is quite clear that the studio/photographer will not release the work until it is fully paid for. We recommend that you use the same policy. Should you not include such a stipulation and allow orders to be collected or delivered without payment in full, it may become difficult or impossible to collect what is due.

Another potential difficulty arises when a substantial amount is left due on completion and the order is not collected within the agreed time. In some instances, a court may rule that unless the order is collected or delivered, any balance due may not be collected. Depending on the statutes of the state in which you do business, it may be that you will have to deliver the order with a signature to establish your claim for the balance. Then, you may well find that you will need to pursue the matter in small claims court. Even if you are successful there, you still do not have a guarantee of payment without the employment of another agency or a court bailiff—all of which represent a significant expense. That is why you need to equip your contract with specific language.

A potential difficulty arises when a substantial amount is left due on completion and the order is not collected within the agreed time.

Clause 12. Even though we have stated in Clause 11 that no work will be released without payment in full, we need to cover numerous potential situations. This may include the completion of work that is uncollected for 30 days or more—or the photographer choosing to release work in the good-faith belief that the client will pay for it as promised.

Each state has laws that permit the charging of interest on unpaid accounts. In Illinois it is 2 percent per month and 24 percent annually. When creating your contract, ascertain what rate your state permits. The

issuing of statements for unpaid balances incurs time, paper, and postage and it is not unreasonable to have a minimum charge for this service. If, for instance, you are reminding a client that she owes $150, past due for more than 30 days at 2 percent, the service charge would be $3—hardly enough to cover the administrative costs of the service. Therefore, Clause 12 allows you to charge $10 instead, if you choose to do so.

Clause 13. Clause 13 protects both the studio and the client in respect to the charges for services and products. The client is protected against price increases from the date of the contract until 60 days after the collection of the proofs. This clause also ensures that, when a client significantly delays placing their order, the studio will not be obliged to supply products and services at prices that may no longer be profitable.

Clause 14. When the original contract is signed, a list of available additional services and products should be attached. Without this clause, the client would be entitled to expect any of these additional services and products to be charged at the rates published at the time of the contract. This clause insures that any charges for services or products not included in the contract can be charged at the currently published charges.

Clause 15. In the event that a client's unpaid balance must be sent for collection or is recovered through a court of law, Clause 15 states that the studio is additionally entitled to recover any costs involved in such an action. In most states, the law does not permit the recovery of costs of such expenses unless it is agreed upon prior to commencement of services. This clause obligates the client to pay the costs of such an action if it is needed.

Clause 16. The terms set out in our suggested event photography contract are designed to provide the photographer with reasonable legal recourse to protect the integrity and financial well-being of his business. However, there are many times when, for the sake of goodwill, we may not wish to exercise all of our legal options. When we enter into a contract with a client, we do so with every intention of a cooperative and rewarding relationship and hope that we never have to use the remedies that are included. In most cases, the decisions we make in this regard are well founded and everything works out quite well for all concerned. However, some-

12. INTEREST CHARGES. Balances unpaid after thirty (30) days are subject to an interest charge of 2 percent (2%) per month (24 percent [24%] annually). Each thirty (30) day statement of overdue balances is subject to a minimum charge of $10 in either interest or service charges.

13. PRICE INCREASES. Orders delayed for sixty (60) days or more are subject to any increase in charges for the same services and product that are published subsequent to this contract.

14. ADDITIONAL SERVICES. Charges for additional services other than those referred to in this contract are subject to rates current at the time they are ordered.

15. COLLECTIONS. The Client agrees to pay any and all charges and expenses incurred in the collection of delinquent balances.

16. NO WAIVER. Failure by the Studio to exercise any and all rights under the terms of this agreement or enforce any part herein shall not limit its rights to exercise said rights in the future and should not be considered a waiver of any right.

17. RETURN OF PROOFS. The Client shall be liable for all fees and charges required to obtain the return of Proofs, including but not limited to attorneys' fees, court costs, and expert witness fees.

18. GOVERNING LAW; LEGAL FEES; ARBITRATION. This agreement shall be governed by and construed in accordance with the laws of the State of _____. The parties agree that in the event of any suit or proceeding brought by one party against the other, the party prevailing therein shall be entitled to payment from the other party hereto of its reasonable attorneys' fees and all costs incurred. Except for the right of either party to apply to a court of competent jurisdiction for a temporary restraining order, a preliminary injunction or other equitable relief to preserve the status quo or prevent irreparable harm pending the selection and confirmation of the arbitrator(s), any controversy or claim arising out of, relating to, or concerned with this Agreement or breach hereof must be settled by binding arbitration in accordance with the Commercial Arbitration Rules of the American Arbitration Association, and judgment upon the award rendered by the arbitrator(s) may be entered in any court having jurisdiction. Exclusively the _____ Regional Office of the American Arbitration Association must administer any arbitration under this Agreement, or in the event that office is unable to act, by the closest available regional office to _____. The arbitration must be held in _____ (county), _____ (state).

Clauses 12–18 of the event photography contract.

times we make decisions that can come back to haunt us. This clause allows us to be lenient without eliminating our future options if things go wrong. Should a client, deliberately or unintentionally, give us the runaround, we can still return to the sanctions we have in the contract.

Clause 17. It may be very difficult to persuade the client to return the proofs. Depending on the photographer's need to have them back, this may mean involving an attorney and even taking legal action. When this happens, someone has to be responsible for these charges—and it should not be the studio or the photographer. In this clause, the client agrees to pay any and all costs to get the proofs back to the photographer.

Clause 18. This is perhaps the most important clause in terms of settling any dispute between the contractor and client. Had this clause been incorporated in the contract of the parties in the example related earlier, the photographer and studio would have saved significantly. Of the $37,000 the photographer and studio owner expended, some $26,000 was spent on attorney fees for depositions, presentations to a court, and other related legal expenses. Arbitration would have saved almost all of this $26,000. This clause is designed to keep disputing parties out of court. Arbitration is a much less expensive route to take in resolving disputes.

Had this clause been incorporated in the contract of the parties in the earlier example, the photographer and studio would have saved significantly.

You may want to locate the American Arbitration Association office nearest to your studio, and state that the arbitration should be held in the county in which you do business.

19. LIMITATION OF DAMAGES. The Client hereby agrees that in the event there is a ruling which determines that the Studio has breached its obligations under this contract, then the maximum damages that the Client is entitled to is the money paid to the Studio to date. The client agrees that they are not entitled to collection of actual damages or any consequential damages. Under no circumstances is the Client able to recover a damage award that would exceed the money paid by the Client to date.

20. BREACH OF COPYRIGHT LAWS. The Client agrees that any violation by the Client of any of the state or federal copyright laws with regard to the proofs, negatives or electronic or other image media produced by the Studio which originated as a result of this contract shall constitute a breach of this agreement, giving the Studio the right to take legal action and pursue all remedies available against the Client per agreement in law and/or equity.

21. PROVISIONAL INFORMATION. The following provisional information is provided by the Client as a guide as to times, locations, and persons, groups, etc., that are to be photographed. This information may be modified at a planning session on or about thirty (30) days prior to the event. Information provided and discussed at the planning session is not part of this contract nor shall such information modify this contract.

Principal subjects to be photographed: _____

Principal times for photography and locations: _____

Number of guests expected: _____ Number of tables to be photographed: _____

Second photographer required: ___ yes ___ no (A second photographer may require an assistant, and fees for both photographer and the assistant will be invoiced separately.)

Client address after date of photography: _____

I have read and agree to the terms of this contract. I have signed this agreement without undue influence and of my free and voluntary act.

Client: _____ Date: _____

Studio: _____ Date: _____

Clauses 19–21 plus advisory and signatures of the event photography contract.

Clause 19. This clause is intended to limit the damages a client may be awarded in a dispute. A client who feels that the photographer is in breach of contract may feel entitled to significant damages. They may claim that, because the photographer missed certain images that the client feels could and should have been taken, they should be monetarily rewarded for the omissions.

This clause is not an attempt to protect the contractor in the event of gross negligence or incompetence. It is, however, designed to protect the contractor from being exploited—as was the attempt by the clients in our previously described example.

If you return to Clause 7, you will note that omissions do not void the contract or result in compensation to the client. However, because we have included arbitration in this contract, the client may seek redress through this process up to the total of the amounts paid to the studio or photographer.

Clause 20. Protecting our copyrights is a major concern for all photographers. However, seeking redress via copyright law is rarely financially productive. This is because, as of the date of this publication, wedding and event photography is extremely difficult and expensive to register with the Copyright Office. With this clause, however, we make copyright infringement a

breach of contract, thereby making it much simpler to recover lost income resulting from copying our images. This clause also ensures that the client signs off on the fact that we hold the copyright and also acknowledges that it is unlawful to copy our work. Should such action be appropriate, we have the option of going to arbitration or (if legally advised) to court. For more on this important issue, see chapter 12.

Clause 21. Knowledge is power, and knowledge of wedding or event plans makes our job significantly easier. Our studio requires clients to meet with us so that we can gain as much knowledge as possible about what is going to happen during the event. However, as previously explained, all the planning in the world is no guarantee that it will happen. In the case we described at the beginning of this book, all sorts of things were intended that never happened. This resulted in disaster as far as the photography was concerned. In that case, there was an attempt to attach the planning session and other alleged prior advice to the contract. To allow this to happen is an invitation to get sued (or in the case of this contract, to go to arbitration). Therefore, this clause clarifies the fact that the planning session is not part of the contract and, in fact, is only advisory.

Advisory and Signatures. This advisory, obtained before the planning session, provides the photographer with basic information that permits him to schedule additional assignments if there is adequate time (and the logistics permit) on the date this photography is contracted to take place. If the event were an evening affair, for example, then it might be feasible to contract for additional morning work, so long as to do so would not potentially jeopardize fulfilling the contract.

Note that space is provided for the address of the client effective after the event. This could be important, as you cannot assume that they will always be at the address provided in the general-heading section of the contract.

Immediately below these statements is space for the signatures of the parties to the contract and the date on which it is signed. Above the client's signature are the words, "I have read and agree to the terms of this contract." This is important, as it eliminates the potential for a client to claim that he or she signed the contract without reading it. The sentence, "I have signed this agreement without undue influence and of my free and voluntary act," prevents a claim that they signed under pressure or that they accepted the photographer's or studio's explanation of the contract and misunderstood the terms. This is a claim that has been upheld in some instances, and we should avoid such possibilities wherever possible.

It should be noted that the majority of people waive their option to read the contract they are signing and may, therefore, overlook matters that could become pertinent at a later date. The ethical way to maintain the integrity of the contract, and to avoid future problems, is for the photographer to apprise the client(s) of their obligations. We take a minute or two to step through the contract with each client so that they are aware of the consequences should their plans change.

ADDITIONAL CONCERNS

Price Schedule and Terms. It is recommended that the studio or photographer's schedule of prices and terms, to which the above contract applies and which were the terms and schedules that caused the signing of the contract, be attached to the contract. This ensures that they will be available in the event that any issues need to be addressed.

The majority of people waive their option to read the contract and may, therefore, overlook matters that could become pertinent later.

Addendum. There are times when the above contract may not fully define all of the aspects of the agreement between the parties. This may be the case when the photographer or studio negotiates or offers special terms and/or services that cannot be accommodated therein. In such a case, an addendum should be attached to the contract and signed by both parties. The addendum must be very precise and not worded in such a way as to compromise the primary contract.

An Alternative Format. For some photographers, the formula used for the above contract may need to be modified to incorporate your own unique terms and conditions into the individual clauses. This may be done in cooperation with your attorney, or if you are located in Illinois you may contact Christopher S. Nudo to arrange a consultation (photography@nudo.net). The

above contract is what we recommend, and the modifications required are well worth the investment for the special protection it provides.

IN SUMMARY

We have now identified the elements of our event contract and the importance of each paragraph. We recommend that you have a contract attorney review it for enforceability in your jurisdiction. The only clause in the contract that we have ever modified is that which refers to our right to use the images for promoting the studio. If a client does not wish us to display their images in magazines and other publications, such as newspapers, we will respect their desire for privacy and modify that clause.

When creating your own version of this contract, you will personalize it according to the way that you want to do business.

The contract has good protections addressing both the client's and the photographer's issues. Prices are protected, and disputes are governed by arbitration and not subject to expensive court proceedings. The client and the contractor have agreed to cooperate, all other cameras and lighting are under the direction of the photographer on the job, and the payment and ordering schedules are clearly set out. We have also clearly defined the copyright issues and made any violation a breach of the contract, simplifying any need for redress.

When creating your own version of this contract, you will personalize it according to the way that you want to do business. The whole purpose of this contract is to do business on *your* terms and not on someone else's. Having said that, be aware that this model event contract cannot protect you if you are grossly negligent and totally fail to perform.

2. PORTRAIT PHOTOGRAPHY CONTRACT

A contract for portraiture is rare, so why should we have one? Most portraiture is done on the understanding that the photographer has the skill and style that appeals to the client. The photographer explains his terms and hands a brochure and/or a price list to the client. Based on the photographer's explanation of his process and the price list, the client makes an appointment. This should imply that the photographer has artistic license to produce the photographs as he sees fit and the client will either be pleased or not. While it's a satisfactory procedure artistically, it is not a wise practice legally.

So, when would a contract be appropriate? For legal reasons, there should *always* be a contract. However, most photographers would cringe at the notion of having a client sign a portraiture contract. It might also be an inhibitor to the client.

The most likely client to want a written contract for portraiture is a corporation that is incurring significant charges. These are usually assigned by a purchase order, which specifies the client's requirements. The photographer, in reviewing these requirements, may see potential problems in getting paid if certain factors prove difficult or impossible. This may require the photographer to request the client to agree to a contract. In most instances, the person providing the purchase order is not involved in the actual photography session or concerned with the specific results. For them, the contract is a nonissue, and they won't have a problem signing one.

Most of our clients come to us in good faith and expect us to produce work that they are going to be happy with. For them, the idea of a contract makes the process appear somewhat officious. But when a client asks what happens if they are not satisfied with the results of their session, what is our response? We might say that if the dissatisfaction is due to our failure to produce a professional or technically satisfactory photo-graph we will reshoot it at no charge. We may also say that if the dissatisfaction is due to the client's choice of clothes and hair style, then there will be a reshoot charge. The client may well then suggest that this is too vague and want something more substantial to give them the assurance they want.

The question here is how does a legally worded contract provide assurance in an exercise that is largely subjective? It is difficult to envision a contract that is, in itself, a warranty of satisfaction. What we *can* do is assure the client that dissatisfaction based on reason and objectivity will be handled in a certain way. Of course, then we have to decide who is being reasonable and who is not. It is, in these cases, up to the individual photographer and client to decide whether they want a written contract.

The most likely client to want a written contract for portraiture is a corporation that is incurring significant charges.

The contract we are proposing here is one that defines the obligations of the photographer to the client, and the client to the photographer. It stipulates how many images are to be shown or taken, when the results will be ready for review, what the charges are, when they will be paid, and how long the finished prints or services will take to complete.

PORTRAIT PHOTOGRAPHY CONTRACT

Client: _____

Telephone: (____)_____

Address: _____

Order number: _____

Description of portraits to be contracted:_____

Portrait(s) of: _____

Location for photography: _____

Date: _____ Time: _____

Extra details about photography:

CHARGES. The Portrait Fee is based on the Photographer's Standard Price List and includes the photographs described therein. In addition the extra charges set forth below shall be billed if and when incurred.

Package Fee (Package description _____)$_____
Fee without package .$_____

EXTRA CHARGES

Additional prints .$_____
Resitting .$_____
Special retouching .$_____
Special finishes .$_____
Rush service .$_____
Unreturned proofs .$_____
Overtime .$_____
Travel .$_____
Other _____$_____

 Subtotal .$_____
 Sales tax .$_____
 Total .$_____
 Less deposit .$_____
 Balance due .$_____

The Client has read and initialed all the pages of this Contract and acknowledges that the Client has read and understands all the Terms and Conditions, and acknowledges receipt of a complete copy of the Agreement signed by both parties.

Client: _____ Date: _____

Photographer: _____ Date: _____

This Contract is subject to the twenty-six (26) terms and conditions appearing on subsequent pages.

TERMS AND CONDITIONS

1. PAYMENT. The Client shall pay the Photographer within thirty (30) days of the date of the Photographer's billing, which shall be dated as of the date of delivery of the Assignment. The Client shall be responsible for and pay all sales tax due. Balances unpaid after thirty (30) days are subject to an interest charge of 2 percent (2%) monthly (24 percent [24%] annually).

2. FAILURE. Failure by the Client to make the second or final payment as scheduled may be deemed a breach of contract by the Client, which hereby relieves the Studio of all remaining obligations herein. Upon a breach of this contract by the Client, the Studio may hereby exercise all if its rights in law and equity and may seek relief as provided in Paragraph 23 below.

3. ADVANCES. Prior to the Photographer commencing the Assignment, the Client shall pay the Photographer the advance shown on the front of this form, which advance shall be applied against the total due. This agreement is valid only on payment of the first payment specified above.

4. RESERVATION OF RIGHTS. Unless specified to the contrary on the front of this form, any grant of rights shall be limited to the United States for a period of one (1) year from the date of the invoice and, if the grant is for magazine usage, shall be first North American serial rights only. All rights not expressly granted shall be reserved to the Photographer, including but not limited to all copyrights and ownership rights in photographic materials, which shall include but not be limited to transparencies, negatives, and prints. The Studio may use reproductions from negatives in part or in full for display, promoting and advertising the Studio, teaching and lecturing, and illustration of related or unrelated articles as may be published. All copyrights are reserved, and unauthorized copies or scanning made by the Client or his/her representatives or with his/her consent are chargeable at ten (10) times the listed charges of such prints by the Studio. The Client acknowledges that unauthorized scanning or copying of images is unlawful and subject to statutory prosecution. Release of negative materials to the Client, his or her heirs, or duly appointed assigns shall be subject to the payment of $2,000, plus any assessed taxes, and shall be delivered only after the Studio has made such reproductions as it may require. The Studio may retain all negative materials indefinitely but may limit such retention to the negatives from which orders have been placed by the Client.

5. VALUE AND RETURN OF ORIGINALS. (A) The Client agrees that all proofs (in whatever form the Studio designates) remain the property of the Studio unless otherwise provided above, and any proofs not returned according to the terms herein are chargeable at $10 each. Invoices or statements requiring payment for unreturned proofs will be paid within thirty (30) days. Proofs may not be part of the minimum order or coverage fees and are loaned to the Client for a period of 45 days, after which they shall be returned together with any and all orders. In the event the Client fails to return the proofs and present an order, there will be an order processing fee of $100 for each thirty (30) days' delay. Subsequent orders will be subject to a 15 percent (15%) surcharge. The Client is responsible for payment of all orders placed by the Client, and the Studio is not obligated to accept separate orders or provide separate billing of individual orders; to do so is a courtesy to the Client. (B) Proofs shall be collected not later than fourteen (14) days after notification they are ready for collection, and any balance due shall be paid at the time of collection. The Studio shall endeavor to make proofs available within twenty-one (21) days after photography.

6. ADDITIONAL USAGE. Any extension of such loan period is at the discretion of the Studio. If the Client wishes to make additional uses, the Client shall seek permission from the Photographer and pay an additional fee to be agreed upon.

7. EXPENSES. If this form is being used as an estimate, all estimates of expenses may vary by as much as 10 percent (10%) in accordance with normal trade practices. In addition, the Photographer may bill the Client in excess of the estimate

for any overtime which must be paid by the Photographer to assistants and freelance staff for a shoot that runs more than eight (8) consecutive hours.

8. COOPERATION. The Studio and Client shall cooperate, agreeing to all schedules and arrangements for services to be provided, including arriving promptly for scheduled photography as agreed upon at a planning meeting. Changes to scheduled times shall be agreed upon prior to photography. The Client agrees to meet with Studio representative(s) at least thirty (30) days prior to photography, agreeing on a schedule. The Studio shall endeavor to meet all reasonable Client expectations, save only that in the circumstances they may not be possible, and the Studio makes no express or implied warranty for producing specific images. When the Client, or others referred to in the schedule, is not on time, the Studio shall not be liable for omissions of requested photographs that may otherwise be feasible.

9. CAMERAS AND LIGHTING. Any and all cameras and related lighting, including video, shall be under the direction of the Studio and the Client shall advise any and all users or providers of services of this clause.

10. RESHOOTS. If the Photographer is required by the Client to reshoot the Assignment, the Photographer shall charge in full for additional fees and expenses, unless (A) the reshoot is due to Acts of God or is due to an error by a third party, in which case the Client shall only pay additional expenses but no fees; or (B) if the Photographer is paid in full by the Client, including payment for the expense of special contingency insurance, then the Client shall not be charged for any expenses covered by such insurance in the event of a reshoot. The Photographer shall be given the first opportunity to perform any reshoot.

11. CANCELLATION. Should the Client cancel the assignment date or cancel this agreement, all deposits paid shall be retained by the Studio, unless the Studio is able to secure an assignment for a comparable fee for the date cancelled, at which time deposits shall be returned in full. The Studio shall not cancel unless serious illness or other such physical handicap shall render the Studio incapable of carrying out its obligations. The Studio having made every endeavor to obtain the services of a qualified and competent substitute, all deposits held by the Studio shall be returned to the Client, as the Client's sole remedy.

12. ASSIGNED PHOTOGRAPHER. The Studio reserves the right to replace assigned photographers as necessary, such as in the event of an emergency, in order to honor this agreement. The Client, subject to time permitting, shall be advised accordingly and has the right to approve or disapprove such change in assignment. On approval any paid attendance fees will then be refunded. In the event the Client disapproves, this contract shall be deemed cancelled and all deposits shall be returned to the Client.

13. LIABILITY. The Studio shall not be liable for omissions caused by failure of the Client to maintain all agreed schedules or caused by delays due to inaccurate or unreliable information provided by the Client. The Studio shall not be liable for failures or faults in the manufacturer or processing of materials or other causes that may reasonably be deemed beyond the control of the Studio. In the event such circumstances prevent the Studio from performing its obligations or delivering the agreed product or service, the Client's sole remedy shall be the refund of any deposits, as a Limitation on Damages as set forth in Clause 24. Omissions or failure to produce specific images that may be discussed or proposed at a planning session shall not void this agreement or result in compensation to the Client by the Studio.

14. RELEASES. The Client shall indemnify and hold harmless the Photographer against any and all claims, costs, and expenses, including attorneys' fees, due to uses for which no release was requested or uses which exceed the uses allowed pursuant to a release.

15. ORDERS AND DELIVERY. Any order for prints and services in excess of those contracted are subject to a deposit of 50 percent (50%) at the time of the order and prior to commencement of work, with the balance due on completion. Finished work will not be released without payment of balances due. The Studio shall endeavor to complete all orders within sixteen (16) weeks. The Client acknowledges that some phases of production are dependent on supplies and outside contractors and may be subject to delay.

16. PRICE INCREASES. Orders delayed for sixty (60) days or more are subject to any increase in charges for the same services and product that are published subsequent to this contract.

17. SAMPLES. Client shall provide the Photographer with two copies of any authorized usage.

18. ASSIGNMENT. Neither this Agreement nor any rights or obligations hereunder shall be assigned by either of the parties, except that the Photographer shall have the right to assign monies due hereunder. Both the Client and any party on whose behalf the Client has entered into this Agreement shall be bound by this Agreement and shall be jointly and severally liable for full performance hereunder, including but not limited to payments of monies due to the Photographer.

19. COLLECTIONS. The Client agrees to meet any and all reasonable charges and expenses incurred in the collection of delinquent balances. The Client shall be liable for any reasonable fees and charges required to obtain the return of Proofs, including but not limited to attorneys' fees, court costs, and expert witness fees.

20. ADDITIONAL SERVICES. Charges for additional services other than those referred to in this contract are subject to rates at the time they are ordered.

21. NO WAIVER. Failure by the Studio to exercise any and all rights under the terms of this agreement or enforce any part herein shall not limit its rights to exercise said rights in the future.

22. PROVISIONAL INFORMATION. The following provisional information is provided by the Client as a guide as to times, locations, and persons, groups, etc. that are to be photographed. This will be modified at a planning session on or about thirty (30) days prior to the date of photography. Information provided and discussed at a planning session is not part of this contract nor shall such information modify this contract.

23. GOVERNING LAW; LEGAL FEES; ARBITRATION. This Agreement shall be governed by and construed in accordance with the internal laws of the State of _____ without regard to the conflicts of laws principles thereof. The parties agree that in the event of any suit or proceeding brought by one party against the other, the party prevailing therein shall be entitled to payment from the other party hereto of its reasonable counsel fees and disbursements in an amount judicially determined. Except for the right of either party to apply to a court of competent jurisdiction for a temporary restraining order, a preliminary injunction, or other equitable relief to preserve the status quo or prevent irreparable harm pending the selection and confirmation of the arbitrator(s), any controversy or claim arising out of, relating to, or connected with this Agreement or the breach hereof must be settled by binding arbitration in accordance with the Commercial Arbitration Rules of the American Arbitration Association, and judgment upon the award rendered by the arbitrator(s) may be entered in any court having jurisdiction thereof. Any arbitration under this Agreement must be administered exclusively by the _____ Regional Office of the American Arbitration Association.

24. LIMITATION ON DAMAGES. The Client hereby agrees that, in the event there is a ruling which determines that the studio has breached its obligations under this contract, then the maximum damages that the Client is entitled to is the money paid in to the Studio to date. Under no circumstances is the Client entitled to any damage reward which would exceed the money paid in by the Client to date.

25. BREACH OF COPYRIGHT LAWS. The Client agrees that any violation by the Client of any of the State or Federal Copyright Laws with regard to the proofs, negatives, or images which originated as a result of this contract shall constitute a breach of this agreement, giving the Studio the right to pursue all rights and remedies in law or equity against the Client, per Agreement.

26. PHOTOGRAPHER'S STANDARD PRICE LIST. The charges in this Agreement are based on the Photographer's Standard Price List. This price list is adjusted periodically and future orders shall be charged at the prices in effect at the time when the order is placed.

3. BOUDOIR PHOTOGRAPHY CONTRACT

There are many circumstances that require male photographers to photograph women, and mostly these do not involve risk of unpleasant or serious repercussions. Headshots for brochures or press releases are common assignments that we take for granted and present virtually no risk of legal complications. Portrait sessions normally should not present us with challenges to anything more than our photographic skills. There are other situations, however, that may present problems.

When I first began professional photography, I was working out of my home and our living room was converted into a camera room whenever I had a studio session. On one occasion, I made an appointment for a young woman and did not discuss the purpose of the portrait or the style. When she arrived for her session, she had a bag that she said held her change of clothes. I had a screen and a mirror for ladies to change and check their attire and makeup, so she went behind the screen to prepare for the portrait while I made my last-minute preparations. When she said she was ready, she asked me if I was too and I said yes. When she stepped out from behind the screen I was stunned. She was naked with just a shawl over her arm. After the initial shock, I did manage to complete the session. I am pleased to say that the results were all that she wished them to be and there were no repercussions.

Yet, just think of the potential consequences of my not having properly discussed the purpose and style of this woman's portrait session! Impropriety could have been alleged, and I might have been accused of sexual misconduct or worse.

In today's world, it is vital that we discuss our client's purpose and the style of portrait they desire. When it becomes obvious that the portraits are for other than conventional purposes, we should make sure that we have another female of our choice present and encourage the subject to have a friend, her husband, or a significant other accompany her. (While problems may arise in instances where female subjects are photographing male subjects, these are more rare. Therefore, we shall consider the case of a male photographer and a female subject; the basic issues would generally be the same were the genders reversed.)

Boudoir photography has become fairly common and can be very profitable—but it has risks. I have heard several stories resulting from these sessions. In one case, the husband of the subject stormed into the photographer's studio and accused him of all sorts of improper actions. In another case, a photographer admitted to me that such a session resulted in him and the client indulging in extracurricular activity. Ouch! Imagine the potential consequences.

Keep in mind that, in these types of situations, the verbal aspects of the session are also of a delicate nature.

It is my personal opinion that our contract for boudoir photography should be different than the one we may use for conventional portraiture. It should state that the client agrees that the portraits to be made may be of a provocative or revealing nature, that individual images will only be taken after she has given her consent at the shoot, and that she holds the photographer harmless in regard to the use to which she may put the photographs after delivery.

It should also make it clear that she is invited to have a personal assistant with her, and that the studio will also have one of its own female employees present. This is especially useful if there is a need for you to assist the subject in posing or the adjustment of attire. Instead of you needing to become physically involved in making adjustments, your female assistant would do so. If you need to make a final adjustment, make sure that

your assistant is up close while you do it, and be sure that you are seen to be very discreet.

Keep in mind that, in these types of situations, the verbal aspects of the session are also of a delicate nature. One photographer told me that, after one of his sessions, he was accused of making sexual advances toward his subject, and that he was working alone at the session. It involved him in an exchange of letters with his subject's attorney. Apparently it went away without any great difficulty, but it might not have. Your personal female assistant is insurance against such an accusation.

A sample boudoir photography contract appears on pages 30–33.

BOUDOIR PHOTOGRAPHY CONTRACT

Client: _____

Address: _____

Order Number: _____

CLIENT'S UNDERSTANDING AND AGREEMENT: The definition and general understanding of this contract is Boudoir photography, which is photography of the body in circumstances that may include sexually suggestive poses or nude photography. It is the Client's desire and voluntary action to pose and participate in the photography and this contract. The Client agrees to hold the Studio and Photographer harmless from any third-party involvement or actions that may arise from the publication of any of the images from this contract. Additionally, the Client shall hold the Photographer and the Studio harmless from any claims whatsoever from the content or suggestive nature that may be portrayed in any of the images as a result of this contract.

Description of boudoir images to be photographed:

Boudoir images of, (if different than Client):

Location for Photography:

Date:_____ Time: _____

Extra detail about photography:

CHARGES. The Boudoir fee is based on the Photographer's Standard Price List and includes the photographs described therein. In addition the extra charges set forth below shall be billed if and when incurred.

Package fee (package description: _____)$_____

Fee without package .$_____

EXTRA CHARGES

Additional prints .$_____

Resitting .$_____

Special retouching .$_____

Special finishes .$_____

Rush service .$_____

Unreturned proofs .$_____

Overtime .$_____

Travel .$_____

Other .$_____

 Subtotal .$_____

 Sales tax .$_____

```
Total  . . . . . . . . . . . . . . . . . . . . . . . . . . . . . . . . . . . . . . . . . .$_____
Less advance  . . . . . . . . . . . . . . . . . . . . . . . . . . . . . . . . . .$_____
Balance due  . . . . . . . . . . . . . . . . . . . . . . . . . . . . . . . . . . .$_____
```

TERMS AND CONDITIONS

1. PAYMENT. The Client shall pay the Photographer upon receipt of the Photographer's invoice, which shall be dated as of the date of delivery of the Assignment. The Client shall be responsible for and pay any sales tax due. Balances unpaid after thirty (30) days are subject to an interest charge of 2 percent (2%) monthly (24 percent [24%] annually).

2. FAILURE. Failure by the Client to make the second or final payment as scheduled may be deemed a breach of contract by the Client, which hereby relieves the Studio of all remaining obligations herein. Upon a breach of this contract by the Client, the Studio may hereby exercise all if its rights in law and equity and may seek relief as provided in Paragraph 22 below.

3. ADVANCES. Prior to the Photographer's commencing the Assignment, the Client shall pay the Photographer the advance shown on the front of this form, which advance shall be applied against the total due. This agreement is valid only on payment of the first payment specified above.

4. RESERVATION OF RIGHTS. The Photographer is the owner of all the rights, including copyrights, in all the images and prints, whether on paper, film, transparencies, or electronic media. The Studio may use reproductions from negatives in part or in full for the Studio, teaching, lecturing, and illustration of related articles as may be published. All copyrights are reserved, and unauthorized copies or scanning made by the Client or his/her representatives without the Studio's consent is chargeable at ten (10) times the listed charges of such prints by the Studio. The Client acknowledges that unauthorized scanning or copying of images is unlawful and subject to statutory prosecution. Release of negative materials to the Client, his or her heirs, or duly appointed assigns shall be subject of another agreement should the parties want to enter into such agreement. The Studio may retain all negative materials indefinitely but may limit such retention to the negatives from which orders have been placed by the Client.

5. VALUE AND RETURN OF ORIGINALS. (A) The Client agrees that all proofs (in whatever form the Studio designates) remain the property of the Studio unless otherwise provided above, and any proofs not returned according to the terms herein are chargeable at $10 each. Invoices or statements requiring payment for unreturned proofs will be paid within thirty (30) days. Proofs may not be part of the minimum order or coverage fees and are loaned to the Client for a period of forty-five (45) days, after which they shall be returned together with any and all orders. In the event the Client fails to return the proofs and present an order, there will be an order processing fee of $100 for each thirty (30) days' delay. Subsequent orders will be subject to a 15 percent (15%) surcharge. The Client is responsible for payment of all orders placed by the Client, and the Studio is not obligated to accept separate orders or provide separate billing of individual orders; to do so is a courtesy to the Client. (B) Proofs shall be collected not later than fourteen (14) days after notification they are ready for collection and any balance due shall be paid at the time of collection. The Studio shall endeavor to make proofs available within twenty-one (21) days after photography.

6. ADDITIONAL USAGE. Any extension of such loan period is at the discretion of the Studio. If the Client wishes to make additional uses, the Client shall seek permission from the Photographer and pay an additional fee to be agreed upon.

7. COOPERATION. The Studio and the Client shall cooperate, agreeing to all schedules and arrangements for services to be provided, including arriving on time for scheduled photography as agreed at a planning meeting. Changes to scheduled times shall be agreed upon prior to photography. The Client agrees to meet with Studio representative(s) at least thirty (30) days prior to photography, agreeing on a schedule. The Studio shall endeavor to meet all reasonable Client expectations, save only that in the circumstances they may not be possible, and the Studio makes no express or implied warranty for producing specific images. When the Client, or others referred to in the schedule, is not on time, the Studio shall not be liable for omissions of requested photographs that may otherwise be feasible.

8. CAMERAS AND LIGHTING. Any and all cameras and related lighting, including video shall be under the direction of the Studio and the Client shall advise any and all users or providers of services of this clause.

10. RESHOOTS. If the Photographer is required by the Client to reshoot the Assignment, the Photographer shall charge in full for additional fees and expenses, unless (A) the reshoot is due to Acts of God or is due to an error by a third party, in which case the Client shall only pay additional expenses but no fees; or (B) if the Photographer is paid in full by the Client, including payment for the expense of special contingency insurance, then Client shall not be charged for any expenses covered by such insurance in the event of a reshoot. The Photographer shall be given the first opportunity to perform any reshoot.

11. CANCELLATION. Should the Client cancel the assignment date or cancel this agreement, all deposits paid shall be retained by the Studio, unless the Studio is able to secure an assignment for a comparable fee for the date cancelled, at which time deposits shall be returned in full. The Studio shall not cancel unless serious illness or other such physical handicap shall render the Studio incapable of carrying out its obligations. The Studio having made every endeavor to obtain the services of a qualified and competent substitute, all deposits held by the Studio shall be returned to the Client, as the Client's sole remedy.

12. ASSIGNED PHOTOGRAPHER. The Studio reserves the right to replace assigned photographers as necessary, such as in the event of an emergency, in order to honor this agreement. The Client, subject to time permitting, shall be advised accordingly and has the right to approve or disapprove such change in assignment. On approval, any paid attendance fees will then be refunded. In the event the Client disapproves, this contract shall be deemed cancelled and all deposits shall be returned to the Client.

13. LIABILITY. The Studio shall not be liable for omissions caused by failure of the Client to maintain all agreed schedules or caused by delays due to inaccurate or unreliable information provided by the Client. The Studio shall not be liable for failures or faults in the manufacturer or processing of materials or other causes that may reasonably be deemed beyond the control of the Studio. In the event such circumstances prevent the Studio from performing its obligations or delivering the agreed product of service, the Client's sole remedy shall be the refund of any deposits, as a Limitation on Damages as set forth in Clause 24. Omissions or failure to produce specific images that may be discussed or proposed at a planning session shall not void this agreement or result in compensation to the Client by the Studio.

14. RELEASES. The Client shall indemnify and hold harmless the Photographer against any and all claims, costs, and expenses, including attorneys' fees due to uses for which no release was requested or uses which exceed the uses allowed pursuant to a release.

15. ORDERS AND DELIVERY. Any order for prints and services in excess of those contracted are subject to a deposit of 50 percent (50%) at the time of the order and prior to commencement of work, with the balance due on completion. Finished work will not be released without payment of balances due. The Studio shall endeavor to complete all orders within sixteen (16) weeks. The Client acknowledges that some phases of production are dependent on supplies and outside contractors and may be subject to delay.

16. PRICE INCREASES. Orders delayed for sixty (60) days or more are subject to any increase in charges for the same services and product that are published subsequent to this contract.

17. SAMPLES. The Client shall provide the Photographer with two copies of any authorized usage.

18. ASSIGNMENT. Neither this Agreement nor any rights or obligations hereunder shall be assigned by either of the parties, except that the Photographer shall have the right to assign monies due hereunder. Both the Client and any party on whose behalf the Client has entered into this Agreement shall be bound by this Agreement and shall be jointly and severally liable for full performance hereunder, including but not limited to payments of monies due to the Photographer.

19. COLLECTIONS. The Client agrees to meet any and all reasonable charges and expenses incurred in the collection of delinquent balances. The Client shall be liable for any reasonable fees and charges required to obtain the return of Proofs, including but not limited to attorneys fees, court costs, and expert witness fees.

20. ADDITIONAL SERVICES. Charges for additional services other than those referred to in this contract are subject to rates at the time they are ordered.

21. NO WAIVER. Failure by the Studio to exercise any and all rights under the terms of this agreement or enforce any part herein shall not limit its rights to exercise said rights in the future.

22. GOVERNING LAW; LEGAL FEES; ARBITRATION. This Agreement shall be governed by and construed in accordance with the laws of the State of _____ without regard to the conflicts of laws principles thereof. The parties agree that in the event of any suit or proceeding brought by one party against the other, the party prevailing therein shall be entitled to payment from the other party hereto of its reasonable counsel fees and disbursements in an amount judicially determined. Except for the right of either party to apply to a court of competent jurisdiction for a temporary restraining order, a preliminary injunction, or other equitable relief to preserve the status quo or prevent irreparable harm pending the selection and confirmation of the arbitrator(s), any controversy or claim arising out of, relating to, or connected with this Agreement or the breach hereof must be settled by binding arbitration in accordance with the Commercial Arbitration Rules of the American Arbitration Association, and judgment upon the award rendered by the arbitrator(s) may be entered in any court having jurisdiction thereof. Any arbitration under this Agreement must be administered exclusively by the _____ Regional Office of the American Arbitration Association.

23. LIMITATION ON DAMAGES. The Client hereby agrees that in the event there is a ruling which determines that the studio has breached its obligations under this contract, then the maximum damages that the Client is entitled to is the money paid to the Studio to date. Under no circumstances is the Client entitled to any damage reward which would exceed the money paid by the Client to date.

24. BREACH OF COPYRIGHT LAWS. The Client agrees that any violation by the Client of any of the State or Federal Copyright Laws with regard to the proofs, negatives, or images which originated as a result of this contract shall constitute a breach of this agreement, giving the Studio the right to pursue all rights and remedies in law or equity against the Client, per Agreement.

25. PHOTOGRAPHER'S STANDARD PRICE LIST. The charges in this Agreement are based on the Photographer's Standard Price List. This price list is adjusted periodically, and future orders shall be charged at the prices in effect at the time when the order is placed.

The Client has read and initialed all the pages of this Contract and acknowledges that the Client has read and understands all the Terms and Conditions, and acknowledges receipt of a complete copy of the Agreement signed by both parties.

Client: _____ Date: _____

Photographer: _____ Date: _____

4. RETAKE POLICY

One of the more difficult issues that many photographers have to deal with is that of retakes due to client dissatisfaction. Dissatisfaction with the results of a photography session might occur for a host of different reasons. The problem is that any photography of people is very subjective, and what a photographer sees as at least acceptable, both aesthetically and technically, the client may see as unacceptable.

Some photographers state categorically that any and all retakes will be charged. Others prefer to leave the issue open-ended, to be negotiated if and when the need should arise. So should we or should we not address the issue before it arises? Psychologically it is wise to leave the issue open and allow the photographer to negotiate with the client if and when a problem occurs. However, this leaves the photographer exposed to abuses, as well.

The purpose of a retake policy is to protect you against clients who have no justification for wanting to retake their images, or when the real reason for their dissatisfaction is that they made bad choices as to location, clothing, backgrounds, or hair style. Keep in mind that your retake policy, or the way you deal with requests for a retake, must be considered in relation to the topics discussed in the previous chapters.

Without a retake policy in place, if you refuse to retake a session because you believe you are being misused or abused, you may find yourself subjected to a suit for failing to meet your obligations under the implied contract that provided for the photography.

Unlikely, you might say—but don't rule out such a possibility. In one instance, a photographer retook a session twice and the client was still unhappy. For each session, the subject changed their clothing and hair style, indicating that the reason for the problem was not the photography but the client's choice of attire and hair style. Therefore, the photographer refused a third retake and received a letter from the client's attorney demanding a refund of all fees and minimums, reimbursement for money paid to the beauty parlor, and compensation for the client's time spent at the studio for the last session. The amount was five times what the photographer had received for his services. The photographer consulted his attorney and was advised to settle, since the cost of disputing the claim would exceed the amount demanded.

The photographer could have prevented such an occurrence with a simple statement within his brochures and price schedules, and perhaps in a suitable location at his place of business. This could simply have read:

> **RETAKE POLICY**
>
> Retaking of portrait/photography sessions is strictly at the sole discretion of the studio. It is our aim that you be satisfied with our photography. We will happily retake any session at no charge if you are dissatisfied due to our failure to meet our accepted technical standards. In order to ensure that a retake will not be required, please consult with us as to attire, makeup, hair styling, and choice of background, and the best time of day for your photography session. Thank you.

This statement clearly advises clients that they are responsible for selecting the proper attire and the other elements that will aid the completion of a successful session. It also clearly states that unless the photographer fails to meet his recognized technical standards, any retake is strictly at his discretion

5. VERBAL CONTRACTS

What is a verbal contract, and is it binding? A verbal contract is one in which you and another decide to perform an action or conduct a project and have agreed to the terms. Is it binding? Perhaps—depending on the circumstances, whether there is a legitimate reason for it being so, and whether there is a witness to the agreement.

A verbal contract, in the case of photography, should be very simple and used only when there is virtually no reason for the agreement to be in dispute. This would be the case when you make an appointment via the telephone for a portrait session. You discuss the portrait session to be made and you relate the terms and conditions that govern the session. The client asks you pertinent questions and you provide accurate answers based on your published list. The client agrees to the terms and the appointment is made. Is this a contract? If you have accurately explained your terms as published, yes.

Verbal contracts are not the most reliable, however, so when it is necessary to relate your terms to a client via the telephone, it is also wise to provide them with the written version as quickly as possible. This is difficult if the appointment is on short notice, but you can fax or e-mail your materials if regular mail won't make it in time.

When we relate prices on the telephone, it is possible that the client either will not write the prices down or will make mistakes when doing so. If you make a mistake (and most of us are capable of doing so), you are advised to live with it rather than try to apply terms that are different than what the client expects. In fact, when disputes arise that cannot be related directly to published prices, the client has a genuine issue with you and it should be resolved either by negotiation or by you agreeing to the client's misunderstood terms. The supposed verbal contract is really void.

A verbal contract should be very simple and used only when there is virtually no reason for the agreement to be in dispute.

The primary issue here is the value of the verbal contract. If we are discussing an assignment with a value of less than a couple of hundred dollars, there is not going to be much harm done if it becomes an issue. However, if the value is somewhat more, then you should absolutely not rely on a verbal contract but get your agreement in writing instead.

One simple method of confirming the terms is to send a letter or e-mail setting out the terms as discussed. You client will quickly respond if she believes that the terms were advised differently. Then, you can discuss and clarify them.

6. REPRESENTING YOURSELF

In the previous chapters, we discussed various aspects of protecting the interests of both the client and the photographer. The signing of the contract comes after the prospective client has been sold on the ability of the photographer to provide a service and product to his or her satisfaction. You will recall that in the case described at the beginning of chapter 1, the suit asserted that the photographer had fraudulently caused the plaintiffs to sign a contract because, they alleged, he had falsely claimed he was a PPA Master Photographer. Although that allegation was untrue, it's a good reminder that we need to consider how we represent ourselves to prospective clients.

QUALIFICATIONS

Qualifications are important to prospective clients, and it is important that any claims you make are accurate and provable. This applies to any awards and qualifications advertised either directly or indirectly. While false claims about how many awards are credited to the advertiser may appear to be an innocent embellishment or simply brazen salesmanship, they can backfire in the event of a suit for failure to perform. For example, if you seriously embellish on the truth by advertising that you are the most award-winning studio in your marketplace, this would negatively impact your ability to defend yourself should it become an issue in a suit against you.

False claims of qualifications can also lead to charges of fraud and misrepresentation. We have seen examples of this kind of misrepresentation in several brochures and in advertisements. In each case the presenter of the misinformation has been most fortunate not to be taken to court. We have even heard of one instance of outrageous fraud in which the photographer actually forged a certificate of qualification.

Therefore, it is important that any awards claimed should be listed and verifiable. To do this, you can simply place on display trophies or plaques that identify their source (who awarded them to you) or list your awards in a brochure.

FALSE STAFFING CLAIMS

Another form of misrepresentation is a false claim that a studio has a specific number of full-time photographers on staff when in fact they do not. In the case where there is not an assigned photographer for the event contracted and, on the date of the assignment, the studio cannot make any photographer available, such a false claim would become a genuine cause for litigation. The fact that the studio did not have the claimed number of staff photographers would result in a charge of misrepresentation that would be impossible to defend.

The fact that the studio did not have the claimed number of staff photographers would result in a charge of misrepresentation . . .

In a "notice to produce," either at a deposition or by order of a judge, you would have to produce evidence that you actually do employ the number of photographers you claimed in your sales presentation, brochure, or advertisement.

Our event contract would not protect you from such a prosecution, because you cannot contract protection against false claims or representation.

It is recommended that there be an assigned photographer on all contracts. In our model event contract, we have a clause that provides for the contractor to substitute photographers in the case of an emergency. However, what is important is that if the assigned photographer leaves your employ, the client is immediately advised that a substitution will need to be made. Should you fail to do so, or should it later become known that this information was available at an earlier date but was not provided until it was too late for the client to seek other options, it would negatively impact your ability to defend a potential suit.

MISLEADING DISPLAYS

Another form of misrepresentation is in displaying the work of former staff members or subcontractors who are no longer available to the studio. In most cases, this is an innocent oversight, but nonetheless it is misleading and should be avoided. Images displayed as representative of your studio's work should always be produced by those currently available at the studio. If this is not the case and there is an issue with respect to the style or quality of the images presented, it would weigh heavily in favor of the client in a subsequent suit.

ACCURATE, HONEST, AND CLEAR

There have been many instances where a client has commissioned a studio based on a misunderstanding of the information provided. This has led to disputes that have been difficult to resolve. In a number of instances that we have reviewed, the client has refused to pay the bill, leading to potential legal action and the consequent costs involved.

We were told of one incident in which the client, believing he had been misled, threatened legal action to obtain monetary compensation for what he alleged was wasted time and considerable inconvenience. He had his attorney send a letter to this effect. Indeed, if a client prepares for a session at considerable expense and time—such as an hour of travel, beauty parlor costs, investment in appropriate clothing, possibly taking time off work, etc.—all based on misleading information, it is not unreasonable for her to seek legal help to redress the situation.

With this in mind, everything that we include in both our written and verbal representations to potential clients requires us to be accurate and honest. Furthermore, the descriptions we provide of our services and products need to be clear and understandable in order to avoid misunderstandings that may lead to disputes. This is sometimes a little difficult, since full explanations of services and products can be lengthy and hoped-for clients might be unwilling to read them.

There are, of course, many ways that we may overcome such problems, such as supplementary printed material that supports verbal explanations. Stating our terms of business in a published price list or brochure is essential if we wish to avoid misunderstandings and misinterpretations that might lead to an accusation of misrepresentation—or, worse, fraud. When such supplementary materials are used, be sure that they are all clear and consistent. The primary reason for this is that people tend not to read all the material presented to them, and our verbal presentations will be assumed by the client to prevail.

Having written numerous brochures, I have discovered that it is very easy to assume what we have written is crystal clear when it is not.

Test the potential for misunderstanding of your material by asking three or four people to review it. Then have them discuss with you what they understand the information to mean. If clarification is needed, you can then amend your materials before you commit to their final printing. Having written your price list or brochure with every intention to be understood—and probably having burned the midnight oil to get it done—you may well feel that such an exercise is superfluous. However, having written numerous brochures and price lists on my own behalf, I have discovered that it is very easy to assume what we have written is crystal clear when it is not.

7. TERMS OF BUSINESS

If you require payment in full for sessions and minimums, then this needs to be stated in both the written and verbal information your provide to your clients. If you require a percentage or full payment from your clients for orders placed after a session, then this must be provided in written form as well as verbally. The written terms should be properly memorized so that they mirror those communicated verbally. When an order is written or invoiced it should accurately reflect the terms provided in any prior statement of the terms of business.

DEPOSITS

A deposit is a credit against the final delivery of a specific product or products—such as prints, frames, etc. Should the product(s) never be delivered, then the deposit must be returned. A deposit will normally cover at least 50 percent of the value of the total order. (Remember, a deposit is not the same as a retainer, so examine your terms of business and brochures and be sure that funds used to reserve your time are referred to as retainers, while funds used as credits against delivery of products are called deposits.)

It is wise to establish a minimum deposit that you will collect at the time of the order. For instance, if you have an order for $50 and you collect 50 percent, the balance of $25 may never be collected should the client be forgetful or change her mind. A deposit of only $25 is so small that the client may be willing to sacrifice it, so it may not be an incentive to pay the balance. Collecting the balance owed is usually more difficult with smaller amounts than larger ones. It is therefore wise to have a minimum payment of at least $50 or 50 percent, whichever is greater, as one of your terms of accepting an order.

The one exception to this would be when a deposit is placed on a special-order item that you are unlikely to have the opportunity to sell to another client. Such items should be paid for in full at the time the order is placed and sold on the understanding that they are not returnable unless they are damaged or not as ordered.

INVOICES AND ORDERS

When an order is written for photography, photographic prints, and related items, accuracy is critical. Frequently, orders for photography services and photographs are written in a manner that may be open to interpretation and may mean something different to the client than the photographer.

Frequently, orders for photography are written in a manner that may mean something different to the client than the photographer.

The best advice is that the client sign off on any written order. There are two ways in which they do so: one is to actually sign the order, the other is to make a deposit on the order as required by your terms of business. If the client makes a payment, it is assumed that he or she read the invoice. This is called an act of good faith, and normally it is all that is required to cement the order. However, there is no substitute for the written signature on the order.

COLLECTING PAYMENT

If, despite the fact that you have clearly set out your terms of business, you accept an order without receiving payment, you run the risk of being unable to sustain a prosecution for payment at a later date. In legal terms, if you have stated that you require either full payment or a percentage of the value of an order but do not receive such a payment, you do not have confirmation of that order. The client, should he or she change their

mind or be unable to meet their intended obligation, may say that they did not confirm the order, and this assertion would stand in a court of law. Should you inadvisably decide to accept orders without payment, then you should at least require a signature as confirmation. However, even this may not make it any easier to collect a balance due on completion.

One process for collecting outstanding balances for work completed is through the small-claims court. This is a lengthy process that can eat up considerable time. Some plaintiffs do not go this route until they have a number of such claims to present at one time. Even if you prevail in small-claims court, however, it is no guarantee that you will receive your money. The court simply confirms that your claim is legal and sustainable and issues an order to pay—but the court does not collect your money for you. You have to use other procedures for the collection if your client does not pay as ordered. There are specialists in this form of collection, and using them will require yet more expense. So the best advice is to collect at the time of the order.

SALES TAX

If there is a sales tax in your state, then you must clearly state whether the prices listed include sales tax or if sales tax is to be added. If you are in a state where there are different rates of tax on certain items (or there is no tax on some items and services), listed prices that include tax suggest that the tax is collected on all items equally. In such cases, it is wiser to quote prices that do not include tax and advise that taxes may apply to all or part of any order. This also allows you not to charge tax for out-of-state sales.

Some states have reciprocal arrangements with others to collect tax when sales are made from state to state. If your state has a sales tax, you should write to your state revenue department (or department of taxation) and ask for a list of states with which your state has a reciprocal arrangement so that you may charge tax when required to. If you do not do so, an audit may show that you have back tax penalties and interest to pay. For more on this subject, see chapter 11.

ADDITIONAL ISSUES

Bait and Switch. Be sure that any information you provide cannot be interpreted as a "bait and switch" sit-uation. This occurs when a business offers to provide a service and/or product that appears to be reasonable but is in fact an unacceptable or unavailable product and has to be substituted by another product at a higher price. Such advertising or soliciting, aimed at bringing prospective clients to a business under what amounts to false pretenses, is a practice used by unscrupulous business operations and can lead to criminal proceedings.

Advertising aimed at bringing prospective clients to a business under what amounts to false pretenses can lead to criminal proceedings.

Copyright. In chapter 12 we will cover copyright in great detail. Without getting too deeply into this subject, however, it is recommended that your copyright protection be covered on all your publications and invoices, orders, etc. A clear statement that you own the copyright to all the images should be added to each printed piece. The following is an example of what is recommended:

> The Studio owns and retains all copyrights, and it is unlawful to copy, scan, or otherwise electronically reproduce or manipulate in whole or in part any image created by the Studio. To do so may result in prosecution for appropriate compensatory and statutory damages. In the event of a copyright infringement the studio shall recover ten (10) times the listed charges for each and all images unlawfully copied.

On your invoices and order forms presented to clients it should be stated that:

> Payment on this order/invoice represents a contract that acknowledges the Studio's copyright. Copying, scanning, or otherwise reproducing (or allowing to be reproduced) any of these images is a breach of copyright and of this contract and is subject to damages as published.

This statement emphasizes the need to receive payment in advance or at time of an order and invoice. However, should you be providing services on an open

account, then the above statement would be amended to read as follows:

> I agree that this order represents a contract acknowledging the Studio's copyright. Copying, scanning, or otherwise reproducing (or allowing to be reproduced) any of these images is a breach of copyright and of this contract and is subject to damages as published.

Below this statement there should be a line for the client to sign. Providing this statement without having the client sign it does not change the fact that you have a copyright, but it may mean that you do not have a *contract* to this effect—meaning you would not be able to sue for breach of contract in the event the agreement is violated.

TERMS OF SALE

You may have made purchases from other suppliers or contractors who provide the terms of business and the sale printed on the reverse side of the invoice. You may choose to provide this information in the same manner. However, if you do, then you must clearly communicate to the purchaser that the terms of the sale are printed on the reverse side of the invoice. If you fail to do so, preferably on the face side of the invoice, then the purchaser may legitimately and successfully challenge your enforcement of the terms. Additionally, if you choose to provide the terms of sale on the reverse side of the invoice and the client reviews them after the sale, they could cancel once they have read them.

Most states have laws that protect consumers from fraud, misrepresentation, or misunderstanding in the terms of a purchase and allow from 24 to 72 hours for them to cancel or return a purchase, so long as the product is in the same condition as at the time of delivery. It is therefore wiser not to place your terms of business on the reverse side of invoices

8. LOAN OF PROOFS AND REFUNDABLE DEPOSIT AGREEMENT

W e are in the era of electronic imaging. Yet, despite technology that is moving toward providing proofing while preventing the pirating of photographers' intellectual property, we still need to carefully control how and when our work is reproduced.

A growing number of photographers are presenting their work at projection sessions, during which the client is expected to place an order. These photographers do not permit proofs to leave the premises, so the client has less opportunity to copy their images. Someday, the technology may be available to prevent copying of images no matter how they are delivered to the client. For now, however, a significant percentage—perhaps as high as 80 percent—of photographers still choose to provide paper proofs. Others provide low-resolution files on CDs, while still others offer online image proofing.

In this chapter, we deal with the issue of proofs that leave the photographer's premises, either in paper form or as files on a CD. Keep in mind that even low-resolution files on a CD can be used to reproduce images—though they will doubtless be of poor quality. (*Note:* At the time of this writing it has become possible to burn a CD that can not be copied, so when the CD is returned we know that the images have not been copied or reproduced from it. Additionally, at least one processing laboratory provides encrypted CDs that prevent copying of the images. As these become more widely used, it may become easier to protect your images from unauthorized reproduction.)

LOAN AGREEMENT

In order to ensure control over our images, we need a loan agreement that will control the timing of their return, describe the consequences if the agreement is not fulfilled, and restrict the client from reproducing the images. The agreement must also state that the proofs, however presented, remain the property of the photographer/studio.

The agreement on page 42 is an example of what may be used. It may be modified to suit individual photographers, but we recommend that the principles within not be modified. Also, keep in mind that everything within the agreement must be consistent with the terms and conditions we have established with the client.

You will note that the agreement proposed here provides for all the pertinent information relating to the original session and the proofs to be released on loan. The words "Loan Agreement" at the top of the document make it immediately clear to the client that the proofs are only on loan to them. The client should be asked to read it, and a copy should also be provided as a reminder of the terms and conditions they agreed to. You might also wish to include a section that schedules an appointment for the return of the proofs and the placement of an order.

In order to ensure control over our images, we need a loan agreement that will control the timing of their return . . .

This agreement offers the photographer protection against the failure to return proofs that leave his premises and also makes copyright infringement a breach of contract, enabling him to recover losses caused by the infringement. Provided that an infringement can be proved, the photographer, based on the terms of the above agreement, may directly invoice the client for the appropriate amount. As noted previously, statutory damages cannot be claimed unless the images that are the subject of the agreement have been registered with the Library of Congress.

This agreement provides several options for both the photographer and the client. In signing the loan

LOAN AGREEMENT

File: _____ Date: _____

With _____ (Studio/Photographer) at _____
_____ (address) or other locations as may apply and: _____
_____ (the Client) at _____
_____ (address), (_____)_____ (telephone),
_____ (e-mail).

Agrees to return _____ proofs in the form of _____ proofs/CDs, the property of the Studio, not later than _____ and agrees that the above stated proofs, whether on paper or CD, will be valued at the rate of $10 per image, in the sum of $ _____, plus sales tax in the sum of $ _____, and charged to the following credit card: _ Visa _ MC _ Discover (Card Number _____, Expiration Date _____).

In the event that a charge is declined or the proofs are released without a credit card number, the client agrees to make good the charge by check or cash within ten (10) days. Charges invoiced for failure to return the proofs may not be used against the minimum order required at the time of the original invoice or contract for the photography sitting or session. These charges may be used as a credit against an order (including the purchase of proofs) placed within thirty (30) days of the charge.

The purchase of proofs, after the required minimum, is subject to the terms set out in the Studio brochure that was current at the time of the original photography. When the return of the proofs and the placement of orders is later than the above agreed date, prices current at the time of the return and placement of the order will be charged, plus any other charges as may be stated in a separate written contract.

Wherein the Studio does not exercise rights as to the above terms and conditions within the prescribed period or otherwise delays its option to such rights it shall not waive such rights thereafter or as stated in a separate contract.

COPYRIGHT. The Studio owns all rights to the negatives and/or digital images from the above photography as protected by federal law. Images may not be copied, scanned, duplicated, or manipulated, in whole or in part, and may not be used for the production of any private or commercial purpose, or published without permission. Any copies of images made, or attempts to make copies in whole or in part is a violation of the Studio's copyright as legislated by the United States Congress, and subject to action for compensation and statutory fines. The Studio, other than any penalties assessed by a court of law, reserves the right to charge ten (10) times the published rate (current at the time of the violation), plus $100 for each copy of an image illegally reproduced. In certain circumstances the Studio may authorize the copying of images; however, all exceptions must be expressed in writing and signed by the studio.

THIRD-PARTY AUTHORIZATION.. When a third party signs this agreement, it is with the authority of the Client, and the Client agrees that all the above terms and conditions are not waived and are the same as if the Client signs this agreement. The above terms also apply when the proofs are mailed or shipped.

Signed: _____ Date: _____

agreement, the client provides the photographer the right to charge his or her credit card should the proofs not be returned as agreed. It is also made clear that the photographer may use his discretion as to when to make a charge and may do so at a later date even if he chooses not to charge the client immediately upon their failure to return the proofs on the appointed day. This allows the studio to negotiate with the client for the return of the proofs without waiving its right to apply sanctions at a later date, indicating to the client that the studio is flexible and prepared to be reasonable when the circumstances warrant. After all, there are times when nurturing a good client relationship that has previously proven profitable becomes a priority, and we may prefer to delay making a charge until it becomes obvious it is the only option open to us.

From the client's point of view, the loan agreement makes it clear that any charge made to their credit card may be used toward orders for photographs and services. At the same time, the client will note that when an order is delayed beyond the agreed date for the return of the proofs, any price increases after that date will apply.

Please note that is not recommended that this agreement be used to generate funds by applying the sanctions the moment the agreement permits. Attempts should be made to persuade the client to keep to the agreement, even if a little late. This can be done through telephone calls and letters. It is recommended that the sanctions only be applied as a last resort when the client is clearly not cooperating.

Credit Card Guidelines. While the loan agreement is a useful and efficient means of ensuring our right of ownership, we also have to remember that there are rules laid down by the credit card companies that may complicate the above process. Almost 50 percent of credit card purchases and authorizations are made by telephone, e-mail, and regular mail without a signature. Of these charges, 5 percent are disputed and, despite the fact that the cardholder originally authorized the charge, reversed because the card was not swiped at the time of the charge. If a dispute is investigated and the merchant does not have an imprinted sales draft and adequate invoices to support the charge, it will inevitably be resolved in favor of the cardholder. It is therefore recommended that, in order to substantiate

the loan agreement, the credit card be swiped and the sales draft be retained in case it is needed at a later date.

It is recommended that the client be called and reminded that the proofs were to have been returned and that they are now past due.

This means that at the time the client signs the agreement, you will make an imprint of the card used to support the loan agreement and advise the cardholder that no charge will be made to the card unless the terms of the agreement are not upheld. No signature is required on the imprint; the cardholder should not be expected to sign it if the amount is left open (not filled in on the slip). Neither should we expect him to sign the imprint with a value matching that on the loan agreement, as this would indicate to him that you were making a charge at the time of the imprint. Explain to the cardholder that the imprint is simply evidence that he agreed to be charged according to the terms of the agreement.

Reminders. It is recommended that the client be called and reminded that the proofs were to have been returned and that they are now past due. If two or more calls are made and there is no response, then we suggest that a simple letter be sent. The following format is suggested:

> Dear Mary,
>
> We have several times called to remind you that the (how many) proofs/CDs you took on loan on (date) were due to be returned with your order no later than (date). We are concerned that you may have overlooked your agreement with us and would like to have you return the proofs/CDs and place your order within the next day or two so that we do not have to charge your credit card as agreed. If we do not hear from you by (date), then the amount of $_____, as stated in our loan agreement, will be charged to your credit card. We truly hope to hear from you so that this will not be necessary. It is something we prefer not to do. Our preference is to meet your wishes and complete an order for you.
>
> (continued on next page)

(continued from previous page)

Of course, as agreed, this charge may be used as a credit against the placement of an order up to thirty (30) days from the date of the charge.

We look forward to hearing from you in the next day or so.

Thank you,
Your signature
Your name

P.S.—A copy of our loan agreement is enclosed for your review.

This letter confirms the terms of the loan agreement and alerts the client as to the charges the loan agreement provides. In most instances, this will be an adequate reminder and the client will return the proofs and place an order.

However, should the first letter get no response and force you to make the charge, we recommend that a letter advising the client of the charge be sent together with a copy of the credit card charge receipt. This sample letter again reinforces the agreed terms.

Dear Mary,
We are sorry we have not heard from you in response to our recent letter or to our prior telephone calls. As agreed in our loan agreement, we have charged your credit card in the amount of $ _____ . This charge may be used as a credit against an order if placed no later than (*date*).

We sincerely hope you will be in shortly to use your credit before the expiration date. As we have said before, it is our first priority to provide you with the photographs you desire, and we look forward to working with you.

Enclosed, please find a copy of the credit card charge and also a copy of your loan agreement.

We look forward to hearing from you very soon.

Sincerely,
Your signature
Your name

With the above two letters you will meet your fiduciary obligations under the terms of the loan agreement.

The loan agreement also covers the possibility that the proofs may be mailed or shipped without a signature on the loan agreement. It further covers the possibility that a credit card is not available at the time the proofs are collected or when the client has someone else pick up the proofs.

Having established a criteria for both the protection of your copyright and the return of the proofs, it is important to advise the client of your proof policy before the photography takes place. At the time of the photography session, it is prudent to advise the client again as to when the proofs will be ready for review and, should it be necessary for them to leave the studio, what the terms are. A client-friendly information sheet should be provided, explaining the studio's policy and what you expect of the customer if the proofs are to leave the studio.

Photographers are primarily service providers, so our protective agreements are our last resort in retaining the integrity of our business policies.

REFUNDABLE DEPOSIT AGREEMENT

This type of agreement basically follows the terms of the loan agreement but allows for a charge to be made at the time proofs, or other studio property that is subject to return, are taken from the studio. In this case, the agreement is more a guarantee to the client that the deposit is refundable when the terms of the agreement are met.

The agreement should state that the client may waive the refund and instead use the deposit as a credit against purchases. However, to protect the integrity of this agreement, any purchases toward which this credit is to be used must be directly related to the same photography as the proofs or other property referred to in the agreement.

In regard to such an agreement, it is important that the photographer ensure that there are adequate funds available for a refund when necessary. If the payment is made by credit card, then the refund is to be credited to the same card, as this is a guarantee that the payment is not the result of fraud—especially if the refund is made within a very short time of the original charge.

However, if the refund is owed to a known client, you may choose to refund cash as long as the refund is made after two billing cycles of the card charged. Since this is difficult to ascertain, however, it is still much wiser to refund to the original card.

The primary reason for such a safeguard is that, in some cases, fraudulent charges have been made on credit cards with the intent of acquiring cash refunds. For example, imagine that a stolen card or card number is used at a store and the product is then returned before the billing cycle ends and a cash refund is demanded. If the cash is refunded, the credit card provider or the legal cardholder is the loser. While this is not so likely in a service such as photography, the fundamental safeguards should be followed.

A suggested refundable deposit agreement appears on pages 46–47.

REFUNDABLE DEPOSIT AGREEMENT

This Agreement is made this _____ day of _____, 20____ by and between _____
(hereinafter the "Studio" or the "Photographer") with a principal place of business at _____
_____ and _____
(hereinafter the "Client") who resides at _____.

WHEREAS the Client wishes to remove some images from the Studio's premises, and;

WHEREAS the Studios wishes to retain some collateral as security for the return of said images from Client.

THEREFORE IT IS AGREED:

Client will have the Studio's permission to remove the following images from the premises of the Studio.

Image Description	Image Number	Date of Sitting
_____	_____	_____
_____	_____	_____
_____	_____	_____
_____	_____	_____
_____	_____	_____
_____	_____	_____

Client agrees to deposit $_____ with Studio to insure that the images will be returned. For said deposit, Client will provide a (check/charge) with the following details so that the payment may be processed. Client agrees to pay for each image in the amount of _____ which is a gross dollar value of $_____. Client understands that Studio will be receiving said deposit and will be depositing it into its bank. The images shall be returned to the Studio no later than _____, at which time Studio will either refund the deposit that the Client has paid or said deposit shall be used as a credit toward a future purchase. The deposit shall be the amount indicated above plus sales tax in the sum of $_____ and if a check is not given then the deposit shall be charged to the following credit card: Visa _____ MC _____ Discover (Card Number _____). Expiration date _____ and CIV number _____.

In the event that the check does not clear or a charge is declined and the images are released without a credit card number, the client agrees to satisfy the outstanding debt by charge by check or cash within ten (10) days of receiving notice of the debt from the studio. Charges invoiced for the non-return of images may not be used against the minimum order requirement for the photography sitting or session. These charges may be used as a credit against an order (including the purchase of images) placed within thirty (30) days of the charge. The purchase of images, after the required minimum, is subject to the terms in the Studio brochure which was current at the time of the original photography. When the return of the images and the placement of orders are later than the above agreed date, prices current at the time of the return and placement of the order will be charged, plus any other charges as may be stated in a separate written contract. Wherein if the Studio does not exercise rights as to the above terms and conditions within the prescribed period or otherwise delays its option to such rights it shall not waive such rights thereafter or as stated in a separate written contract. The Studio owns all rights to the image negatives and/or digital image files from the above photography as protected by state and federal law. Images may not be copied, scanned, duplicated, or manipulated, in whole or in part, and may not be used for the production of any private or commercial purpose or published without permission. Any copies of images made, or attempts to make

copies in whole or in part, is a violation of the Studio's copyright as legislated by the United States Congress, and subject to action for compensation and statutory fines. The Studio, other than any penalties assessed by a court of law, reserves the right to charge 10 (ten) times the published rate (current at the time of the violation) plus $100 for each copy of an image illegally reproduced. In certain circumstances, the Studio may authorize the copying of images, however all exceptions must be expressed in writing and signed by the studio.

Client:

Signed _____ Date _____

Signed _____ Date _____

9. ESTIMATES

Most of us have had less-than-happy experiences with estimates we've received for construction and other contractual work. We get the estimate but find that when we receive the final bill it is significantly in excess of the stated figure. When this happens it is our own error because we did not insist that the estimate was to be within a given percentage of accuracy. If you do not read the fine print and miss the clauses that allow the contractor to charge for items that were never discussed, then you are going to be unhappy—but without cause for complaint.

When a client hired you to complete a job for which there is no fixed price, they should be assured that the actual amount they pay will be within an acceptable tolerance. This means that when you provide an estimate for a job, you need to ascertain both the complexity of the assignment and the costs of meeting the client's expectations. There should be a detailed list of the numerous materials and equipment that are to be used in order to produce the final product. If any item or incidental is left out of the estimate, this cost will not be recoverable and cannot be included in the final invoice.

Photographers should never allow themselves to accept an assignment without carefully laying out the costs and fees that are going to be charged.

Photographers should never allow themselves to accept an assignment without carefully laying out the costs and fees that are going to be charged. If you provide a verbal or written estimate that is significantly different from your final costs, you may well find yourself providing services and product for a lot less than they are worth. There are few things we do that can be more aggravating.

Having the client sign off on the estimate/invoice serves as a confirmation of the terms and price of the assignment. Many will cringe at what this means when dealing with prospective clients. In fact, when I have suggested such procedures to photographers they have balked at the idea out of fear that they would not get desired jobs. My feeling is that if a prospective client is not prepared to sign off on such a document, he is not a desirable client. Additionally, it suggests that these photographers are not adequately evaluating each assignment to ascertain the costs that will be incurred.

We've already discussed weddings and event photography and covered the numerous implications of those types of assignments. If you are going to accept other types of assignments with similar costs and charges, it makes no sense to do so on lesser terms. In fact, the terms should be much *more* detailed, as there are numerous elements that need to be considered.

For example, the estimate/invoice should specify whether the photographer is to receive credit in any publication or other application of the photography. It should also detail any grant of rights of use. Terms of payment are to be included, as well as the reservation of any rights that are not granted in the estimate details. The return of originals, and their value if any, must be covered in the terms of the estimate, along with the terms of any additional usage.

When the client signs off on such an estimate he will have the opportunity to read all the terms of the document and have it reviewed by an attorney.

The proposed estimate/invoice below is the basis of a sound way of doing business on assignments that may be quite complex and detailed. Review these terms and understand how they protect you against the possibility of undercharging or creating a situation that may cause you to lose both money and credibility.

ESTIMATE/INVOICE

Studio job number: _____ Date: _____

Client: _____ Due date: _____

Address: _____ P.O. number: _____

Assignment Description: _____

This Estimate/Invoice shall provide the Client with the exclusive rights, when the Client has paid in full all amounts due here-under. The Client may use the photographs for _____,

which shall for the purpose of this Agreement be named _____. Such use shall be limited to

the State of _____ and shall only be used until _____.

DISPLAY OF STUDIO'S NAME OR PHOTOGRAPHER'S NAME

The Studio or the Photographer's name shall be displayed in all reproductions of the photographs in a place which is clear to all whom may view said photographs.

EXPENSES

The Client shall pay all expenses, including but not limited to assistants, special technicians, preproduction, equipment rentals, travel, film, location, messenger, model wardrobe, props, and processing. All Expenses shall be paid upon receipt of an invoice from the Studio.

Photography fees: .$_____

Expenses: .$_____

Total contract: .$_____

Taxes: .$_____

Amount paid: .$_____

Balance due: .$_____

Client: _____ (Company name)

By: _____ (Authorized signatory, title)

SUBJECT TO ALL TERMS AND CONDITIONS ABOVE AND AS FOLLOWS.

The Client hereby acknowledges that he/she has been given the opportunity to read the terms and conditions of this Agreement. The Client has been advised by the Studio of their right to have this Agreement reviewed by an attorney prior to execution of this Agreement. The Client acknowledges having ample opportunity to seek the advice of said counsel.

TERMS AND CONDITIONS

1. PAYMENT. The Client shall pay the Photographer upon receipt of invoice. The Client shall be responsible for and pay any sales tax due. If there is a balance unpaid after ten (10) days, said balance shall be subject to an interest charge of 2 percent (2%) monthly (24 percent [24%] annually) or the maximum rate allowed by law.

 2. FAILURE. Failure by the Client to make the second or final payment as scheduled may be deemed a breach of contract by the Client, which hereby relieves the Studio of all remaining obligations herein. Upon a breach of this contract by

the Client, the Studio may hereby exercise all if its rights in law and equity and may seek relief as provided in Paragraph 20 below.

3. ADVANCES. Prior to the Photographer commencing the Assignment, the Client shall pay the Photographer for all of the Photographer's advances, which advance shall be applied against the total due.

4. RESERVATION OF RIGHTS. The Photographer reserves all rights including all copyrights and ownership rights in all forms of media whether photographic or electronic. The Studio may use reproductions in any form for all legal purposes including but not limited to display, promoting and advertising the Studio, teaching, lecturing, and illustration. All copyrights are reserved, and unauthorized copies or scanning made by the Client or his/her representatives without the Photographer's consent are chargeable at ten (10) times the listed charges of such prints by the Studio. The Client acknowledges that unauthorized scanning or copying of images is unlawful and subject to statutory prosecution.

5. VALUE AND RETURN OF ORIGINALS. The Client agrees that all proofs (in whatever form the Studio designates) remain the property of the Studio unless otherwise provided above and any proofs not returned according to the terms herein are chargeable at $_____ each. Invoices or statements requiring payment for unreturned proofs will be paid within thirty (30) days. Proofs may not be part of the minimum order or coverage fees and are loaned to the Client for a period of fifteen (15) days, after which they shall be returned together with any and all orders.

6. ADDITIONAL USAGE. Any extension of such loan period is at the discretion of the Studio. If the Client wishes to make additional uses, the Client shall seek permission from the Photographer and pay an additional fee to be agreed upon.

7. EXPENSES. If this form is being used as an Estimate, all estimates of expenses may vary by as much as twenty percent (20%). In addition, the Photographer may bill the Client for any overtime which must be paid by the Photographer, assistants, and staff for shoots that run more than eight (8) consecutive hours.

8. COOPERATION. The Studio and Client shall cooperate, agreeing to all schedules and arrangements for services to be provided, including arriving promptly for scheduled photography as agreed at a planning meeting. Changes to scheduled times shall be agreed upon prior to photography. The Client agrees to meet with Studio representative(s) at least thirty (30) days prior to photography, agreeing on a schedule. The Studio shall endeavor to meet all reasonable Client expectations, save only that in the circumstances they may not be possible, and the Studio makes no express or implied warranty for producing specific images. When the Client, or others referred to in the schedule, is not on time, the Studio shall not be liable for omissions of requested photographs that may otherwise be feasible.

9. CAMERAS AND LIGHTING. Any and all cameras and related lighting, including video, shall be under the direction of the Studio and the Client shall advise any and all users or providers of services of this clause. Photography by any persons other than the Studio during sessions is not permitted.

10. RESHOOTS. If the Photographer is required by the Client to reshoot the Assignment, the Photographer shall charge in full for additional fees and expenses, unless the reshoot is due to Acts of God or is due to an error by the Photographer or one of his agents. The Photographer shall be given the first opportunity to perform any reshoot.

11. CANCELLATION. Should the Client cancel the assignment date or cancel this agreement, all deposits paid shall be retained by the Studio, unless the Studio is able to secure an assignment for a comparable fee for the date cancelled, at which time deposits shall be returned in full. The Studio shall not cancel unless serious illness or other such physical handicap shall render the Studio incapable of carrying out its obligations. The Studio having made every endeavor to obtain the services of a qualified and competent substitute, all deposits held by the Studio shall be returned to the Client, as the Client's sole remedy.

12. ASSIGNED PHOTOGRAPHER. The Studio reserves the right to replace assigned photographers as necessary, such as in the event of an emergency, in order to honor this agreement. The Client, subject to time permitting, shall be advised accordingly and has the right to approve or disapprove such change in assignment. On approval any paid attendance fees will then be refunded. In the event the Client disapproves, this contract shall be deemed cancelled and all deposits shall be returned to the Client.

13. LIABILITY. The Studio shall not be liable for omissions caused by failure of the Client to maintain all agreed schedules or caused by delays due to inaccurate or unreliable information provided by the Client. The Studio shall not be liable

for failures or faults in the manufacturer or processing of materials or other causes that may reasonably be deemed beyond the control of the Studio. In the event such circumstances prevent the Studio from performing its obligations or delivering the agreed product or service, the Client's sole remedy shall be the refund of any deposits, as a Limitation on Damages. Omissions or failure to produce specific images that may be discussed or proposed at a planning session shall not void this agreement or result in compensation to the Client by the Studio.

14. RELEASES. The Client shall indemnify and hold harmless the Photographer against any and all claims, costs, and expenses, including attorneys' fees, due to uses for which no release was requested or uses which exceed the uses allowed pursuant to a release.

15. ASSIGNMENT. Neither this Agreement nor any rights or obligations hereunder shall be assigned by either of the parties, except that the Photographer shall have the right to assign monies due hereunder. Both the Client and any party on whose behalf the Client has entered into this Agreement shall be bound by this Agreement and shall be jointly and severally liable for full performance hereunder, including but not limited to payments of monies due to the Photographer.

16. COLLECTIONS. The Client agrees to meet any and all reasonable charges and expenses incurred in the collection of delinquent balances. The Client shall be liable for any reasonable fees and charges required to obtain the return of Proofs, including but not limited to attorneys' fees, court costs, and expert witness fees.

17. ADDITIONAL SERVICES. Charges for additional services other than those referred to in this contract are subject to the published rates at the time they are ordered.

18. NO WAIVER. Failure by the Studio to exercise any and all rights under the terms of this agreement or enforce any part herein shall not limit its rights to exercise said rights in the future.

19. PROVISIONAL INFORMATION. The following provisional information is provided by the Client as a guide to times, locations, persons, groups, etc. that are to be photographed. This will be modified at a planning session on or about thirty (30) days prior to date of photography. Information provided and discussed at a planning session are not part of this contract nor shall such information modify this contract.

20. GOVERNING LAW; LEGAL FEES; ARBITRATION. This Agreement shall be governed by and construed in accordance with the laws of the State of _____ without regard to the conflicts of laws principles thereof. The parties agree that in the event of any suit or proceeding brought by one party against the other, the party prevailing therein shall be entitled to payment from the other party hereto of its reasonable counsel fees and disbursements in an amount judicially determined. Except for the right of either party to apply to a court of competent jurisdiction for a temporary restraining order, a preliminary injunction or other equitable relief to preserve the status quo or prevent irreparable harm pending the selection and confirmation of the arbitrator(s), any controversy or claim arising out of, relating to, or connected with this Agreement or the breach hereof must be settled by binding arbitration in accordance with the Commercial Arbitration Rules of the American Arbitration Association, and judgment upon the award rendered by the arbitrator(s) may be entered in any court having jurisdiction thereof. Any arbitration under this Agreement must be administered exclusively by the _____ Regional Office of the American Arbitration Association or, in the event that office is unable to act, by the closest available regional office to _____. The arbitration must be held in _____ (county), _____ (state).

21. LIMITATION ON DAMAGES. The Client hereby agrees that in the event there is a ruling which determines that the studio has breached its obligations under this contract, then the maximum damages that the Client is entitled to is the money paid to the Studio to date. Under no circumstances is the Client entitled to any damage reward which would exceed the money paid by the Client to date.

22. BREACH OF COPYRIGHT LAWS. The Client agrees that any violation by the Client of any of the State or Federal Copyright Laws with regard to the proofs, negatives, or images which originated as a result of this contract shall constitute a breach of this agreement, giving the Studio the right to pursue all rights and remedies in law or equity against the Client, per this Agreement.

10. ADDITIONAL FINANCIAL ISSUES

As independent business owners, professional photographers have to deal with a great number of financial issues. Many of these have been covered in earlier chapters. The following are a few additional topics concerning monetary issues.

ESCROW OF ADVANCE PAYMENTS

If you are in the wedding (or other special-event) business, many times you will receive advance payments toward future assignments—perhaps as much as 12 months prior to the job. These payments may still be in your bank at the end of your financial accounting year and, if they are included in your general account, may represent a profit that in fact is not a profit. If, at the end of your financial year, you have $5,000 or more in monies received against future assignments, you will be required to pay taxes on it.

If you are in the wedding (or other special-event) business, many times you will receive advance payments toward future assignments . . .

It's a good idea to discuss this issue with your accountant and have a special reserve account set up that will be used for the deposit of funds received against future obligations. Your accountant will no doubt wish you to inform him of any unpaid liabilities prior to your year-end review, and the escrow account will form part of that report. It will help to offset any accounts receivable that may also be liable for taxes.

This special account will be used strictly for funding specific events as they occur and will be protected against income tax. Your accountant will advise you as to how you will be required to operate this account.

This type of account is also ideal for those who are thinking of winding up their business and want to protect their clients' investments in their services after an announcement of retirement or closure.

This is not an attempt to advise you with regard to accounting but simply to let you know that there is a legal way by which you can set aside funds that are held against future obligations, a fact that is not commonly understood by photographers.

FLEXIBLE PAYMENT PLANS

An option that professional photographers rarely consider is offering their clients a payment plan similar to those offered by other retailers. These are commonly described as "hire purchase" agreements. This is a viable option so long as there is a tangible product before the expiration of the agreement or contract.

A sample flex-pay agreement begins on the facing page.

FLEXPAY AGREEMENT ("NOTE")

$_____ _____, 20_____

Due _____, 20_____

FOR VALUE RECEIVED, the undersigned (jointly and severally if more than one) "Borrower" promises to pay to the order of _____ (the "Studio") at its principal place of business located at _____ or such other place as the Studio may designate from time to time hereafter, the principal sum of $_____, in _____ successive monthly installments of principal and interest which are included in each specified installment amount. The amount of each installment shall be $_____, with a final installment of $_____. The first installment shall be due on the same day of each month, thereafter until paid. The Borrower's obligations and liabilities to the Studio under this note shall be defined and referred to herein as the "Borrower's Liabilities."

The unpaid balance of the Borrower's Liabilities due hereunder shall bear interest from the date hereof until paid, computed at a daily rate equal to the daily rate equivalent of _____ percent (___%) per annum computed on the basis of a 360-day year and actual days elapsed; provided, however, that in the event that any of the Borrower's Liabilities are not paid when due, the unpaid amount of the Borrower's Liabilities shall bear interest after the due date until paid at a rate equal to the sum of the rate in effect prior to the due date plus 3 percent (3%).

Accrued interest shall be payable from the Borrower to the Studio with each principal installment of the Borrower's Liabilities due hereunder, or as billed by the Studio to the Borrower at the Studio's principal place of business, or at such other place as the Studio may designate from time to time hereafter.

The occurrence of any one of the following events shall constitute a default by the Borrower ("Event of Default") under this Note: (A) if the Borrower fails to pay any of the Borrower's Liabilities when due and payable; (B) if the Borrower fails to perform, keep, or observe any term, provision, condition, covenant, warranty, or representation contained in this Note which is required to be preformed, kept, or observed by the Borrower; (C) occurrence of a default or an Event of Default under any agreement, instrument, or document heretofore, now or at any time hereafter delivered by or on behalf of the Borrower to the Studio; (D) if the collateral or any of the Borrower's assets are attached, seized, subjected to a writ of distress warrant, or are levied upon or become subject to any lien or come within the possession of any receiver, trustee, custodian, or assignee for the benefit of creditors; (E) if the Borrower or any guarantor of the Borrower's Liabilities becomes insolvent or generally fails to pay, or admits in writing its inability to pay, debts as they become due, if a petition under any section or chapter of the Bankruptcy Reform Act of 1978 or any similar law or regulation is filed by or against the Borrower or any such guarantor, if the Borrower or any such guarantor shall make an assignment for the benefit of creditors, if any case or proceeding is filed by or against the Borrower or any such guarantor for its dissolution or liquidation, or upon the death or incompetency of the Borrower or any such guarantor, or the appointment of a conservator for all or any portion of the Borrower's assets or the Collateral.

Upon the occurrences of an Event of Default, at the Studio's option, without notice by the Studio to or demand by the Studio of the Borrower, all of the Borrower's Liabilities shall be due and payable forthwith.

All of the Studio's rights and remedies under this Note are cumulative and nonexclusive. The acceptance by the Studio of any partial payment made hereunder after the time when any of the Borrower's Liabilities become due and payable will not establish a custom or waive any rights of the Studio to enforce prompt payment hereof. The Studio's failure to require strict performance by the Borrower of any provision of this Note shall not waive, affect, or diminish any right of the Studio thereafter to demand strict compliance and performance therewith. Any waiver of an Event of Default hereunder shall not suspend, waive, or affect any other Event of Default hereunder. The Borrower and every endorser waive presentment, demand, and protest and notice of presentment, protest, default, nonpayment, maturity, release, compromise, settlement, extension, or renewal of this Note, and hereby ratify and confirm whatever the Studio may do in this regard. The Borrower

further waives any and all notice or demand to which the Borrower might be entitled with respect to this Note by virtue of any applicable statute or law (to the extent permitted by law).

The Borrower agrees to pay, upon the Studio's demand therefore, any and all costs, fees, and expenses (including attorneys' fees, costs, and expenses) incurred by the Studio (i) in enforcing any of the Studio's rights hereunder, and (ii) in representing the Studio in any litigation, contest, suit, or dispute, or to commence, defend, or intervene or to take any action with respect to any litigation, contest, suit, or dispute (whether instituted by the Studio, the Borrower, or any other person) in any way relating to this Note or the Borrower's Liabilities, and to the extent not paid, the same shall become part of the Borrower's Liabilities hereunder.

The Note shall be deemed to have submitted by the Borrower to the Studio at the Studio's principal place of business and shall be deemed to have been made thereat. This Note shall be governed and controlled by the laws of the State of _____ as to interpretation, enforcement, validity, construction, effect, choice of law, and in all other respects.

TO INDUCE THE STUDIO TO ACCEPT THIS FLEXPAY AGREEMENT, THE BORROWER, IRREVOCABLY AGREES THAT, SUBJECT TO THE STUDIO'S SOLE AND ABSOLUTE ELECTION, ALL ACTIONS OR PROCEEDINGS IN ANY WAY, MANNER, OR RESPECT ARISING OUT OF OR FROM OR RELATED TO THIS NOTE SHALL BE LITIGATED IN COURTS HAVING SITUS WITHIN THE CITY OF _____, STATE OF _____. THE BORROWER HEREBY CONSENTS AND SUBMITS TO THE JURISDICTION OF ANY LOCAL, STATE, OR FEDERAL COURT LOCATED WITHIN SAID CITY AND STATE. THE BORROWER HEREBY WAIVES ANY RIGHT IT MAY HAVE TO TRANSFER OR CHANGE THE VENUE OF ANY LITIGATION BROUGHT AGAINST THE BORROWER BY THE BANK IN ACCORDANCE WITH THIS PARAGRAPH.

THE BORROWER IRREVOCABLY WAIVES ANY RIGHT TO TRIAL BY JURY IN ANY ACTION OR PROCEEDINGS (I) TO ENFORCE OR DEFEND ANY RIGHTS UNDER OR IN CONNECTION WITH THIS NOTE OR ANY AMENDMENT, INSTRUMENT, DOCUMENT, OR AGREEMENT DELIVERED OR WHICH MAY IN THE FUTURE BE DELIVERED IN CONNECTION HEREWITH, OR (II) ARISING FROM ANY DISPUTE OR CONTROVERSY IN CONNECTION WITH OR RELATED TO THIS NOTE OR ANY SUCH AMENDMENT, INSTRUMENT, DOCUMENT, OR AGREEMENT, AND AGREES THAT ANY SUCH ACTION OR PROCEEDINGS SHALL BE TRIED BEFORE A COURT AND NOT BEFORE A JURY.

Borrower: _____ (signature)

_____ (print)

(Address)

NSF CHECKS

Hopefully, you will not have too many checks returned by your bank for insufficient funds. If you do, there are certain procedures to use to correct the problem.

First, you need to decide if the return of a check due to insufficient funds is a simple case of client oversight or if it is a case of someone seeking to obtain your services without meeting his obligations. Once in a while a client may make a genuine mistake. If it should happen with a regular client with a good history with you, a little latitude is probably called for. Following the recommended guidelines as we describe them here will soon make it clear if you have a problem that you will need to refer to the appropriate authorities.

Begin with a friendly telephone call to the customer or client. Often, this call alone is enough to resolve the matter. If this friendly tactic does not get the job done (we usually allow three days), a friendly but firm letter should be sent to the customer. The letter will obviously advise the customer of the fact that the check has been returned and that there is also a bank charge to be made good. (In fact, you should state in your published terms of business that returned checks will incur a charge of $25.)

Your letter will request that the check be replaced by cash, money order, or by credit card within four days. If this also fails to yield success, then a second letter must be sent that advises the customer that failure to replace the check (including the bank charges) within three days, you will have no alternative but to refer the matter to the appropriate law-enforcement authority. Additionally, this letter should advise the customer that, according to the law, presenting a check without sufficient funds is deemed an attempt to defraud a vendor of his or her property and is punishable by three years in prison and a $500 fine.

After sending this to the customer, call your local police department and ask to speak to the business liaison officer and advise him or her of your case. Often, all that will be required is for the officer to call the offender with the appropriate advice. If not, then the officer will require all the paperwork and the failed check in order to make an arrest for fraud. If the matter goes this far, you may or may not get your money. However, this is the proper course of action for the integrity of your business and for businesses at large.

Every community is a little different and the actions that you take will be geared to the culture that is generally understood to exist. In an upscale community, the above action will almost certainly result in very rapid results. In others, there may be a more complex process—but the threat of criminal prosecution is usually adequate.

A common practice is for vendors to record the client's driver's license number on the check. This is fine if the client is someone you have not done business with before, but it's really no guarantee that the check is either good or that, if it bounces, it can be made good.

A service that validates checks prior to acceptance is an option you may consider. Consult with your bank or credit-card processing service for information on check verification.

DELIVER AND GET PAID

Photographers are frequently left waiting to get paid for work delivered—especially in the commercial field. Often, this waiting time is due to an inadequate form of delivery memo that certifies the delivery and the terms on which the work is delivered.

If payment is to be received within some specified time after delivery, then a delivery memo should be made out . . .

If the work is covered by contract that requires payment on delivery or prior to delivery, then a precise delivery memo is not needed; you should simply collect the payment as per your agreement. In fact, if you have agreed that payment will be made either prior to delivery or upon delivery, you absolutely should not release the work without payment—even if you drive 50 miles to make the delivery and have to turn around without completing the transaction. To do otherwise is asking for trouble.

If payment is to be received within some specified time after delivery, then a delivery memo should be made out and you should receive the appropriate signature at the time the work is released. A delivery memo lists the work delivered in detail, restates the terms under which the work was commissioned or placed on

loan, and lists the date by which the work is to be returned (if any).

The form below is just one example of how a memo should be made out. It can be modified to suit the contract from which it was derived. Note that the terms of delivery should be restated on the back of the memo and clients should be sure to read it prior to signing it.

In the suggested memo below the most important line is that which states the purpose of the delivery. On this line there should be a reference to any contract for the work delivered so that there is no misunderstanding as to the terms.

DELIVERY MEMO

Client: _____ Date: _____

Address: _____

Telephone: _____

QUANTITY	FORMAT	ORIGINAL	DESCRIPTION/FILE NUMBER	VALUE*
_____	_____	_____	_____	_____
_____	_____	_____	_____	_____
_____	_____	_____	_____	_____
_____	_____	_____	_____	_____

*Value is based upon loss, theft, or damage.

Return of one signed copy of this form must be received by the Studio on or before the thirtieth (30th) day after the date set forth above. The signature of the Client shall be considered as the Client's acceptance of the accuracy of the information written above and that the photographs are suitable for reproduction. No objections of any type shall be the responsibility of the Studio if the receipt or nonreceipt of this form by the Studio from the Client occurs after the thirtieth (30th) day.

Copyright and all reproduction rights in the photographs are the property of the Photographer. The Client acknowledges that the photographs shall not be displayed, copied, or modified. Any and all reproduction shall be allowed only upon the Photographer's written permission.

The Client agrees to assume full responsibility and be strictly liable for loss, theft, or damage to the photographs from the time of shipment by the Photographer. Reimbursement for loss, theft, or damage to a photograph shall be in the amount of the value entered for that photograph. Both the Client and the Photographer agree that the specified values represent the value of the photographs. If no value is entered for an original transparency, the parties agree that a fair and reasonable value is $1500.

The Client agrees to insure the photographs for all risks from the time of shipment from the Photographer until the time of delivery to the Photographer for the values shown on the front of this form.

Acknowledged and Accepted: _____ (Company Name)

Date: _____

By: _____ (Authorized signatory, title)

Depending on the state in which you are registered to do business, the collection of sales tax (if the state collects it) may be either simple or complicated. The first thing you need to do is ask your state's Department of Revenue (or Taxation) whether you are required to pay sales tax. Most states have a minimum amount of annual revenue to be generated before you are required to collect sales tax. If you are required to collect sales tax, you will be issued a sales tax certificate. If you incorporate or register your business with the state or your city, the state will automatically notify you of your tax obligations. When you have been assigned such a certificate, you will be exempt from paying sales tax when you purchase products and services that are to be resold to your clients. In some states, there is no sales tax on services. If this is the case, you should inquire of your state's Department of Revenue what services are deemed exempt from tax.

It is most important that you understand all the rules as laid out by your state with regard to sales tax. If you err and it is not discovered until much later, you may find that you are very much in debt to your state. Should you fail to collect the correct amount of tax, you will not be able to go back to your clients and ask them to make good. Instead, you will have to make up the shortfall from your own resources—plus penalties and interest. The shortfall in actual tax may not be that serious, but the penalties and interest can be crippling. Additionally, it is possible that your certificate may be voided; that will increase your cost of doing business. It is also possible that, if you are negligent, the state may seek to prevent you from operating a business—especially if this negligence is persistent or appears to be intentional. It is, therefore, important to keep accurate records and apply the tax correctly.

Remember that the state's Department of Revenue can conduct an audit that is similar to that of the Internal Revenue Service. If you should be a victim of such an audit, you will probably, at best, find it disruptive to your business.

A STATE-BY-STATE ISSUE

My studio is located in Illinois, so we'll look at the the laws that apply here as an example of the kinds of issues that can arise. Again, you need to check your own state's laws in order to ensure that your tax-collection and reporting policies are appropriate and sufficient.

In 1988, the Illinois State Assembly passed perhaps the worst piece of tax legislation in its history. It was so badly formed that it required photographers to charge sales tax on every item invoiced, even postage. Consequently, the Associated Professional Photographers of Illinois contested the tax, as it was clearly unconstitutional, representing a tax on services and applying only to photography services—not to accounting, medical services, legal services, etc. After more than two years of negotiating with both the Illinois Department of Revenue and the Photo Marketing Association (PMA), the prime instigator of the tax, a compromise was achieved. The compromise was a winner for the photographer, the state, and the PMA.

If you are negligent, the state may seek to prevent you from operating a business—especially if this negligence is persistent . . .

Therefore, if you are an Illinois photographer, the tax is applied as follows.

Services. First, photography services, such as time billed and personal applications (such as session fees, proofing services, artwork, and services that did not provide a tangible product to the customer) are exempt from tax. Services such as shipping, postage, delivery,

travel time, mileage, and other incidental items are also exempt from tax in Illinois.

Additionally, instead of the 100 percent tax on all the photographer's billing, it was agreed that the tax applied to photographs supplied to the client would be at 10 percent of the tax applied in the community where the photographer does business. If you bill $100 for photographs, for example, you would charge tax on only $10.

Wedding Album Packages. Album packages that include frames, when such are of a lesser value than the photography, are also to be taxed at 10 percent of the full tax rate, providing that the album is not "disassembled" in either your published price list or on an invoice. You will have disassembled a package if, at any point, you refer to any element of the package separately. This includes any reference to the price of additional pages.

To qualify as a package all the elements have to be inclusive and none may be identified separately. If you wish to offer the client the option of expanding the album, therefore, you should do so by offering the expansion in terms of prints, not pages. In fact, it is recommended that you do not mention the number of pages included in the album package, only the number of photographs or images.

> Wherever you reside, when selecting an accountant you should inquire as to his understanding of your state's sales tax laws.

You are advised not to offer albums as a separate item in any of your published prices, nor should you bill them as such to any client. If you are to offer albums, they should always be included in a package or you will be providing an issue for the taxing authority and may invite an audit.

Portrait Packages. Offering portrait package that include frames requires you to ensure that the estimated retail cost of the frame is significantly less than the charge of the photographs to be included in the package. As an example, if the package includes a frame that you may retail at $50, the package, including the photographs, should be approximately $250 (five times the charge for the frame if sold separately). It is unreasonable to include a $50 frame with a package value of $100. To do so will raise a red flag to an auditor.

Out-of-State Sales. When your state revenue department exempts out-of-state sales from sales tax, you are required to ship the order to an out-of-state address to qualify for the exemption. If the order is collected from your location, the exemption does not apply. Should there be a reciprocal agreement between the state in which you are registered and the state in which you are providing services, you will be advised by your state revenue department as to how such taxes are to be accounted for.

Sales Tax Exemptions. Sales tax is not collected from organizations that have tax-exempt status. These include schools, universities, government offices (but not government officers), and nonprofit organizations. Should you be in doubt as to the claimed exemption, you should request the organization's tax exemption ID.

HIRING AN ACCOUNTANT

Wherever you reside, when selecting an accountant you should inquire as to his understanding of your state's sales tax laws. However, should you not find such a specialized service in your area, you will need to research the laws yourself and explain the tax information to the accountant so that he or she can properly check your sales-tax reports.

12. COPYRIGHT

In this chapter, perhaps the most complex, we examine how copyright affects the professional photographer and what may be done to protect our legitimate rights. While most copying of professional images is the result of ignorance, there are always some people whose actions are calculated to avoid the cost of purchasing our work legally. These people copy our images in full knowledge that what they are doing is unlawful.

For example, a client made copies of one of our images. She then claimed it was her image and entered it into a contest sponsored by a well-known radio station. The image won the contest and a $50,000 scholarship. We learned directly from the client that she made copies but we did not, at first, know that she had claimed the image as own her creation (a necessary qualification for entry).

On learning of the fraud, we advised the radio station—and they were quite grateful for the information since they were about to issue a press release and announce the winner on the radio. The scholarship was recalled, but our primary issue was the theft of our image. We wrote to the client and, based on all the evidence, demanded redress. The client's husband was an attorney who, upon receipt of the letter, called and agreed to a suitable settlement. This was relatively easy because we had more than adequate evidence of the infringement. We may not always be so lucky as to have the evidence placed in our lap.

Copyright has been and continues to be a matter of considerable concern for photographers. Wedding and portrait photographers in particular have experienced significant losses through clients copying their images instead of purchasing them from the creator. Commercial photographers have also had their work blatantly stolen by unscrupulous clients.

EDUCATING THE CLIENT

Our first action in protecting our copyright is to educate the client about how copyright works and why it is so important to us. Many clients attempt to make copies of our work, ignorant of the fact that they are acting illegally. They assume that because they have bought the print they have the right to make copies at will. The great majority react with surprise when they are told that making copies without written permission is illegal. Most then accept the fact and return to us to get the copies they want. There will always be people who disregard the law, but if we educate the public about copyright issues, we will keep the law-breakers to a minimum.

There are nice ways to tell our clients about our copyright and advise them that copying our work without our permission is against the law. Obviously, a cold statement during a telephone call or person-to-person communication that they should be aware that your images are copyright protected is not the way to establish a productive relationship. Instead there are a number of ways to achieve this objective.

There are nice ways to tell our clients about our copyright and advise them that copying our work without our permission is against the law.

For out-of-town clients, a mailed confirmation of the appointment prior to travel could be used to advise the client of your copyright. If you are able to contact the client via e-mail, the confirmation and the advice of copyright could be communicated in this way. By using these two methods, you can ensure that, if a client had the intention of copying your work, he will have received due notice and will be aware of the potential consequences.

For clients you meet in your studio, you can produce a friendly advisory that explains why copyright is so important to the photographer and his livelihood. The overwhelming majority of our clients do appreciate our right to protect our images.

The Photo Marketing Association (www.pmai.org) also offers a well-written customer advisory that can be obtained by contacting them. It is designed to be given to consumers who may seek to have processing shops, labs, one-hour processors, or camera stores who provide film-processing services make copies of original photographs without a signed release by the originator of the photograph.

We also need to be able to explain copyright issues such as one I recently experienced (for perhaps the third or fourth time). A portrait client had not had her wedding photographer produce an album for her and had waited three years to seriously consider having one made. She no longer wanted to work with the original photographer and wanted us to make the album for her. Because she had a CD of images and several 5x7-inch prints, purchased from the photographer, she assumed that we would be able to produce an album for her.

Although she had the CD, she did not have the right to reproduce the images without permission from her wedding photographer.

We had to advise her that, although she had the CD, she did not have the right to reproduce the images without permission from her wedding photographer. Additionally, the prints she had were copyrighted and also needed a release. Additionally, she needed more images from the original photography, and these would also need copyright releases. You can understand how confused she felt.

The only remedy she really had was to purchase the negatives and copyright from the photographer. However, if you own the negatives, you still need to have a clear receipt of ownership in order to confirm copyright if you were not actually the originator of the photography.

Ownership of prints and scanned images is not ownership of copyright unless the originator provides written release.

REGISTERING COPYRIGHTS

There has been (and still is) a great deal of lobbying of governments for greater protection of the creator's intellectual rights. But even if there were the kind of protections photographers would desire, there would still be every possibility that a client would make copies despite the law.

As high-quality reproduction equipment becomes more readily available at affordable prices, the ability to copy original works will greatly increase, as will our experience with such copyright issues. In the old days, making copies required making copy negatives—and good copies were only available when the maker of the copy negative had the required skills. Now, on the other hand, computer technology is advancing rapidly, and those intent on breaking the law have more opportunities to do so.

Now that the playing field has changed, we must provide ourselves with as much legal and contractual protection as is possible. Presently (at the time of publishing this book), in order to establish our copyright with the full weight of the law behind us, we have to register our images with the Copyright Office at the Library of Congress. At the time of writing, the fee to register images for copyright protection is $30 and can be achieved by sending a CD, transparencies, or printed images with the registration fee.

The real power of the copyright-registered image is the threat of statutory damages, which has been as high as $110,000. Without a copyright registration, however, and without another instrument of protection, our redress against copyright thieves is limited even when we have adequate proof that an infringement has taken place.

Without registering images with the Library of Congress, we could easily lose significant sums of money in seeking redress for an infringement. Relying on the laws available to us, the cost of redress may well exceed the compensation. If our images are registered, on the other hand, then we could receive not only commensurate compensation for the infringement but also statutory damages. However, for the overwhelming majority of professional photographers, this is not going to be practical.

For the photographer who is shooting weddings on film, the burden of registering copyright of all the

images is considerable. However, as stated above, if the negatives are scanned onto a CD a copy of the CD can then be used to register all the images with the copyright office. The fee of $30 is a small amount to invest for the maximum protection under the law. In fact, if every photographer were to do this, it is very likely that there would be a major change in the policy of the Copyright Office. This is because the volume of registrations would overwhelm the registration process. They might then consider a much simpler system for our registrations.

MAKING COPYRIGHTS A CONTRACTUAL ISSUE

As was previously noted, in order to limit potential financial losses through infringement of your rights, you must include clauses in all of your contracts, invoices, brochures, and loan agreements that clearly state that infringing your copyright constitutes a breach of contract.

What you are telling your clients is that when they commission you for their photography, they are entering into a contract that recognizes your copyright. Breaking the contract will entitle you to compensation as stated in the terms of business you provide with your services.

To back this up, you should imprint or mark your work with a copyright stamp. While paper manufacturers have incorporated wording on the backs of their professional papers that state that the print is a professional image (which indicates it is copyrighted), ideally you should add your name, address, and telephone number so that the copy stations can advise you when someone is trying to copy an image. Keep in mind that it is not always the original purchaser who is seeking to obtain unlawful copies. Cousin John or Mary who received a print from the bride or groom may want an additional copy, and they should be directed to the original source—you.

In Clause 20 of our event contract (see page 20), we said that breach of copyright law is also a breach of contract and entitles us to pursue whatever legal remedies we have at our disposal. In Clause 9 of that contract, we also advise that for each copied print we are entitled to 10 times the listed charge for the same size print. By making copyright infringement a breach of our contract, we avoid having to sue via the copyright

acts to obtain compensation for any infringement when we have evidence that a breach has taken place.

As a result of our experiences with copyright breaches, the text of our current references to copyright is much tighter and more concise. It is recommended that the following be incorporated within all written materials presented to clients.

> Commissioning us to provide photography services and photographs represents a contract between us acknowledging copyright law protects our images. Infringement of our copyright is a breach of contract and will result in action for compensation as set forth in our terms of business.

You should also state what you would claim as compensation in the event of an infringement. At the Norman Phillips of London studio, we advise that we will charge 10 times the listed rate for the same size print plus $100 for each infringement. An infringement is each time an individual image is copied. This means that each separate image copied represents an infringement. In other words, if a client copies five images it represents five infringements. This is intimidating.

The following advice should be placed on invoices and orders for photography and photographs.

> Payment or other confirmation of this order/invoice is acknowledgment of our copyright, and any infringement of this right will result in action for appropriate compensation as previously advised.

If this statement is placed on an invoice or order, it requires either a signature or a payment to confirm it as a contract. While it may well be possible to get judgment without a signature or payment, it is inadvisable to proceed with work without one or the other. A client might claim that he was not advised or did not read the terms and, therefore, seek to disclaim any liability. This could happen despite much evidence of such advice in materials available throughout negotiations and presentations.

We need to be vigilant and not take the easy way out. Many photographers have failed to follow their own terms in fear that they may lose a client. Most clients will respect us for insisting on our terms of busi-

ness. If they do not want to sign or agree to our terms, then we should not do business with them, as we are likely to have expensive problems later on.

CLIENT BREACHES OF CONTRACT

Should you become aware of a breach of this contract, advise the client of the breach and state that you require the appropriate compensation as published by the studio. For your first letter, you will want to avoid attorneys' fees by drafting a letter to the client that sets out the facts as you know them and what is required to resolve the issue.

The suggested draft that follows is one that you would send if you are satisfied that the client you are dealing with is someone who clearly infringed your copyright and breached your contract with intent to deprive you of the compensation your work would normally have brought.

> Dear Mrs. Smith,
> It has come to our attention that you have made or had made reproductions of photographs produced by us without permission or release by us, which is both a breach of our contract and infringement of our copyright as proscribed by the United States Congress.
>
> It is noted that the following copies were made _____ and that as advised in our tariffs and price guides, each individual image copied represents an infringement of our copyright. As there are three infringements, the compensation required is $300. In each infringement there were two 5 x 7-inch copies made. Charged ten (10) times our published rate of $40 each, this amounts to $2400. The total, therefore, to settle our account is $2700.
>
> Enclosed are copies of the materials from which the above charges are derived.
>
> Please be in touch with us to arrange settlement of this breach of contract.
>
> Sincerely,
> *Your signature*
> Your name

If you have not had a response after 10 days, you have two options. The first is to write once more in an attempt to obtain an amicable settlement. The other option is to retain an attorney to press your claim. If your decision is to retain an attorney, you should be sure that he or she is a specialist in this area of law. It is recommended that the first option be used with the following text:

> Dear Mrs. Smith,
> We are concerned that we have not received a response to our letter dated _____ and we would very much like to arrange an amicable settlement of our claim.
>
> Please understand that it is our intention to establish our rights provided by copyright law as much as it is to receive an appropriate compensation for the infringement of our copyright. Such infringements seriously undermine both the integrity of our business and our professionalism as well as our ability to survive economically.
>
> If you contact us, we can negotiate a reasonable settlement with which we both can be comfortable. We look forward to hearing from you.
>
> Sincerely,
> *Your signature*
> Your name
>
> P.S. If we do not hear from you by _____ *(seven days from the date of this letter)*, we will instruct our attorney accordingly.

Essentially, you are offering to settle the infringement on reasonable terms. The aim of this process is to properly establish the fact that the infringement is not acceptable under any circumstances. The original demand was to set the stage for a settlement, not to indiscriminately extract a large sum in settlement. What this process enables you to do is assess whether the infringement was a deliberate act of piracy or ignorance. This allows you room to settle based on what response you receive from the client.

If, on first discovering the infringement and breach of contract, you believe the client has made an innocent error of judgment and that you would like to nurture the relationship, you might start the process differently. In this case you might write to him and advise him that you have learned of the infringement and again set out

the terms of the contract and invite them to meet with you to discuss what would be a reasonable settlement. The following is a suggested text.

> Dear Mrs. Smith,
> We have learned that, in breach of our contract and in infringement of our copyright, you have made copies of our photographs.
>
> We would like to emphasize that what you have done is deprive us of our lawful reward for the production of our work. Apart from unlawfully copying our work and breaching our agreement, your action undermines our economic viability.
>
> We would appreciate meeting with you to discuss a reasonable settlement of this issue. Please contact us to make an appointment as soon as possible.
>
> Yours Truly,
> *Your signature*
> Your name

This letter enables you to arrange a meeting and settle the issue in a way that maintains a good relationship with the client. At a meeting, you will discuss the issues of the copyright protection granted to you by the United States Congress. If the client is apologetic and genuinely repentant, you could simply arrange to take possession of the illegal copies and supply the client with copies as you would under normal circumstances.

COPY-STATION VIOLATIONS

In my own experience, a branch of a national chain allowed a client to make copies of one of our images. When I learned of this, I wrote to the chief executive of the photographic division. His response was immediate. We have since monitored different branches of the chain, and they are now so strict that we are unable to make copies from our own images without a letter from the studio signed by me.

You may wish to advise copy stations within your market that you have a contract with your clients that protects your copyright and that when this is infringed, you will hold both the client and the copy station liable for the compensation. You can also personally monitor whether copy stations are living up to their obligations to protect your copyright. Simply take one of your

images to each and ask them to make copies for you. If they do so without checking to see if the image is copyrighted, then you should immediately write the following letter to the owner/manager/director of the copy station. This notice should be sent by certified mail and you should request a receipt of delivery.

> Dear Sir or Madam,
> I visited your copy station on (*date*) at (*time*) and requested that your staff make (*state what you requested*), and your operator made the requested copies without ensuring that it was legal to do so. I have the referred-to copies as proof that your company illegally makes copies of copyrighted photographs.
>
> I would draw your attention to the fact that it is illegal to make copies of photographs without the express permission of the originator and owner of the copyright and that there are significant legal repercussions and potential fines for such infringement of copyright as established by the United States Congress and administrated by the Library of Congress.
>
> Please be advised that it is my intention to continue monitoring your copying policies. In the event that it is confirmed that you illegally copy any of my photographs, I will seek redress as prescribed by the law as well as any statutory fines as may be awarded by the designated court of law.
>
> Please be advised that my clients have been made aware of the compensation I shall require in the event that illegal copies are made of my work, and I will hold you equally responsible for this specific compensation.
>
> I would like to have your assurance that you will be taking the appropriate measures to prevent further illegal copying of photographs.
>
> Yours truly,
> *Your signature*
> Your name

It is likely that you will hear from the copy station owner with an apology and a promise that he or she will take the appropriate measures to ensure that such illegal actions do not happen again. Copy station owners are responsible for the actions of their employees and they are not able to deflect responsibility for their fail-

ure to adhere to the law. You should continue to monitor this situation to make sure that your own or other photographers' images are not being copied.

What if you have it confirmed that a copy station has made copies of your work in the full knowledge that it is against the law? The action you take will depend on several factors. The first relates to your contract, be it written or verbal, with your client. You will have noted that copyright issues are addressed in our suggested loan agreement (see page 42) and terms of business (see chapter 7), and under these terms you would be entitled to specific compensation for each illegal copy made. The clauses in each of these documents set out what compensation you are entitled to based on the contract you have with your client.

With this in mind, you should write to both the client and the copy station advising them of the specific demands for compensation. Initially, this demand can be written on your letterhead; at this juncture you will not want to incur the expense of your attorney. You will state, however, that without a suitable reply, you will have your attorney carry the matter forward. Your initial letter will be as follows:

Dear Sir or Madam,

It is with regret that I write to you with regard to the copying of my photographs, which you were previously advised is illegal.

I have definitive information that you have made (*the specific details of the infringement*) and that in accordance with my terms of business to which my client has agreed and of which you have been advised, the total compensation for the above infringement of my copyright is $_____. This is due to the following terms for the images illegally copied (*details of the specific amounts*).

I request that you respond within fourteen (14) days of receipt of this advice with your proposal as to how you propose to settle this matter. Regretfully, if I do not have your response within the above stated time I will instruct my attorney accordingly.

Yours truly,
Your signature
Your name

RELEASE OF COPYRIGHT

One-Time Use Release. There are occasions when you may wish to release copyright either in total or for a limited purpose. Such an occasion may be that your client wishes to produce something from one of your images in a manner that you are either unable or unwilling to do—such as a special greeting card or a poster for a special occasion. For such circumstances, the release should be specific as to what it permits. If, for instance, it is for a greeting card, the release should very plainly state it is for a one-time use only and the purpose of that one-time instance. You should very carefully word the release so that there is no possibility that it may be interpreted as a general release or that it may be used for a second use. A sample form for this type of release appears on the facing page.

Copyright Transfer Form. Other than limited releases, as just discussed, you may also have occasion to transfer copyright. This may be done in order to allow you to serve a client in a more efficient way, or because, in a special circumstance, it is advantageous for both the photographer and the client. A typical situation would be one in which a business portrait session has been provided and the initial prints delivered as per your standard terms of business. The client then wishes to purchase the rights to the image so it can be reproduced in-house, since this would be a more efficient way in which to have prints available. You would then sell the rights and complete a copyright transfer form.

This form would also be appropriate for the sale of images to a gallery or other intermediary in the fine art field. This is also covered in chapter 23, on fine art photography. The form on page 66 is an example of a copyright transfer.

Copyright Ownership Transfer. Another form for the transfer of copyright ownership is the copyright ownership transfer. This is somewhat different from the copyright transfer form because it covers different aspects of the transfer. This document is more comprehensive in its legal surrender of the copyright and the transfer is total. It should also be notarized. A sample form of this type appears on page 67.

COPYRIGHT OWNER'S CONSENT FORM
One-Time Use

This Agreement is entered into this _____ of _____, 20_____, by and between

_____, (hereinafter referred to as the "Photographer"), whose

principal place of business is at _____ and

_____, (hereinafter referred to as the "Customer").

 WHEREAS, the Customer desires to reproduce certain copyrighted material from the Photographer; and

 WHEREAS, the Photographer has agreed to permit the Customer to reproduce certain copyrighted materials described below.

 THEREFORE it is Agreed:

For the consideration of $_____ and other valuable consideration, the receipt and sufficiency of which has been received and acknowledged, the Photographer consents to permit the Customer the right to reproduce the above-described photos and to deliver said photos. All restrictions, if any, on the Customer's use of these photos are written on the reverse side of this document.

 This consent is for the following photography ("Photographs"), described as follows, and photo static copies which are attached as exhibits:_____. These Photographs are owned by me and I am the owner of the copyright.

 I authorize and consent to the ONE-TIME LIMITED reproduction of these Photographs as follows:

 (A) Number of permissible reproductions: _____

 (B) Use and purpose for each reproduction:_____

 At the time that the Photographs are reproduced, I will want a confirmation phone call from the company doing the reproduction to the following number _____.

 A violation of this agreement shall be agreed to be equal to violation of the Photographer's Copyright as well as breach of contract.

Photographer: _____

Telephone Number: ()_____

Customer: _____

Telephone Number: ()_____

The Customer hereby acknowledges that he/she has been given the opportunity to read the terms and conditions of this Agreement. The Customer has been advised by _____ of their right to have this Agreement reviewed by an attorney prior to execution of this Agreement and, by initialing this paragraph, acknowledges having ample opportunity to seek the advice of said counsel.

_____ Initials _____ Initials _____ Initials

COPYRIGHT TRANSFER FORM

This Agreement is entered into this _____ of _____, 20_____, by and

between _____ (hereinafter referred to as the "Photographer") whose principal

place of business is at _____ and

_____ (hereinafter referred to as the "Transferee").

 WHEREAS, the Transferee desires to acquire certain copyrighted material from Photographer; and

 WHEREAS, the Photographer has agreed to transfer certain copyrighted material which the Photographer owns to the

Transferee.

 THEREFORE it is Agreed:

 For the consideration of _____dollars ($_____) and other valuable

consideration, the receipt and sufficiency of which has been received and acknowledged, the Photographer transfers to the

Transferee all rights, title, and interest contained in the copyright for the following photograph(s): _____

 The Transferee may duplicate, distribute, and display the photographs described above.

 Additionally, this contract also transfers and conveys the ownership of all other forms of the photographs that may

exist.

 The Photographer warrants and guarantees that he is the Author/Owner of the above-described works and licensed

right(s), and that there are no prior transfers or licenses which restrict the undersigned's authority.

Photographer

STATE OF _____
 } SS
COUNTY OF _____

I, _____, a Notary Public in and for said County, in the State aforesaid, do here-

by certify that _____, personally known to me to be the same person whose

name is subscribed to in the foregoing instrument, appeared before me this day in person and acknowledged that they signed

and delivered said instrument as their own free and voluntary act.

Given under my hand and Notarial Seal this _____day of _____, 20_____.

Notary Public

COPYRIGHT OWNERSHIP TRANSFER

This Agreement is entered into this _____ of _____, 20_____, by and between _____, (hereinafter referred to as the "Photographer") whose principal place of business is at _____ and _____, (hereinafter referred to as the "Transferee").

 WHEREAS, the Transferee desires to acquire certain copyrighted material from the Photographer; and

 WHEREAS, the Photographer has agreed to transfer certain copyrighted material which the Photographer owns to the Transferee.

 THEREFORE it is Agreed:

For the consideration of $_____ and other valuable consideration, the receipt and sufficiency of which has been received and acknowledged, the Photographer transfers to the Transferee all rights, title, and interest contained in the copyright for the work(s) described below which includes, but is not limited to, the exclusive right to perform and/or to authorize any or all of the following: (A) to duplicate the work; (B) to distribute copies of the work; (C) to prepare derivational works; (D) to publicly display the work. This transfer includes the original photograph(s) of the Photographer, which are described as follows, and/or copies of said work(s) attached:

Description of photograph(s): _____

Additionally, this contract also transfers and conveys the ownership of all negatives, if available.

The Photographer warrants and guarantees that he is the Author/Owner of the above-described works and licensed right(s), and that there are no prior transfers or licenses which restrict the undersigned's authority.

 Photographer: _____

 State of: _____

 County of: _____ } SS

I, _____, a Notary Public in and for said County, in the State aforesaid, do hereby certify that _____, personally known to me to be the same person whose name is subscribed to in the foregoing instrument, appeared before me this day in person and acknowledged that they signed and delivered said instrument as their own free and voluntary act.

Given under my hand and Notarial Seal this _____ day of _____.

Notary Public

Copyright Declaration. Individuals who wish to have copies made from old family photographs sometimes do not return to the creator for copies. Instead, they request that other photographers make the copies. Indeed, there are times when the creator of an image is either unknown or untraceable. The owner of the copyright, obviously or apparently professional, may be deceased or out of business. However, if the original creator is traceable, there is an obligation to seek permission to make copies or refer the prospective customer back to the original photographer.

If the creator of the image(s) has no interest in the copyright ownership, then it is reasonable to agree to make copies. However, it is frequently an impracticable and expensive endeavor to determine this. The logical option is to decline the assignment unless the client has definitive proof that he or she has a release of copyright.

To protect yourself against infringing a copyright when there is reason to believe that the originator of the image(s) may still have an interest in its ownership, it is recommended you use a copyright declaration. This is a detailed document that strictly states who owns the copyright and that every endeavor has been made by the customer to trace the originator of the work to be copied. It further identifies what the client is presenting for reproduction and demonstrates that every effort has been made to locate the original owner of the copyright of the image or images.

You might suspect that there are individuals who would be prepared to complete such a form without ever having made such endeavors. If you sincerely believe that the customer is not honest in this matter, you would be well advised not to offer the document. Otherwise, you may still be subject to some form of redress. For the genuine cases, however, it is unlikely that someone would complete such a document without having seriously made every effort as indicated on the document.

An example of the recommended document begins on the facing page.

Copyright Owner's Consent Form. A photographer may be approached by a prospective customer with a request for copies to be made from an image and advised that he is the owner of the copyright or has received permission to reproduce it. When a customer has obtained the ownership of an image, including the copyright, that customer should be required to provide a copyright owner's consent form. This may occur when the customer has purchased not just the prints from the original photographer but also all the right of reproduction.

If you sincerely believe that the customer is not honest in this matter, you would be well advised not to offer the document.

Now that we are in the digital era these images may be on a CD or on film. When film is used to create the image, the film will usually be surrendered with the completion of the contract if it included the purchase of copyright. Should the original photography be digital and recorded on a CD, it is important that the images be deleted from your computer when the copyright is transferred. If you inadvertently reproduce an image after ownership has been transferred, then you will be liable for copyright infringement prosecution. If you wish to retain the right of reproduction, then this must be stated within the transfer document. In this case, the limits on the originator's use should be specified.

The copyright owner's consent may be acquired in two different forms. One is that which provides limited use with the requirement that notice be given when the reproductions have been made. The other is used when the copyright is surrendered at the time the contract for the original photography is completed. Both of these documents protect the copier from any possible legal complications.

An example of the recommended document appears on page 71.

COPYRIGHT DECLARATION

_____ (Declarant)

_____ (Address)

I, _____, as the Declarant hereby acknowledge that the photographs which are herein in question are copyright protected and that authorization from the owner of the copyright is necessary for the reproduction of said photos. For the purposes of this Declaration the photographs may be film, print, slide, movie, artwork, CD-ROM, disk or any other material (hereinafter, all referred to as the "Photographs"). I declare the following concerning my request for reproductions of the photographs:

1. That I am the Photographer and have not transferred my copyright interest.
2. That I am supplying written documentation which is evidence of consent by the owner of the Photographs.
3. This request is for personal use with special circumstances. Description of special circumstances:
 (A) Photograph needs to be restored to original condition.
 (B) I don't know who the photographer is.
 (C) I have attempted and can't locate the photographer.
 (D) I have made an effort to contact the photographer for authorization and was unsuccessful.
 Efforts made to contact photographer:
 (i) Searched the Internet and local directories
 (ii) Contacted PPA Locator service at (800)786-6277
 (iii) Other

4. This request is for a "Fair Use." The Fair Use standard is a standard in which, when all the evidence provided for the reproduction request is evaluated, the weight of the request supports that the photographer who owns the copyright will not be impacted by the reproduction. Some examples may be:
 (A) The Photograph reproduction size is small and insignificant;
 (B) I am using the Photograph for a purpose which is newsworthy, supplying criticism, or for my research and/or teaching;
 (C) Reproduction will not impact the photographer's resale in any manner;
 (D) My original is damaged and the copy will replace the damaged original.

The intended use of the reproduction is:

As the Declarant, I hereby save and hold harmless _____ ("Reproducer") its successor, agents, and assigns from any and all claims which may arise now or in the future which may be asserted by the Photographer or any person or entity which asserts a claim of ownership or interest in the Photograph(s) being reproduced. I further agree to pay all attorneys' fees, court costs, expert witness fees, and any other costs or fees which may arise

as a result of reproducing the Photograph. I also agree to pay the Reproducer their hourly published photographer rate (at the time of the claim) for any time used in the defense of reproducing the photograph.

Declarant

Reproducer

The Client hereby acknowledges that he/she has been given the opportunity to read the terms and conditions of this Agreement. The Client has been advised by _____ of their right to have this Agreement reviewed by an attorney prior to execution of this Agreement; and by initialing this paragraph, The Client acknowledges having ample opportunity to seek the advice of said counsel.

_____ Initials _____ Initials _____ Initials

COPYRIGHT OWNER'S CONSENT FORM
Unlimited Use

This Agreement is entered into this _____ of _____, 20_____, by and

between _____, (hereinafter referred to as the "Photographer") whose

principal place of business is at _____ and

_____, (hereinafter referred to as the "Customer").

WHEREAS, the Customer desires to reproduce certain copyrighted material from the Photographer; and

WHEREAS, the Photographer has agreed to permit the Customer to reproduce certain copyrighted materials described below.

THEREFORE it is Agreed:

For the consideration of _____ ($_____) dollars and other valuable consideration, the receipt and sufficiency of which has been received and acknowledged, the Photographer consents to permit the Customer the right to reproduce the above-described photos and to deliver said photos. All restrictions, if any, on the the Customer's use of these photos are written on the reverse side of this document.

 This consent is for the following photography ("Photographs") described as follows and of which photostatic copies are attached as exhibits: _____. These Photographs are owned by me and I am the owner of the copyright.

 I authorize and consent to the UNLIMITED reproduction of these Photographs for the following purposes: _____ (use and purpose for each reproduction).

 A violation of this agreement shall be agreed to be equal to violation of the Photographer's Copyright as well as breach of contract.

_____ Telephone Number () _____

Photographer

_____ Telephone Number () _____

Customer

AUTHORIZATION TO REPRODUCE

This permission is granted to _____ (Studio/Photographer name) to provide reproductions of images from session _____ (file) and created on _____ (date) containing images of _____ (name[s] of subject[s]) at _____ (address or location of session) commissioned by me, _____ (name of Client who originated the session) resident at _____ _____ for delivery to and billed to _____ _____ (name of person[s] to whom images are to be provided) and to no other person or persons. It is further understood that this authorization does not allow the Studio/Photographer to reproduce images from the above referenced file for any purpose other than to provide copies to the named person(s) herein and may not be displayed or used without my signed release. The Client shall save and hold the Studio/Photographer harmless from any action that may arise from the Client's issuance of this authorization. Payment for all reproductions is the sole responsibility of the person requesting such reproductions.

_____ (Client Signature) Date: _____

CLIENT PERMISSION TO REPRODUCE

It is important to note that copyright ownership does not give you the unlimited right to reproduce an image. In law, there is no right to produce without the authorization of the owner of the photography.

Photographers may occasionally receive requests to provide prints or other services by persons who were not the originators of the photography from which the prints or services are requested. In some cases, this is clearly not a problematic issue—for example, when a member of a family group requests prints from their session. There are, however, circumstances in which this could become an issue. For example. if a company has arranged and paid for headshots of their employees for brochures or advertising, it is important to obtain the authorization of the original client—the company—before producing prints for the personal use of the individual employee(s).

A different, more contentious case could arise when a child is photographed at the order of a parent or guardian and another member of the family (or a separated parent) requests copies. Let's imagine that Mary, a high-school senior, is photographed and Dad pays the bill. In this case, Mary's dad, who is divorced from her mother and remarried, is the owner of the right to produce. If Mary's mother requests copies from this photography session, any prints supplied must be with the authorization of Mary's dad.

Too frequently, divorce results in spiteful and otherwise not-nice relationships between the former spouses. I recall one mother of my clients, a mother of four lovely girls, refusing to allow me to provide portrait copies to their father from whom she was separated. I received numerous calls from the father who insisted that he had paid for the session and could not understand why I would not show him the proofs and allow him to order.

I tried to explain to him that, although I did not doubt his claim to have paid for the session, the children's mother was my client and without her authorization I could not serve him. In this incident, I found myself becoming a go-between and negotiator. I felt for the father, who clearly was distressed, but my hands were tied. Even though I owned the copyright, the mother owned the right to reproduce.

Authorization to produce for a third party in the situations described here can be obtained with a relatively simple form as suggested below. This form needs to be worded so that the authorization is specific and limited so that it may not be used for any other purpose. Note that we refer to the permission to reproduce as *authorization* because the term is more precise.

The above authorization form should be completed with the relevant information as indicated and then sent to the originator of the referred to session with the following cover letter requesting the signature:

Dear Mr. / Ms. _____,

I have been requested by _____
(name of requesting party) to produce reproductions
of _____ (name of subject[s]) from the
portrait session we made on _____
(date) at _____ (location) on
our file _____ (file number).

I am unable to meet this request without your
approval and am requesting that you provide such
authorization. I have enclosed an authorization form,
along with a postage-paid envelope, for your signature.
I would greatly appreciate your kind cooperation and
look forward to receiving the completed form as soon
as possible.

If you have any questions or require any further
information please do not hesitate to call.

Yours sincerely,
Signature
Name

You may find that a personal contact with the requested signor may help to expedite the return of the signed authorization form.

Commissions by Minors. Should there be a request from a third party for images created in a session that was commissioned by a minor, you should contact the subject. The young person may have to consult a parent or guardian before such a request can be met. It is important to determine and secure the appropriate authorization. For a high-school senior's portrait, for example, the funds for the session will likely have been provided by a parent. If you proceed with a request for reproductions without the required permission you may find yourself with a legal problem.

LICENSING

Nonexclusive License. Licensing copyrights is a useful way of increasing a photographer's income. Generally, the release for the use of the copyright-owner's works is for exclusive use of the images, and this will clearly result in greater fees. However, a nonexclusive license is another way to allow the use of images within a specific region or market or for a specific purpose. This latter arrangement allows the photographer to license his copyright to a number of markets and uses, so long as they do not overlap or create a conflict of interest. The license may also limit the timeframe for the use of the images. Should this type of licensing be an option, it is important to advise the prospective licensee of any other previous or concurrent use(s) of the images. Not only will this prevent the possibility of legal complications, it may also reduce the value to the potential licensee. An example of such a license begins on the following page.

License of Electronic Rights. Now that we are in the digital age, new issues arise when it comes to licensing work that can be manipulated, recorded and retrieved, uploaded and downloaded, and transmitted via the Internet, or via mail and delivery services in the form of a CD. These we refer to as electronic media, and you will need to be clear about what license is being given to a client.

As related in Clause 4 of the recommended licensing document (which begins on page 76), the territory that the license is limited to must be clearly stated. This paragraph also includes a date by which the work licensed is to be used and states that, if it is not used by that date, the license is ended. In this event, all rights granted return to the photographer, he retains all payments received, and is due any balances listed in the license.

This paragraph is most important, as the Internet is pervasive and you need to be able to control the use of your work. You will be aware that digital files come in a vast range of resolutions and the quality of your work as displayed or transmitted electronically may undermine your reputation. Additionally, the resolution of the images you provide affects the end production, and you need to ensure that it is shown as you wish it to be.

Once a client has a license to use your work electronically in one way, he may think he has a right to additional use of the work. Paragraph 5 in the suggested license ensures that if the licensee wishes to use the work for another purpose, he is required to obtain the photographer's permission and this may mean additional payments.

Paragraph 6 bars the client from altering or allowing alteration of the image(s), so that the integrity of your work is maintained.

NONEXCLUSIVE LICENSE AGREEMENT

THIS AGREEMENT is for the purpose of licensing of Images and entered into as of this _____ day of _____, 20 _____, between _____, with a principal place of business at _____ (hereinafter referred to as the "Customer") and _____, with a principal place of business at _____ (hereinafter referred to as the "Photographer").

 1. IMAGES. The Customer desires to license certain electronic rights in the Images which are owned by the Photographer and are described below:

 2. POSSESSION. The Photographer agrees to deliver the Images on _____ or within _____ of the signing of this Agreement.

 3. LICENSING OF RIGHTS. The Photographer licenses to the Customer the following rights in the Images:

_____. Such right to use said Images is for a period which shall expire on _____ if the Customer does not complete its usage under this paragraph and all rights will revert to the Photographer without the Photographer having any obligation of any sort to the Customer. With respect to the usage shown above, the Customer shall have nonexclusive rights to the use of the Images.

 4. RIGHTS NOT LICENSED. If a specific right is not expressly stated above, then the right has not been granted, transferred, or licensed to the Customer by the Photographer.

 5. FEE AND PAYMENT. The Customer agrees to pay the following: $_____ for the usage of the Images and rights granted by the Photographer. The Customer agrees to pay the Photographer within thirty (30) days of delivery of the Images. Payment that is not receive by Customer within the thirty (30) days will be subject to a 5 percent (5%) late fee on said payment for each thirty (30) days that the payment is late.

 6. CHANGES IN IMAGES. Customer shall not make or permit any alterations, including but not limited to the adding or removing of items from the Images, without the expressed written permission of the Photographer.

 7. LOSS OR DESTRUCTION. Full rights title and interest of the Images other that the rights identified above shall remain with the Photographer. The Customer shall be fully responsible for any and all loss or destruction to the Images. Unless another value is specified in this Agreement by exhibit both parties agree that each original Image has a fair and reasonable value of $_____. The Customer agrees to reimburse Photographer for these fair and reasonable values in the event of loss or destruction.

 8. NOTICE OF COPYRIGHT. The Customer shall post a notice that the Photographer is the owner of the copyrights for the Image(s). Said notice shall be clear and close to the image so as not to be missed by anyone who reproduces the Image(s).

 9. OWNERSHIP RECOGNITION. The Photographer shall be recognized as the owner of the Images when the Images are used in a magazine or for a book.

 10. RELEASES. The Customer agrees to indemnify and hold harmless the Photographer against any and all claims, costs, and expenses, including attorneys' fees, due to uses for which no release was requested, uses which exceed the uses allowed

pursuant to a release, or uses based on alterations not allowed pursuant to Paragraph 6.

11. ARBITRATION. All disputes arising under this Agreement shall be submitted to binding arbitration before _____ in the following location _____ and settled in accordance with the rules of the American Arbitration Association. Judgment upon the arbitration award may be entered in any court having jurisdiction thereof.

12. TOTAL AGREEMENT AND CHOICE OF LAW. This Agreement shall be binding upon the parties hereto, their heirs, successors, assigns, and personal representatives. This Agreement constitutes the entire understanding between the parties. The courts of the State of _____ shall have jurisdiction over the terms of this Agreement.

IN WITNESS WHEREOF, the parties hereto have signed this Agreement as of the date first set forth above.

Photographer: _____

Customer: _____ (Company name)

By: _____ (Authorized signatory, title)

ELECTRONIC RIGHTS AGREEMENT

This Agreement is entered into on this _____ day of _____, 20___, by and between _____ (Customer), who resides at _____ _____ and _____ (Studio), located at _____ with respect to the use of certain electronic rights of the Studio's photograph(s) ("Photographs").

1. DESCRIPTION OF PHOTOGRAPHS. The Customer desires to use and license certain electronic rights in the Photographs which the Studio owns, which are described below:

 Description of Photographs: _____

 Quantity of Photographs: _____

 Topic in the Photographs: _____

 The Photographs shall be delivered to the Customer in the following format: _____

Delivery of the Photographs shall take place at the time this Agreement is executed.

2. AGREEMENT OF USE. The Studio shall agree to permit the Customer to use the Photographs in the following matter: _____ _____ _____.

Said use shall not exceed the _____ day of _____, 20____.

The Customer shall have nonexclusive rights to the Photographs and shall not act or do something that would be inconstant with the nonexclusive right. Further, the Customer may be limited in use by: _____ _____ _____ _____.

This Agreement shall terminate and the Customer's rights to the Photographs shall terminate on _____, and all rights shall revert to the Studio. All compensation paid to the Studio shall be fully vested in the Studio and the Studio shall have no obligation to the Customer.

3. COMPENSATION. The Customer shall pay to the Studio $_____ for use permitted under this Agreement.

4. ELECTRONIC RIGHTS DEFINED. Electronic Rights are the digitized form of Photographs which are stored on and retrieved from electronic media including but not limed to floppy disks, CD-ROMs, DVDs, hard drives, memory sticks, and memory cards.

5. CUSTOMER'S OBLIGATION FOR PERMISSION. Should the Customer need additional rights which are not agreed to or are outside the scope of this Agreement then the Customer agrees to seek permission from the Studio. Further, the Customer agrees that such additional permission may come with additional fees due to the Studio.

6. CHANGES TO PHOTOGRAPHS. The Customer shall not make nor shall the Customer allow anyone else to make any alterations to the Photographs. If such alterations are necessary, then the Customer shall seek the permission of the Studio.

7. OWNERSHIP. The ownership of the Photographs shall remain with the Studio. The Customer agrees that in the event that the Photographs are lost or misplaced or stolen, the Customer will promptly notify the Studio and take whatever steps are necessary to recover said Photographs. The Parties agree that if the Photographs have a significant insurable value, the Customer will obtain a policy for insurance or be bonded in such a manner that will insure the Photographs from destruction, loss, or theft.

8. ACKNOWLEDGEMENT AND COPYRIGHT. At the Studio's request, the Customer shall make any and all arrangements to have an Acknowledgment and a Copyright Notice accompany the Photographs in whatever form that they are in, acknowledging Studio as the owner of both the Photographs and copyright.

9. HOLD HARMLESS. The Customer agrees to indemnify and hold harmless the Studio against any and all claims, costs, and expenses, including attorneys' fees or for violations of this Agreement including but not limited to loss if there is a violation of Clauses 5 and 6.

10. ARBITRATION. The Parties agree to settle all disputes under this Agreement by binding arbitration and in accordance with the rules of the American Arbitration Association. Judgment upon the arbitration award may be entered in any court having jurisdiction thereof.

IN WITNESS WHEREOF, the parties hereto have signed this Agreement as of the date first set forth above.

Studio: _____ Customer:_____

Licensing Contract to Merchandise Images. The contract we propose is relatively simple but it protects the photographer's copyright and allows him to control how his work is sold and used.

You will note throughout this book that we continue to stress the ownership of copyright. This contract does so again. It also states the grant of merchandising rights and the royalties that are to be paid in advance. Note, too, that Clause 4 requires monthly statements of royalties and accounts.

In Clause 8, the licensee is required to make a genuine effort to promote the photographer's work. Too often an agent or merchandiser will (perhaps not deliberately) overlook the work of some photographers while they concentrate on others' work. When you have invested in time, effort, and materials you do not want to have your interests neglected.

Note too, Clause 10. This is the most important part of the contract, and you will find it in other documents that we have recommended. This paragraph prevents you from numerous potential suits and demands for damages.

Clause 7 is also important. Your reputation is on the line when your images are licensed and published or otherwise used. This paragraph requires that the quality of your work not be misrepresented.

Clause 6 may be relevant or irrelevant. It applies when the product that is carrying the photographer's work is of such a nature that the paragraph makes sense. So, if it does not make sense, it can be lined out of the contract.

The contract recommended is as follows:

LICENSE TO MERCHANDISE IMAGES

THIS AGREEMENT, is made this _____ day of _____, 20___, by and between _____ _____ (hereinafter the "Photographer"), with a principal place of business at _____ _____ and _____ (hereinafter "Marketer"), with a principal place of business at _____ _____ as it relates to the use of a certain Works created by the Photographer (hereinafter the "Works") for products (hereinafter the "Products").

WHEREAS, the Photographer has produced the Works which shall be licensed for purposes of manufacturing and sale on wholesale and retail markets; and

WHEREAS, the Marketer desires to use the Works with certain products for manufacturing and sale on the wholesale and retail markets; and

WHEREAS, both parties will use best efforts and maximize their return on investment;

NOW, THEREFORE, in consideration of the above recitals and the mutual obligations and promises hereinafter and other valuable consideration, the receipt and sufficiency which is hereby acknowledged, the parties hereto agree as follows:

1. LICENSING OF MERCHANDISING RIGHTS. The Photographer Licenses to the Marketer the right to use the Works which are described as: _____, which are owned by the Photographer. The Marketer shall manufacture and distribute the following merchandise _____ _____ which will contain the Works. Said merchandise shall be sold in the following geographical area:_____ _____ and will be available for sale from _____, 20_____ until _____, 20____.

2. COPYRIGHT. Unless expressly stated in this Agreement, all copyrights to the Works shall remain the property of the Photographer. All of the merchandise sold shall identify the Photographer as the creator of the Works and the owner of the copyright.

3. ADVANCE AND ROYALTIES. As an inducement to the Photographer, the Marketer shall pay to the Photographer an Advancement of future earned Royalties, equal to $_____ at the time this Agreement is signed. Said Advancement shall be nonrefundable. The Marketer is entitled to offset the Advancement by the first Royalties earned. The Marketer further agrees to pay the Photographer a royalty fee based upon the "Gross Sales" of the Products. The Royalty Fee shall be equal to _____ percent (____ %) of the gross sales volume of the Products. "Gross Sales" as used herein shall mean the total gross sales price to customers less shipping, taxes, and actual returns. Royalties shall be deemed to accrue when the Products are sold, shipped, or invoiced, whichever first occurs.

4. PAYMENTS STATEMENT, OPTION TO TERMINATE. Royalty payments shall be paid monthly on the first day of each month commencing _____, 20 ___, and the Marketer shall with each payment furnish the Photographer with a monthly statement of account showing the kinds and quantities of all Products sold and the price the Products sold for. If the Marketer fails to make any payment as required herein and the Marketer does not cure this default within thirty (30) days of the date the payment was due, then the Photographer has the right to terminate this Agreement and all rights licensed herein shall revert immediately to the Photographer. No notice of a right to cure shall be required by the Photographer to the Marketer.

5. INSPECTION OF BOOKS AND RECORDS. Upon written notice, the Photographer shall have the right to inspect the Marketer's books and records as it relates to the sale of the merchandise. Said inspection shall take place during 9:00am and 5:00pm, Monday through Friday, unless the Parties agree to a different time.

6. FREE SAMPLES. The Photographer is entitled to _____ samples of the Products from the Manufacturer for any

purpose the Photographer sees fit. The Photographer shall have the right to purchase additional samples of the Products at the Marketer's manufacturing cost plus any shipping and applicable taxes.

7. INSPECTION OF PRODUCT. The Photographer shall have the right to inspect the Products to ensure a minimum quality for the Photographer's reproduced Works. The Marketer agrees not to sell or distribute any product if the Photographer does not agree with the minimum quality of the reproduced Work. The Photographer agrees the he/she will not unreasonably withhold approval.

8. SALES AND DISTRIBUTION. The Marketer shall use its best efforts to promote, distribute, and sell the Products.

9. RESERVATION OF RIGHTS. All rights not expressly licensed by this Agreement are reserved to the Photographer.

10. INDEMNIFICATION. The Marketer shall hold the Photographer harmless from and against any loss, expense, or damage occasioned by any claim, demand, suit, or recovery against the Photographer arising out of the use of the Works for the Products.

11. ASSIGNMENT. This Agreement is not assignable by either party without the express written consent of the other.

12. RELATIONSHIP OF THE PARTIES. Marketer and Photographer have not entered into any relationship which may be interpreted as a joint venture, employer/employee or any other relationship whereby doing business together.

13. GOVERNING LAW. This Agreement shall be governed by the laws of the state of _____; The Parties consents to the jurisdiction of the courts of _____.

14. NOTICE. All notices, demands, payments, royalty payments, and statements shall be sent to the addresses first noted on this Agreement unless either party specifies another address in writing to the other party.

15. FULL AGREEMENT. This Agreement is the entire agreement between the parties. There are no oral agreements or supplemental writing that modifies this Agreement. Any future amendments to this Agreement shall be in writing signed by both Parties and shall make reference to this paragraph.

IN WITNESS WHEREOF, the parties have signed this Agreement as of the date first set forth above.

Photographer: _____

Marketer: _____ (Company Name)

By: _____ (Authorized Signatory, Title)

13. MODEL RELEASES

In our event contract, we provide for the use of images for the purpose of promoting our business. However, many photographers are involved in other aspects of photography and need to use images to advance their businesses and careers. Most clients are flattered that we want to use their images for promotion and advertising. In our studio, it has become something of an honor to be seen in our window—even before we've created any images, some clients ask if their portrait will be on display!

Even so, it is important to have the client's permission to publicly display their image. Imagine if a mother was delighted that her child's portrait was going to be in your window, but then the dad objected and wanted to make a case of it.

Many years ago, I used a portrait of an elderly woman in an advertisement and her son called and then wrote to advise that I did not have permission to do so and wanted to negotiate with me for compensation. I agreed to supply him with copies of the portrait to a value of $500 as settlement. In retrospect, I was lucky he was prepared to negotiate with me. He might simply have sued me for infringement on his mother's privacy. This could have resulted in a lawsuit that would have probably cost significantly more than $500. Even a $500 cash settlement would have been much more expensive than the cost of prints.

Even with permission from one of the parties in a portrait, there may be an objection from someone else in the picture. For instance, there may be friction in a family subsequent to the time of the portrait. Therefore, the signature of only one member of a family in a portrait slated for display may not be enough to avoid a legal challenge.

Even if you have a release to use the image, if someone objects, you will do well to accede to their wishes and remove it from view. Recently, we had a newly remarried couple agree to have their portrait on display, and we selected a 20x24-inch image matted in a 24x30-inch frame. A little later, we received a call from one of their children telling us that they were uncomfortable with the portrait being on display, so we removed it. Because we had the client sign a release, we were at least legally protected, which is most important, but the release must hold us harmless in the event of another party contesting our right to show an image.

Using someone's image for public display without permission is an infringement of that person's privacy and may be subject to a lawsuit.

The issue here is that using someone's image for public display without permission is an infringement of that person's privacy and may be subject to a lawsuit, which could be very costly. The release you use may offer some form of compensation, such as monetary reward, products, or services. If you have a special reputation and your clients are simply flattered at having their portrait on show at your studio, you may obtain a release without any monetary compensation or product being part of the release. Therefore, it is wise to have two distinctly different releases: one that provides for reward, and one that does not refer to any exchange of service, product, or money.

In most instances, a simple release is all that is needed to use a client's image for display in our studio or at another location to promote our studio. Even

though there is not likely to be a problem, we should have a signed release.

BASIC MODEL RELEASES

Having discussed the issues of displaying or using a client's images for promotion, we recommended three versions of model releases:

The first (A) is a comprehensive release that allows for multiple uses. This is the preferred version when the image is to be used for reward, such as in an advertisement for which you receive payment. The same release would be used when a model is hired for a general commercial purpose.

The second (B) is a modification that has a strictly limited use for placing an image on show as a sample of our work or for use in an advertisement.

Using someone's image for public display without permission is an infringement of that person's privacy and may be subject to a lawsuit.

A third release (C) is for an assignment in which the model (or his or her guardian) restricts the use of the images to be created. Such a release would apply to a circumstance in which a model is solicited for the purpose of a particular assignment, such as a fashion advertisement or illustration in a children's book. This release allows the images to be used only for the purpose for which they were created. All three versions are known as model releases.

Version A. In Version A (pages 83–84), it is suggested that the terms and rewards agreed to be inserted in the space provided. You will note that, compared to other releases, this version covers more of the areas that can lead to complications, such as the incorporation of copy over which the photographer has no control. Additionally, this version waives the right of the model to approve the photographs, an element not included in other releases. Also waived is the right to claims for invasion of privacy or libel, something that is also not included in other versions.

This version of the release is also good in situations when the model is under age and there is a need for the parent's or guardian's consent. There may be serious problems should you wrongly assume that a minor has parental permission to participate in any photography session. (The primary exception to this caveat is in high-school senior portraits, which are, in essence, licensed by tradition or by sponsorship of a high school.) When the model is under legal age, the sentence in the release that states "I am of full age and competent to sign this release" will be deleted, and the bottom section of the release will be signed by either a parent or guardian.

In addition to the release, it is advised that, prior to using a minor for modeling, you have the written consent of the parent(s) or guardian. A contract or letter of proposal that states the purpose of the photography and the compensation, and a response in writing, should be secured. This may be done via an agency, if the minor model has such representation. The misuse of any image, such as the use of an image for a purpose to which the model and his or her parents have not agreed, may lead to serious repercussions.

Please note that all releases should not only be signed, but also witnessed. The witness may be any individual who is of full age, but preferably not the photographer.

Version B. This release (page 85) is simply for the purpose of displaying the photograph (or derivative thereof) at the photographer's place of business or at a location where he advertises and promotes his work. This release specifies a particular image, which will be released for use as witnessed by the client. In other words, the photograph may not be altered in any way after the client signs the release except, perhaps, to be cropped when used in media. Simply stated, when the photograph is seen publicly, it would be recognized by the client as one and the same.

In most cases, photographers obtain these releases with a "handshake" as it were, and the client is usually flattered that their picture has been chosen for such a use. The "handshake" might be that the client is given a discount or a free print in exchange for the release.

If the image is considered exceptional, however, and might be put to wider use (and the photographer is prepared to pay other than in kind for its use), then Version A should be used.

VERSION A—UNRESTRICTED-USE MODEL RELEASE

In consideration of $_____, and other valuable consideration, receipt of which is acknowledged, by and between, _____ (the Model) and _____ (the Photographer) agree as follows:

WHEREAS the Model has agreed to permit the Photographer the use of the Model's name (or any fictional name), picture, portrait, or photograph in all forms and in all media and in all manners, without any restriction as to changes or alterations (including but not limited to composite or distorted representations or derivative works made in any medium) for advertising, trade, promotion, exhibition, or any other lawful purposes.

NOW, THEREFORE, for the promises and considerations contained herein, the undersigned does hereby covenant and agree as follows:

1. CONSIDERATION. The Model shall receive compensation as outlined first above as consideration for allowing the Photographer to use the Model's name (or any fictional name), picture, portrait, or photograph in all forms and in all media and in all manners, without any restriction as to changes or alterations (including but not limited to composite or distorted representations or derivative works made in any medium) for advertising, trade, promotion, exhibition, or any other lawful purposes.

2. PARTIES RELEASED. The term "Parties Released," as used in this Release, shall mean the Model and the Photographer, and shall include all individual parties if no corporate entity exists, or any parent company, subsidiary, divisions, successors, assigns, predecessors, partnerships and related companies, corporations and organizations. The term shall also include all the shareholders, officers, directors, members, partners, limited partners, agents, employees, and insurers of the parties identified in the first sentence of this paragraph.

3. RELEASE. For the consideration set forth in Paragraph 1 of this Release, the Model does hereby release, acquit, and forever discharge the Photographer of and from any and all actions, causes of action, claims, demands, and lawsuits arising from or to arise from, the transactions and/or occurrences from the use my name (or any fictional name), picture, portrait, or photograph in all forms and in all media and in all manners, without any restriction as to changes or alterations (including but not limited to composite or distorted representations or derivative works made in any medium) for advertising, trade, promotion, exhibition, or any other lawful purposes, and I waive any right to inspect or approve the photograph(s) or finished version(s) incorporating the photograph(s), including written copy that may be created and appear in connection therewith. I hereby release and agree to hold harmless the Photographer, his or her assigns, licensees, successors in interest, legal representatives, and heirs from any liability by virtue of any blurring, distortion, alteration, optical illusion, or use in composite form, whether intentional or otherwise, that may occur or be produced in the taking of the photographs, or in any processing tending toward the completion of the finished product.

4. COPYRIGHT. I agree that the Photographer owns the copyright in these photographs and I hereby waive any claims I may have based on any usage of the photographs or works derived therefrom, including but not limited to claims for either invasion of privacy or libel. I am of full age and competent to sign this release. I agree that this release shall be binding on me, my legal representatives, heirs, and assigns. Further, if I am the legal parent or guardian of the Model that I have read this Release and have the legal authority to execute and bind the Model in this Release.

This Release specifically releases, acquits, and forever discharges the Photographer from any and all claims whether for breach of contract, breach of express warranty, breach of implied warranty, fraud, misrepresentations (intentional, innocent and/or negligent), negligence, negligent design, products liability, any claim under the Uniform Commercial Code, revocation of acceptance and/or any other cause of action or claim whether founded in law or equity.

However, this release provision does not release the Photographer from his/her obligations to pay the consideration provided for in Paragraph 1.

5. DAMAGES RELEASED. The Model expressly agrees and understands that he/she is releasing the Photographer from any and all damages arising from the photography and use of the images and any and all actions as described in this Release.

The damages which the Model releases include, but are not limited to, any and all compensatory damages, exemplary damages, punitive damages, loss of income, lost profits, damage to business, injury to reputation, loss of business, diminished value, costs, interest, attorney fees, or litigation expenses.

6. WARRANTIES AND REPRESENTATIONS. The undersigned do hereby warrant and represent to each other the following, knowing that the other party is relying on these representations: (A) That if a party is a corporation, then each of the corporations are a corporation in good standing under the laws of the state of their respective incorporation; (B) That each party has had the opportunity to consult its own respective attorney regarding the terms and conditions contained in this Release. (C) That the Model has reviewed this Release and knows and understands the terms and conditions contained herein. (D) That the person signing this Release for their respective corporations, or individually, is authorized to execute this Release on behalf of that corporation and to thus bind that corporation to the terms and conditions contained herein.

9. MISCELLANEOUS PROVISIONS. This Agreement shall be interpreted and enforced in accordance with the laws of the State of _____.

Model: _____ Witness: _____

Address: _____ Address: _____

Date: _____, 20____

-- Consent (if applicable) --

I am the parent or guardian of the minor named above and have the legal authority to execute the above release. I approve the foregoing and waive any rights in the premises.

Parent or Guardian:_____ Witness:_____

Address:_____ Address: _____

Date: _____, 20____

VERSION B—MODEL RELEASE TO DISPLAY IMAGE TO PROMOTE STUDIO

I _____ (*Client's name*), do hereby give _____ (*Photographer's name*), his or her assigns, successors, and/or licensees in interest the right to use my image in photograph number _____ from my photography session dated _____ as seen by me prior to signing this release, the right to use for the limited purpose of advertising and promoting his or her business as a photographer. The photograph stated shall not be altered or manipulated other than enlarged for framing and display or reproduced for media distribution. This release does not permit the sale or trade of the stated photograph in whole or in part for any purpose whatsoever. I have the right, after _____ days from the date of this release, to request that there be no further use of this photograph other than that which has been irreversibly distributed, and the Photographer agrees to adhere to such a request. I am of full age and competent to sign this release. I agree that this release shall be binding on me, my legal representatives, heirs, and assigns. I have read this release and am fully familiar with its contents.

Subject: _____
Signed: _____

Witness: _____
Signed: _____

VERSION C—RESTRICTED-USE MODEL RELEASE

In consideration of _____ Dollars ($_____), and other valuable consideration, receipt of which is acknowledged, by and between, _____ (Model's name) and _____ (the Photographer) agree as follows:

1. USE OF IMAGE. Photographer, his or her assigns, licensees, successors in interest the right to use my photograph, number _____ from my photography session dated _____ as seen by me prior to signing this release the right to use for the limited purpose of his or her business as a photographer. The photograph stated shall not be altered or manipulated other than enlarged for framing and display or reproduced for media distribution and as other than that as witnessed by me prior to signing this release. This release does not permit the sale or trade of the stated photograph in whole or in part for any purpose whatsoever. I have the right, after _____ days from the date of this release, to request that there be no further use of this photograph other than that which has been irreversibly distributed and the Photographer agrees to adhere to such a request. I am of full age and competent to sign this release. I agree that this release shall be binding on me, my legal representatives, heirs, and assigns. I have read this release and am fully familiar with its contents.

2. CONSIDERATION. Model shall receive compensation as outlined first above as consideration for allowing Photographer to use the image as restricted for advertising, trade, promotion, exhibition, or any other lawful purposes.

3. PARTIES RELEASED. The term "Parties Released," as used in this Release, shall mean the Model and the Photographer, and shall include all individual parties if no corporate entity exists, or any parent company, subsidiary, divisions, successors, assigns, predecessors, partnerships and related companies, corporations and organizations. The term shall also include all the shareholders, officers, directors, members, partners, limited partners, agents, employees and insurers of the parties identified in the first sentence of this paragraph.

4. RELEASE. For the consideration set forth in at first and in Paragraph 3 of this Release, the Model does hereby release, acquit and forever discharge the Photographer, of and from any and all actions, causes of action, claims, demands and lawsuits arising from or to arise from, the transactions and/or occurrences from the use of the image as restricted. The Parties hereby release and agree to hold harmless each other or, his or her assigns, licensees, successors in interest, legal representatives and heirs from any liability by virtue of any use of the image that is found lawful per the restricted terms of this Release

5. WARRANTIES AND REPRESENTATIONS. The undersigned do hereby warrant and represent to each other the following, knowing that the other party is relying on these representations: (A) That if a party is a corporation then each of the corporations are a corporation in good standing under the laws of the state of their respective incorporation; (B) That each party has had the opportunity to consulted its own respective attorney regarding the terms and conditions contained in this Release. (C) That the Model has reviewed this Release and knows and understands the terms and conditions contained herein. (D) That the person signing this Release for their respective corporations, or individually, is authorized to execute this Release on behalf of that corporation and to thus bind that corporation to the terms and conditions contained herein.

6. MISCELLANEOUS PROVISIONS. This Agreement shall be interpreted and enforced in accordance with the laws of the State of _____.

Model:_____ Witness:_____

Address:_____ Address: _____

Date: _____, 20____

-- Consent (if applicable) --

I am the parent or guardian of the minor named above and have the legal authority to execute the above release. I approve the foregoing and waive any rights in the premises.

Parent or Guardian:_____ Witness:_____

Address:_____ Address: _____

Date: _____, 20____

Version C. This release, which begins on page 86, states the purpose of the photography to be produced with the model and specifies the reward applied for this limited use.

In the case of a commercial assignment, the client will have clearly stated what the images are to be used for and the release can be prepared prior to photography. Models should be informed of the details so that they may decline the assignment if the images are to be used for a purpose to which they object. In a majority of cases, models will be acquired via an agency, and higher-level agencies are savvy when it comes to negotiating the terms for each model's services.

Note that, when images with usage limitations are released for sale, they should be accompanied by a clear statement as to how they may and may not be used (such as pornography, the sale of alcohol or tobacco, etc.).

When images with usage limitations are released for sale, they should be accompanied by a statement as to how they may and may not be used.

Here, the release states clearly that the images may not be used (in whole or in part) or manipulated for any purpose or reason other than for the purpose of the assignment. This release varies from version A, in which the photographer is granted carte blanche to use the images.

RELEASE TO END USER

The limitations on the usage of your images must be clearly communicated to the end user and agreed upon prior to the hiring of the model so that there is no misunderstanding. When the end user wishes to have full and any use of images provided to them, it is important that the model is appropriately advised and the release properly worded. It is not unreasonable, especially for a parent, to be concerned with how a model's images may be used.

The release you send to the end user should also clearly define the permitted usages, and a copy of the release signed by the model must be provided with the images. The images to be transferred to an end user should be placed in a sealed envelope and a statement that binds the user to the previously agreed-upon terms should be attached to the envelope. This statement says that opening the envelope is confirmation of the terms of the agreement.

This is also important when offering images for selection by an end user. Transparencies should be placed in sealed, transparent envelopes. In this case, your notice on the envelope should inform the prospective end user that they will be billed for any images that have a broken seal, in accordance with the terms of either a prior agreement or an agreement that is attached to the image offered.

The release on pages 89–90 should be used when transferring images to the end user.

RELEASE TO END USER

In consideration of _____ dollars ($_____), and other valuable consideration, receipt of which is acknowledged, _____ (hereinafter the "End User") and _____ (hereinafter the "Photographer") agree as follows:

WHEREAS the End User is acquiring the usage of certain Images described as follows:

The End User acknowledges that the Photographer has provided copies of all releases from property owners and models that may be the subject of the photography.

NOW, THEREFORE, for the promises and considerations contained herein, the undersigned does hereby covenant and agree as follows:

1. CONSIDERATION. The End User shall pay compensation as outlined first above as consideration for the use of the Images, said usage shall be limited to: _____

Further, the End User may not make changes or alterations to the Images (including but not limited to composites, distorted representations, or derivative works made in any medium) or use them for any unlawful purpose.

2. PARTIES RELEASED. The term "Parties Released" as used in this Release shall mean the End User and Photographer, and shall include all individual parties if no corporate entity exists, or any parent company, subsidiary, divisions, successors, assigns, predecessors, partnerships, and related companies, corporations, and organizations. The term shall also include all the shareholders, officers, directors, members, partners, limited partners, agents, employees, and insurers of the parties identified in the first sentence of this paragraph.

3. RELEASE. For the consideration set forth in Paragraph 1 of this Release, the End User does hereby release, acquit, and forever discharge Photographer, and any parties to which have provided Released to the Photographer, including but not limited to all model and property owners who are the subject of the Images, from any and all actions, causes of action, claims, demands, and lawsuits arising from or to arise from the transactions and/or occurrences from the use of the Images that may be in any form or media. The End User hereby releases and agrees to hold harmless the Photographer, his or her assigns, licensees, successors in interest, legal representatives and heirs from any liability by virtue of any blurring, distortion, alteration, optical illusion, or use in composite form whether intentional or otherwise, that may occur or be produced or in any processing tending toward the completion of the finished product.

This Release specifically releases, acquits and forever discharges the Photographer from any and all claims whether for breach of contract, breach of express warranty, breach of implied warranty, fraud, misrepresentations (intentional, innocent and/or negligent), negligence, negligent design, products liability, any claim under the Uniform Commercial Code, revocation of acceptance and/or any other cause of action or clam whether founded in law or equity.

4. DAMAGES RELEASED. The End User expressly agrees and understands that they are releasing the Photographer from any and all damages arising from the photography and use of the images and any and all actions as described in this Release.

The damages which the End User releases include, but are not limited to, any and all compensatory damages, exemplary damages, punitive damages loss of income, lost profits, damage to business, injury to reputation, loss of business, diminished value, costs, interest, attorneys' fees, or litigation expenses.

5. WARRANTIES AND REPRESENTATIONS. The undersigned to hereby warrant and represent to each other the following, knowing that the other party is relying on these representations:

(A) That if a party is a corporation then the corporation is a corporation in good standing under the laws of the state of their respective incorporation;

(B) That each party has had the opportunity to consulted its own respective attorney regarding the terms and conditions contained in this Release.

(C) That the End User has reviewed this Release and knows and understands the terms and conditions contained herein.

(D) That the person signing this Release for their respective corporations, or individually, is authorized to execute this Release on behalf of that corporation and to thus bind that corporation to the terms and conditions contained herein.

6. MISCELLANEOUS PROVISIONS. This Agreement shall be interpreted and enforced in accordance with the laws of the State of _____.

Witness:_____ Signed:_____ (End User)

Address:_____ Address: _____

Date: _____, 20___

FAIR COMPENSATION

A fairly common practice by photographers has been the exchange of prints for the use of the images created at a particular session. When this is the case, it is wise to ensure that the exchange has equitable value in regard to how the image is to be employed. If this is not done, and the use of the image significantly exceeds the value of what was provided in the trade, the model may claim to have been exploited and have the right to action. This could occur when, in all innocence, the model provides his or her time in exchange for a few prints when the photographer knows that the resulting images will yield significant financial rewards.

It is recommended that, in any release, the purpose of the photography be included so that the payment, in kind or in monetary terms, is seen to be fair and reasonable. While it is not required that the monetary payment for the release be equated with the value of the photography in either the short or long term, a fair-market value for the model's services should be the basis for the privilege of the release.

If you are simply seeking an image for a brochure that will have limited distribution, perhaps within your market area, the hourly rate the model charges may be quite modest. In this instance, the model may well decide that an exchange of their time for prints that will add significantly to their portfolio is good business. This is often the case with models who are new to the field and working to develop their portfolios. In the event that you are hiring a much-desired model, the actual use of the images may have no bearing on his or her fees for the session, which could be $1,000 or more per hour. (In many cases, these models will also not accept assignments that are less than four hours.)

There are some occasions when the use of an image becomes opportune after a conventional session, such as a portrait session or special event that falls outside the provision we discussed in the wedding contract. In this case, a new release must be drawn up, based on the new information, and the value of the release will have to be negotiated.

PERMISSION FORM

As an author of books and articles, I am aware that I may want to use certain photographic works in these publications, and that some of these uses may require the permission of my subjects. When these are incidental, a simple word of approval may be sufficient, but there are times when a permission form would be appropriate. Additionally, when publication in articles and books is known from the outset to be a potential, a permission form should be agreed.

Perhaps you are photographing a family and then the individuals separately. The permission form will make clear what may be used, and any images not included in the form may not be used.

There are occasions when the use of an image becomes opportune after a conventional session, such as a portrait session or special event . . .

Another permission may be for you to use images from a commercial assignment in publication, advertisements for your studio, or direct-mail pieces. This means that the permission is not exclusive and you know that images from this assignment will be used in other publications. Clearly, in such circumstances, your use of the images is not exclusive and that is why the permission is not exclusive.

If the authorizing signatories on the form are not the owners of all the individual rights of permission, then the other parties to be contacted will be listed on the form. This refers to the instances where the family is made up of several adults who have an individual right to refuse permission. In other words, one consenting adult may not permit the use of another consenting adult's image without their knowledge.

In the section of the permission form that says "Additional Provisions" you would enter what method of payment, if any, is part of the permission.

On the next page is an example of the recommended form.

PERMISSION FORM

This Permission Form ("Permission") is entered into this _____ day of _____,
20____ by and between _____ (the "Photographer"), whose principal place of
business is _____, and
_____ (the "Subjects"), residing at _____
_____.

 WHEREAS, the Subjects are displayed or their property is displayed in certain Images that are owned by the
Photographer, and;

 WHEREAS, Photographer wishes to get permission to use said images which contain the Subjects or their property
for _____, and;

 WHEREAS, the Parties have agreed on an arrangement where the Photographer may use the Images and the Subjects
will receive fair compensation and consideration for such use;

 THEREFORE it is Agreed:

 In consideration of the sum of _____ dollars ($_____) and other valuable considera-
tion, the sufficiency and the receipt of which is hereby acknowledged, the Subjects do grant to the Photographer, his assigns,
licensees, successors in interest, legal representatives, and heirs permission to use the Images for the purpose first described
above.

 The Subjects hereby warrant to the Photographer that they are the rightful and lawful Owners of said property and
have full and sole authority to grant such permission.

 Subjects hereby waive any and all rights that they may have to inspect or approve the Image(s) or finished version(s)
of the Images as they may be incorporated.

 Additional Provisions (if any): _____

 Finally, the Subjects warrant that they are over the age of eighteen (18) and have every right to contract and give the
required permission with respect to the foregoing matters. The Subjects have read the above Permission Form prior to its
execution and are fully aware of its terms.

_____ (Subject)

_____ (Subject)

_____ (Subject)

_____ (Subject)

Date _____, 20_____

Photographing other people's property when the images created are not for the owner's personal use requires you to obtain a property release. This is to protect both the privacy of the owner and their personal integrity. This is also to ensure that, should an image of that person's property be used for monetary gain, they will receive appropriate compensation. Should you fail to obtain such a release and it is later discovered that you or your third-party client released the image for any purpose, including profit, you may well find yourself defending a legal action. This could be financially crippling and should be avoided at all costs.

For a Kodak Dream Makers portrait session in the 1990s, a client wanted to be represented as a 1930s "flapper." It required me to locate a property that was built either in the 1930s or earlier and also required me to have the use of a vintage Ford. To obtain the permission to stage the portrait on the desirable site, I paid the owners a fee and received a written release for the purpose. Without doing so, I would have been infringing the owners' property rights.

Whenever a third-party property is going to be included within the image, it is important to obtain appropriate permission. In many cases, it may be adequate for the permission to be verbal. Such a case may be that where the property is that of a relative of the client and it is a collaborative situation. However, if the image to be created is of property that is owned by or leased by an otherwise uninvolved party, a legal release is crucial.

If the image to be created is of property that is owned by or leased by an otherwise uninvolved party, a legal release is crucial.

This is especially important if the image is likely to be exhibited in the media to the public. It doesn't matter what kind of property may be involved; if it is recognizable in any form whatsoever, it needs a property release. If you rent property, whether real estate or transportable, it also needs a release. That release should describe the purpose and define the reward for the release.

An example of such a release follows on page 94.

PERSONAL PROPERTY RELEASE

This Personal Property Release, ("Release") is entered into this _____ day of _____, 20____ by and between _____, (the "Photographer") whose principal place of business is _____ and _____ (the "Owner") residing at _____ _____.

WHEREAS, the Owner is the legal owner of _____ ("the Property");

WHEREAS, the Photographer wishes to purchase the use of the Property for some photography;

WHEREAS, the Parties have agreed on an arrangement where the Photographer may purchase the use of the Property and the Owner will receive fair compensation and consideration for such use.

THEREFORE, it is Agreed:

In consideration of the sum of _____ Dollars ($_____) and other valuable consideration, the sufficiency and the receipt of which is hereby acknowledged, the Owner does irrevocably empower the Photographer, his assigns, licensees, successors in interest, legal representatives, and heirs to copyright, publish, and use in all forms and media and in all manners for advertising, trade, promotion, exhibition, or any other lawful purpose, images of the following property:_____.

The Owner hereby warrants to the Photographer that he is the rightful and lawful owner and has full and sole author-ity to license for such uses, regardless of whether said use is composite or distorted in character or form whether said use is made in conjunction with my own name as owner or with a fictitious name, or whether said use is made in color, black and white, or otherwise, or other derivative works are made through any medium.

The Owner hereby waives any and all rights that the Owner may have to inspect or approve the photograph(s) or fin-ished version(s) incorporating the photographs, including written copy that may be used in connection therewith.

I warrant that I am over the age of eighteen (18) and have every right to contract in my own name with respect to the foregoing matters. I agree that this release shall be binding on me, my legal representatives, heirs, and assigns. I have read the above authorization and release prior to its execution, and I am fully cognizant of its contents.

Owner: _____ Witness: _____

Address: _____ Address: _____

_____ _____

Date: _____, 20_____

15. INSURANCE

The almost cavalier attitude that many business owners take toward insurance is really quite remarkable. While at the time of writing this book there were no definitive statistics, my general impression is that more than 60 percent of photographers are either not covered by appropriate insurance or are seriously underinsured. This is partly due to ignorance of the consequences of failure to indemnify themselves against potential disasters, and partly due to the notion that insurance is expensive. Unfortunately, we've all heard too many stories that demonstrate just how *inexpensive* insurance really is when something totally unexpected occurs. Insurance is the second most important expense after the rent or mortgage.

Most photographers appear to consider only two of the many facets of insurance issues. These are errors-and-omissions insurance and equipment insurance. However, there are other risks that can be far more damaging to our financial well-being—liability, personal injury, worker's compensation, property damage, etc. If you drop your camera, your loss is easily calculable. However, when damage is done to another person's property, or when injury occurs, the eventual cost may far exceed your expectations. If it is not covered by insurance, it could potentially bankrupt you. The victim of such an incident is very likely to issue suit, or his or her own insurers will do so. Therefore, your coverage should be based on the replacement value of any item that may be lost or damaged and not on the actual value of the item at the time of loss or damage. This type of coverage is obviously more expensive, but it is more than worth the additional cost.

Fire and flood are also areas that should be covered—and both of these are insurable, although under-writers may be difficult to find in certain flood-plain areas. A burst water pipe or fire in your rented or owned space may not be expensive to repair, but keep in mind that these situations can also affect those property owners or businesses around you, increasing the cost to a level where your insurance is not sufficient. The last thing you need is for third parties to come to you for compensation that may cause you to go out of business. Again, adequate coverage is imperative.

When damage is done to another person's property, or when injury occurs, the eventual cost may far exceed your expectations.

Keep in mind that when you are not on your own property, you also have obligations in the event that damage is caused to a person or their property. As such, there will be times when the owner of a property will require you to produce a certificate of insurance before allowing you to work on that property.

WHERE TO GET INSURANCE

Most professional photography associations have access to group coverage, and this is a good place to start the process (or to revise what you currently have), since these group policies are specialized for the field of photography and its related liabilities. In addition, these organizations are usually able to negotiate group policies based on their membership numbers. If you prefer, you can also consult a reputable insurance company or broker. Make sure that you have the right amount of coverage, and be sure to schedule an annual review to make sure your coverage remains adequate.

UMBRELLA COVERAGE

Anyone in business should obtain what is commonly referred to as "umbrella" coverage. This will not only cover equipment loss and damage, it will include third-party property damage, personal injury to a third party, fire and theft, and, depending on your location, flood damage. In 2001, it was estimated that anyone in business with business assets of up to $100,000 should have umbrella coverage of at least $1.5 million. You can add a percentage equal to the rate of inflation for each year thereafter.

However, at the time of this writing, the cost of insurance had risen dramatically due to terrorism and the high cost of settling claims—especially in the area of equipment, because photographers have managed to lose a record number of cameras. Additionally, due to its recent cost, many insurers have left the equipment insurance market.

> If you do not have the insurance and an employee is injured, you will find yourself paying his or her medical bills for the injury.

This umbrella insurance must be purchased in addition to errors and omissions coverage, which is discussed below. Not having this type of coverage may well be ruled irresponsible when adjudicated by a court, and any personal assets you may have in addition to your photography-business assets may be lost in order to meet the costs of settlement.

WORKER'S COMPENSATION

Additionally, worker's compensation insurance may be obligatory in your state. If it is required and you are an employer of one or more workers (even part-timers) and do not have it, you will be in violation of the law. Worse still, if you do not have the insurance and an employee is injured, you will find yourself paying his or her medical bills for the injury.

ERRORS AND OMISSIONS COVERAGE

Errors and omissions coverage is a serious insurance issue. Failure to produce the desired images in situations that would be seen as inexcusable or due to failure of equipment can lead to crippling lawsuits. Coverage for such circumstances is not easy nor is it inexpensive. When you research your options, you may find that there are two available to you: genuine insurance and a trust fund. If you decide to rely on a trust fund, you should be aware of its limitations.

A trust fund has severe financial restrictions due to the fact that its resources are limited by the funds paid in by association members or other relatively small groups. There are laws that control what trust fund administrators are able to do with the fund, which generally requires the fund to be protected from inappropriate investments. Essentially this means that the fund is relatively static and does not generate the kind of capital needed to meet the demands that an insurance company is able to meet. Therefore, a trust fund administration will likely limit its assistance to legal representation and assistance at arbitration. Additionally, in order to protect the trust fund from a heavy demand, even this assistance will likely be limited, requiring you to accept the fund attorney as your proxy and to accept whatever settlement they negotiate. In the event that the fund attorney has no option but to agree to a settlement, you will be responsible for meeting the settlement amount. Therefore, before you rely on a trust fund to meet your potential errors and omissions liability, you should study the terms and rules by which the fund is controlled and what you may expect from it. You will probably find that, in fact, there is no liability by the fund to meet the demand of any agreed or adjudicated settlement. This does not mean that the fund's lawyers may not be of valuable assistance in the event of a lawsuit; their attorneys may well be able to persuade a plaintiff to withdraw his or her suit or settle for a nominal amount that will not hurt your bank balance. It may even be possible to use both the trust fund administration and your insurance to fend off or settle the lawsuit.

As of this writing, we know of only one errors and omissions insurance. This is administered by Hill and Usher and is underwritten by The Hartford and is available to members of Wedding & Portrait Photographers International (WPPI). You can contact WPPI by writing to them at 1312 Lincoln Boulevard, Santa Monica, CA, 90401, or via their website, www.wppinow.com.

16. PROTECTION OF MINORS

When working with children, special considerations need to made to ensure that the session is conducted in a safe environment and with appropriate protections for the child's well-being. This starts by having a chaperone present but also includes ensuring the toys you provide are safe, that any treats you hand out are approved by the parents, and that children do not have access to dangerous equipment or wires.

CHAPERONE

It is important that when we work with minors, especially children under fifteen, we have a parent or guardian (or an appointed chaperone) present during the photography session to represent the child's interests. Additionally, circumstances may arise during a minor's photography session that require the attention of a parent or guardian. For example, if a child should become ill and require the attention of a paramedic or a physician, or in case of a minor injury, the guardian or chaperone should be responsible for requesting such services. Except in emergency situations, it is unwise for the photographer to independently seek medical attention, as there is potential for a lawsuit if something goes wrong.

Having a chaperone present also acts as protection against the possibility that the actions or behavior of the photographer may be misinterpreted, misunderstood, or misreported. Obviously, the vast majority of photographers have no interest in creating images that would exploit a child or be considered in bad taste, but the very suggestion that something inappropriate had taken place would create an untenable environment for the photographer to continue practicing. Things that are said or done in a photography session (such as touching the child to adjust posing) may be completely misinterpreted and retold in such a way that a wary parent or guardian is led to believe that it was inappropriate. There is no release or waiver that can be made to cover this—no matter how innocent or innocuous the statement or action may have been. Therefore, the presence of a chaperone (preferably an adult who clearly has the minor's interests at heart) is as much for our own protection as for the protection of the minor.

Having a chaperone present acts as protection against the possibility that the actions of the photographer may be misinterpreted . . .

This is particularly important when the subject of the photography is female and the photographer is male, because what is said and done can more readily lead to unexpected problems. This is also possible, but less likely, when the photographer is female and the subject male. For these sessions, having a parent or guardian present is nothing more than common sense.

SWEETS

It is not uncommon for studios to have some kind of sweets (like cookies or candy) available for children. At first sight, this is perfectly reasonable. What is important is that, before such items are given to children, the parent or guardian should be asked if this is acceptable. You can imagine the repercussions if you inadvertently provide a sugar-loaded product to a diabetic child. Apart from the medical issues, a parent may simply not wish the child to have candy for a variety of reasons, so what appears to be an act of kindness may result in an issue of concern.

TOYS

In our studio, we have traditionally had a box of toys that small children visiting us for the second or third

time immediately run to. It has always been regarded a little reward for their cooperation, and it also helps reaffirm that coming to our studio is a pleasant and friendly event. These toys and children's items have always been very carefully selected for their safety.

Should you decide to provide toys for children, you must be extremely careful to ensure that they are childsafe. If you give a small child a toy and an injury of any kind results, you may find yourself defending a suit for personal injury that may not be covered by your umbrella insurance.

EQUIPMENT HAZARDS

When exploring a new environment, many children are quite adventurous and bold—and they can get into places you'd never imagine! Therefore, it is very important to make sure that all wires, cables, tripods, and other equipment are secured in such a way that they do not create a potential hazard for children. While you may have public liability insurance, negligence may well result in legal complications. This is covered in further detail in the next chapter.

17. SAFETY AND LIABILITY

No amount of insurance can protect you if you are negligent and fail to take reasonable precautions to protect your employees and the clients who visit your studio. This includes everything from shoveling your sidewalks to ensuring that darkroom chemicals are handled correctly.

Don't pretend that a lawsuit can't happen to you. We live in a society where, for some unscrupulous people, even a simple accident has to be someone else's fault. When they trip and fall, it's likely that they will seek to blame someone else, rather than accept that they were careless.

There are also lawyers out there whose entire practice is focused on creating suits for compensation that goes far beyond reason. You will, no doubt, recall the lady who sued an international fast-food franchise when she carelessly spilled hot coffee in her lap.

SAFETY

Even if there weren't issues of liability involved, most of us would take the time to ensure our studio is safe for our clients, our employees, and ourselves. Still, there are things that we may just choose to overlook because they don't seem too important—like precariously stacked props, uneven sidewalks, etc. A single incident, however, can be damaging, so take some time to evaluate your studio for potential hazards—and do so on a regular basis.

Make sure that there are no items in or around your studio that might fall and create an incident or cause injury—or that may cause someone to trip or fall. Check that cables, tripods, light stands, etc., are not placed where people are likely to trip on them—or knock them over and cause equipment to fall and injure someone. If cables and wires must cross areas where people walk, they should be securely taped down. Also, make sure that any equipment stored on shelves is properly secured. You might even have someone walk through your operation with you and seek their opinion as to the potential dangers.

If any of these things could be considered negligent on your part, then you may well find yourself facing legal repercussions.

CHEMICALS

Traditionally, photographers have used chemicals and other processes that are now restricted or prohibited. OSHA (the Occupational Safety and Health Association) does not allow you to use contaminating chemicals or processes. You are not permitted to dump or allow certain substances to leak or drain into the sewage system or dispose of such in the common disposal systems. Photographic chemicals, for instance, may be required to be stored for disposal and then collected by a contractor. Certain spraying processes are restricted, even if you are using a spray tent.

Disobeying them can lead to very serious consequences, including fines—and possibly having your business closed down.

These laws and rules are designed to protect the health of your employees, customers, and the public. Disobeying them can lead to very serious consequences, including fines—and possibly having your business closed down.

Most cities will require you to complete a questionnaire before granting you a permit to commence business. If you have been operating for a period of time and have developed your business in such a way that you now need to use any of the above restricted chemicals and sprays, you should first discover what your local authority will or will not permit. You are strongly

advised not to indulge in any of the prohibited processes in the belief that you will not be found out.

NONCOMPLIANCE

Earlier, we discussed insurance. Be advised that you cannot insure yourself against the consequences of breaking the law. Additionally, if you are careless and allow practices that may endanger your employees or members of the public, you may find that you have not complied with the terms of your insurance. No one wants to read all the fine print in their insurance policies, but you should be aware of the exclusions and waivers. Carelessly breaking either the law or the provisions of your insurance policy may cause you not to be covered, your policy rate to increase, or, worse still, your policy to be canceled.

18. CONTRACTORS AND COLLABORATORS

From time to time (or in some cases, on an ongoing basis) studios need the services of photographers who are not permanent employees. These photographers may be needed to cover sessions during high-volume seasons, to cover for another photographer who becomes unavailable to complete an assignment, or to meet the special needs of an individual client. When this occurs, spelling out the relationship between the studio and the contracted photographer is extremely important.

SUBCONTRACTORS
Studios or photographers who subcontract with others to photograph weddings, portraits, or any other photography work should have a work-for-hire contract with the subcontractor. This is a contract very few ever consider, yet it is critical to establishing the ownership of the images created by the subcontractor. Without a work-for-hire contract, the subcontractor can claim all rights to the images he creates, and the contracting photographer may be restricted in how the images are used, sold, or produced.

The relationship between the contractor and the subcontractor may appear to be very simple—and perhaps you have been doing it for years without any problems. However, when you hire a photographer to photograph a wedding and you have only a verbal agreement, the rights of both parties are open to dispute. Additionally, any legal precedents existing in the state in which the photography is undertaken may apply, and both parties may be limited therein.

Even if you are both clear about the purpose of the photography to be subcontracted, any other use of the photography is not legally permitted. If the photogra-

phy is for a wedding and the opportunity arises to sell the images for another purpose, even with the written consent of the client, the subcontractor can legitimately claim all rights to such sale or use. If you sell the images for $1,000, the subcontractor can claim that amount as his. He could even claim that the image was actually worth *more* and demand compensation in excess of the amount of the sale! You can see how messy this can be.

When you hire a photographer to photograph an assignment, he will probably review your fees to the client before determining whether to accept your proposed payment to him for completing the assignment. But what if you increase the fees to the client? This could happen for any number of reasons—perhaps because the subcontractor worked longer hours on the job, or because he shot additional film, or traveled farther than originally agreed. In any one of these instances, the subcontractor could legitimately claim that part or all of these charges to the client are rightfully his.

When you hire a photographer to photograph a wedding and you have only a verbal agreement, the rights of both parties are open to dispute.

Your work-for-hire contract will include your right of use for any and all images created by the subcontractor, at your discretion and for whatever purpose deemed appropriate by you.

The contract will describe the responsibilities of the subcontractor and the agreed fee to be paid to him for the photography. If the subcontractor is to interview

the client prior to the photography, then this should be included in the contract.

The contract will also state who is to provide the film and equipment required for the photography. This is an important element within the contract. If you require the subcontractor to provide certain photography but do not specify who is to provide the necessary equipment, then you are responsible for omissions if the equipment is not available on the assignment.

Another issue is the relationship between the subcontractor and the client. There have been instances in which the subcontractor has made contact with the client after the photography and after the delivery of the finished work in an endeavor to solicit work for his own business. Subcontractors have also been known to solicit work at a subcontracted assignment by handing out their own business cards and soliciting wedding assignments from engaged couples attending the wedding that is being photographed. This means the contract should incorporate restrictions on the subcontractor. This can be done in such a way as to not impair the relationship between the contractor and subcontractor.

The contract will also state when and how payment is to be made. Some contracting photographers have refused to pay the agreed fee to the subcontractor at the time the film was delivered to them, asserting their right to see if there were any images on the processed film. In other cases, the subcontractor refused to hand over the film without payment of the agreed fee.

A contract that is created to lock in the services of an operator must also guarantee payment, even if there is no assignment for that date.

Additionally, any agreed-upon commissions (and when they are to be paid) for sales above and beyond the original photography should also be included in the contract. In this regard, it is important to keep good records of such sales for review by the subcontractor. These records need to be provided in a proper manner so that there can be no misunderstanding and so that the terms of the contract are met.

Right to Work. Many studios seek to contract freelance and subcontracting photographers to long-term agreements. Some are designed to have the sub-

contractor exclusively available to the contracting photographer for a specific period, for specific dates, or for a certain day of the week. These contracts are used to assure the high-volume studios that they will have a very competent photographer available for any booking they may obtain.

This type of agreement or contract needs to be carefully worded and must protect both parties equally. An agreement that is too one-sided may be voided. No contract can hold a non-employed photographer to exclusive use by a contractor unless the subcontractor is remunerated for all the dates within the agreement. Several of the agreements I reviewed locked in the subcontractor to a list of dates with the only reference to remuneration being what would be paid when the subcontractor photographed an assignment. The contract made no reference to dates on which the subcontractor did not have an assignment. Neither did these contracts allow for the subcontractor to accept assignments from another studio when the contractor to whom he was committed did not assign him.

Assume the following scenario: The contractor fails to assign the subcontractor an event for a given date. Two weeks prior to the assumed-vacant date, the subcontractor accepts an assignment from a competitor of the contractor. One week prior to the given date, the contractor suddenly finds he needs the subcontractor to fill a void he had not allowed for—only to find he is not available. The contractor is infuriated for two reasons. First, he does not have the coverage he assumed he had guaranteed and, second, he finds the subcontractor is working for a competitor. Consider the ramifications of this situation.

No contract may prevent one of the signers from obtaining employment for any given date. A contract that is created to lock in the services of an operator must also guarantee an agreed payment, even if there is no assignment for that date. Otherwise, the contract is unlawful. Essentially, such a contract would be limiting the subcontractor's right to work. No freelance operator should consider signing an agreement or contract in which there is no guarantee of payment for all of the dates referred to in the contract.

No studio should attempt to limit the ability of the subcontractor to obtain alternate assignments for dates not being paid by the studio. The contract should also

be clear as to the remuneration to the subcontractor in exchange for the guarantee of this exclusivity.

Another element within this contract is one in which the contractor may release the subcontractor to accept assignments elsewhere when he has knowledge that a given date will be without an assignment. Such a release should allow adequate time for the subcontractor to find alternate employment for the given date. It is recommended that notice be given at least 60 days prior to the date, or the contracting studio will be obligated to pay for that date.

It is also recommended that the contract should limit the contracting studio to a maximum number of dates that may be released (preventing the studio from signing on the subcontractor, then cancelling all of the contracted dates). If there is no set limit, then the contract will have no integrity.

Right of Portfolio. Every one of us has the right to create a résumé of how we have come to be what we are. For the office worker, it is a list of employment situations with appropriate references that provide a guide to future employers. For the photographer, it is a portfolio of his work that indicates his ability to meet desired standards. However, many studios refuse the right of their subcontractors to obtain copies of images they have created in fulfilling their assignments.

This is morally wrong and also may be judged as a restrictive practice if tried in a court of law. It is recommended that all work-for-hire contracts permit the subcontracting photographer to obtain a limited number of prints from any and all assignments in order to create a professional portfolio. The contract may make this available as part of the remuneration or at a cost to the photographer. If it is included as part of the remuneration, the amount designated for each print should not

exceed the actual cost of the prints plus 10 percent. In any legal dispute, such a minimal charge would not be considered excessive or prohibitive; it would be termed a professional courtesy, which would be ethical and morally acceptable.

The contract on pages 104–6 is suitable.

INDEPENDENT CONTRACTORS

There is a difference between a subcontractor and an independent contractor that needs to be noted. With a subcontractor, you are able to dictate exactly what you need to be done and require it to be done in a particular style with definitive guidelines. Additionally, you can exclude the subcontractor from soliciting business from the client for whom his services are being provided. An independent contractor would not be limited to such terms and may, due to the expanse of the contract, be permitted to subcontract to others in order to complete the assignment.

Many studios refuse the right of their subcontractors to obtain copies of images they have created in fulfilling their assignments . . .

With a subcontractor, the contracting photographer is responsible and liable for any failures or misrepresentations by the subcontractor. In the case of an independent contractor, on the other hand, these liabilities fall on the contracted photographer. While the situation is not without possible legal repercussions, it does allow you to reduce the potential liabilities you would face if doing the job yourself.

On pages 107–8 is a draft of the recommended agreement.

PHOTOGRAPHER–SUBCONTRACTOR AGREEMENT

THIS AGREEMENT is made this _____ day of _____, 20___, between _____

_____, an _____ corporation (hereinafter called the "Studio"), and

_____, (hereinafter called the

"Photographer").

WITNESSETH

WHEREAS, the Studio has entered into a contract (hereinafter called the "General Contract") with _____

_____ (hereinafter called the "Owner") to provide photography

services as per plans, specifications, and general conditions incorporated therein, and these are made a part hereof and

incorporated herein by reference, the same as if fully set out herein, and

WHEREAS, the parties desire to provide this Agreement for the performance by the Photographer on behalf of the

Studio, and all the Studio's obligations under said General Contract in connection with the work hereinafter specified, or

provided for.

NOW THEREFORE, for and in consideration of the covenants and agreements herein contained and of the payments

hereinafter provided to be made by the Studio to the Photographer, the parties do hereby agree as follows:

1. ASSUMPTION OF OBLIGATIONS. The Photographer has examined the General Contract, with the Owner or rep-

resentative, for the photography, and that he and his employees or subcontractors will be and are bound by any and all parts

of said General Contract insofar as they relate in any part or in any way to the work undertaken herein, and shall be fur-

ther bound to the general and special conditions of the specifications. The Photographer also has thoroughly familiarized

himself with the photography matters and conditions which will affect the completion of said work and he assumes all risks

therefrom.

2. DUTIES OF THE PHOTOGRAPHER. The Photographer shall furnish and pay for all labor, materials, tools, supplies,

equipment, transportation, insurance, and services necessary to complete in a workmanlike manner all the photography

included in this Agreement, namely:

Type of contract: _____

Division of work: _____

Scope of work: _____

Contract amount: _____

Special conditions: _____

and shall do everything else necessary to fully perform all of the Studio's obligations under the General Contract in refer-

ence to said work.

3. TIME AND MANNER OF WORK. That time is of the essence in this Agreement.

4. DEFAULT AND REMEDIES. If the Photographer shall fail to complete the photography in a workmanlike manner due

to Photographer's tardiness, lack of equipment, or supplies, then the Studio may withhold any or all of the compensation

due the Photographer. Should the Photographer's compensation not be sufficient to cover the amount of the loss, then the

Photographer shall be responsible to pay, and hold the Studio harmless from, the amounts claimed by the Owner under the

General Contract.

5. ASSIGNMENT. The Photographer shall not sell, assign, sublet, transfer, or set over this Agreement or any part there-

of or any money due or to become due hereunder without the written consent of the Studio. In case such consent is given,

it shall not relieve the Photographer from any of the obligations of this Agreement, and any transferee or the Photographer

shall be considered the agent of this Photographer and, as between the parties hereto, the Photographer shall be and remain

liable as if no such transfer had been made. Any assignment made in violation hereof shall not be binding on the Studio.

6. INDEMNIFICATION. The Photographer shall indemnify and save harmless the Studio from and against any and all loss, liability, damages, costs, attorneys' fees, or other expense incidental thereto of every kind and nature whatsoever on account of any claim or claims for death or injury to persons employed by the Photographer if any, his agents or employees, or any of them; or for claim or claims for injuries or death caused by them or either of them; or for loss, damage to, or destruction of property, real or personal, including loss of use thereof.

7. INSURANCE. The Photographer shall furnish, at the Photographer's expense, prior to commencing upon the performance of this Agreement, and keep in full force and effect during the Photographer's performance thereof, the following insurance: (A) Worker's compensation insurance in a form satisfactory to the Studio and meeting the requirements, if any, of the state in which the work is to be prosecuted and sufficient to cover the Photographer's maximum liability under the applicable so-called worker's compensation; (B) Public liability insurance with limits of not less than $2,000,000 for injury to or death of one person and $5,000,000 for injury or death arising out of one occurrence; (C) Property damage insurance with limits of not less than $500,000 for each occurrence and $1,000,000 aggregate; and (D) Automobile and other motor vehicle public liability insurance with limits of not less than $2,000,000 for injury to or death of one person, $5,000,000 for bodily injuries or deaths arising out of one occurrence and $1,000,000 for damage to property.

The Photographer agrees to obtain a so-called contractual liability endorsement to the policies referred to in subparagraphs 7(B) and 7(C) whereby the insurers shall insure the Photographer's obligations under Paragraph 6 above. The Photographer agrees to furnish said insurance with companies satisfactory to the Studio (except in cases where worker's compensation insurance is required to be insured under so-called "state fund" provisions) and to obtain and deliver to the Studio a certificate issued by the respective insurer showing said insurance to be in effect and providing that same may not be cancelled without ten (10) days' written notice to the Studio. If the Photographer fails to carry any insurance herein provided for, the Studio may procure same and charge the cost thereof to the Photographer, but the Studio shall not be required to obtain such insurance.

8. CHANGES IN WORK. The Studio, at any time before the start of the work, may order additions, omissions or alterations to or in the said work, materials, or equipment, but no such changes shall be made except by a written order signed by the Studio in which the additional amount to be paid by it therefore, or to be deducted from the amount paid to the Photographer, together with additional time, if any, for the performance thereof, shall be stated.

9. OWNERSHIP. All images photographed under this Agreement are owned by the Studio and not the Photographer. The Photographer shall make no claim as to ownership of said images. The Photographer agrees to deliver all negatives, digital images, images, and any and all media which contain images or prints of the photography. The Photographer agrees not to make a claim as to ownership and copyright of said photography and its images. The Photographer agrees that payment shall be withheld under this Agreement until all images, media, negatives, and any and all other items are delivered to Studio.

10. DISPUTES. All disputes concerning questions of fact arising under this Agreement shall be decided by the Studio, subject to written appeal by the Photographer within seven (7) days to the Studio, who in turn will submit said appeal to the Owner or his representative, whose decision shall be final and conclusive upon the parties hereto. In the event the dispute does not involve the Owner or its representative the settlement of the dispute shall be made in accordance with the Standard Form of Arbitration Procedure as issued by the American Association of Arbitration.

11. PAYMENT. The Studio shall pay the Photographer the sum of $_____, subject to additions and deductions as hereinbefore provided, in full and complete compensation for all work performed and all things furnished hereunder. Payments on account of said sum shall be made upon the final completion and acceptance by the Owner's designated representative of all work to be performed hereunder.

12. PAYMENT OF TAXES. The Photographer shall pay, at his expense, direct to the governing body, all sales taxes, use taxes, occupational taxes, excise taxes, old-age benefit, unemployment compensation taxes, or similar levies on all material, labor, tools, and equipment furnished under this Agreement, as required by the statutes of the United States, or of any state or the statutes or ordinances of any municipality which are applicable to any transaction in connection with the Photographer's work. All such taxes or levies are included in the Photographer's price and are to be paid by the

Photographer. Any records maintained by the Photographer pertaining to the taxes and levies itemized in this paragraph shall be available to the Studio or his designated representative, or to the legal agent or representative of any of the taxing bodies.

13. TERMINATION OF GENERAL CONTRACT. In the event of the termination of the General Contract between the Studio and the Owner, this Agreement shall also be terminated, upon written notice by the Studio to the Photographer, and the Studio shall only be liable for labor and materials furnished up to the date of receipt of the written notice of termination and/or materials specifically fabricated for this Agreement.

14. GENDER. The word "he" when used herein shall include both singular and plural number and masculine, feminine and neuter genders, as may be appropriate.

15. SUFFICIENCY OF DOCUMENTS. The Subcontractor hereby specifically acknowledges and declares that said contract documents are full and complete, are sufficient to have enabled the Photographer to determine the cost of the work in order to enter into this Contract.

16. BINDING EFFECT. This Agreement shall be binding upon and inure to the benefit of the respective heirs, executors, administrators, successors and assigns of the parties hereto.

17. ENTIRE AGREEMENT. This Agreement constitutes the entire agreement between the parties and all previous agreements and negotiations, whether oral or written, relating to the subject matter herein are merged herein and, except as herein stated, are declared to be null and void. If there is any conflict between the provisions of this Agreement and the General Contract, the provisions more onerous to the Photographer shall control and anything herein required of the Photographer not required of the Studio by the General contract shall nevertheless be the obligation of the Photographer to the Studio hereunder.

18. EFFECTIVE DATE. It is the intention of the parties to this Agreement that all the provisions of the Agreement apply from the commencement of any work by the Photographer regardless of the date of signing of this Agreement.

IN WITNESS WHEREOF, the parties hereto executed this Agreement the day and year first above written.

Studio: _____

By: _____

Photographer: _____

By: _____

Attest: _____ (Secretary)

Attest: _____ (Secretary)

PHOTOGRAPHER–INDEPENDENT CONTRACTOR AGREEMENT

THIS AGREEMENT is made this _____ day of _____, 20_____, between _____

_____, an _____ corporation (hereinafter called the "Studio"), and

_____, (hereinafter called the "Contractor").

WITNESSETH

　　WHEREAS, the parties desire to provide this Agreement for the performance by the Contractor on behalf of the Studio and all the Studio's obligations under said General Contract in connection with the work hereinafter specified, or provided for.

　　NOW THEREFORE, for and in consideration of the covenants and agreements herein contained and of the payments hereinafter provided to be made by the Studio to the Contractor, the parties do hereby agree as follows:

1. DUTIES OF THE CONTRACTOR. The Contractor shall furnish and pay for all labor, materials, tools, supplies, equipment, transportation, insurance, and services necessary to complete in a workmanlike manner all the work included in this Agreement, namely:

　　Type of contract: _____

　　Division of work: _____

　　Scope of work: _____

　　Contract amount: _____

　　Special conditions: _____

and shall do everything else necessary to fully perform.

　　2. TIME AND MANNER OF WORK. That time is of the essence in this Agreement.

　　3. DEFAULT AND REMEDIES. If the Contractor shall fail to complete the photography in a workmanlike manner due to the Contractor's tardiness or lack of equipment or supplies, then the Studio may withhold any or all of the compensation due the Contractor. Should the Contractor's compensation not be sufficient to cover the amount of the loss, then the Contractor shall be responsible to pay, and hold the Studio harmless, from the amounts claimed.

　　4. ASSIGNMENT. The Contractor shall not sell, assign, sublet, transfer, or set over this Agreement or any part thereof, or any money due or to become due hereunder, without the written consent of the Studio. In case such consent is given, it shall not relieve the Contractor from any of the obligations of this Agreement, and any transferee or Contractor shall be considered the agent of this Contractor and, as between the parties hereto, the Contractor shall be and remain liable as if no such transfer had been made. Any assignment made in violation hereof shall not be binding on the Studio.

　　5. INDEMNIFICATION. The Contractor shall indemnify and save harmless the Studio from and against any and all loss, liability, damages, costs, attorneys' fees, or other expense incidental thereto of every kind and nature whatsoever on account of any claim or claims for death or injury to persons, if any, employed by the Contractor, his agents or employees, or any of them; or for claim or claims for injuries or death caused by them or either of them; or for loss or damage to or destruction of property, real or personal, including loss of use thereof.

　　6. CHANGES IN WORK. The Studio, at any time before start of the work, may order additions, omissions, or alterations to or in the said work, materials, or equipment, but no such changes shall be made except by a written order signed by the Studio in which the additional amount to be paid by it therefore or to be deducted from amount paid to the Contractor, together with additional time, if any, for the performance thereof, shall be stated.

　　7. RELATIONSHIP OF PARTIES. The Studio and the Contractor agree that the Contractor is an independent contractor. This Agreement is not an employment agreement or a subcontractor agreement, nor does it constitute a joint venture

or partnership between the Studio and the Contractor. Nothing contained herein shall be construed to be inconsistent with this independent contractor relationship.

8. OWNERSHIP. All images photographed under this Agreement are owned by the Studio and not the Contractor. The Contractor shall make no claim as to ownership of said images. The Contractor agrees to deliver all negatives, digital images, images, and any and all media which contain images or prints of the photography. The Contractor agrees not to make a claim as to ownership and copyright of said photography and its images. The Contractor agrees that payment shall be withheld under this Agreement until all images, media, negatives, and any and all other items are delivered to the Studio.

9. DISPUTES. All disputes concerning questions of fact arising under this Agreement shall be decided by the Studio, subject to written appeal by the Contractor within seven (7) days to the Studio. In the event the dispute is not resolved by the Studio the settlement of the dispute shall be made in accordance with the Standard Form of Arbitration Procedure as issued by the American Arbitration Association.

10. PAYMENT. The Studio shall pay the Contractor the sum of _____ dollars ($_____) subject to additions and deductions as hereinbefore provided, in full and complete compensation for all work performed and all things furnished hereunder. Payments on account of said sum shall be made upon the final completion of all work to be performed hereunder.

11. TERMINATION. In the event the photography which is the issue of this agreement is terminated, this Agreement shall also be terminated upon written notice by the Studio to the Contractor.

12. GENDER. The word "he" when used herein shall include both singular and plural number and masculine, feminine, and neuter genders, as may be appropriate.

13. SUFFICIENCY OF DOCUMENTS. The Contractor hereby specifically acknowledges and declares that said contract documents are full and complete, and are sufficient to have enabled the Contractor to determine the cost of the work in order to enter into this Contract.

14. BINDING EFFECT. This Agreement shall be binding upon and inure to the benefit of the respective heirs, executors, administrators, successors, and assigns of the parties hereto.

15. ENTIRE AGREEMENT. This Agreement constitutes the entire agreement between the parties and all previous agreements and negotiations, whether oral or written, relating to the subject matter herein are merged herein and, except as herein stated, are declared to be null and void. If there is any conflict between the provisions of this Agreement and the General Contract, the provisions more onerous to the Contractor shall control and anything herein required of the Contractor not required of the Studio by the General Contract shall nevertheless be the obligation of the Contractor to the Studio hereunder.

16. EFFECTIVE DATE. It is the intention of the parties to this Agreement that all the provisions of the Agreement apply from the commencement of any work by the Contractor regardless of the date of signing of this Agreement.

IN WITNESS WHEREOF, the parties hereto executed this Agreement the day and year first above written.

Studio: _____ Contractor: _____

By: _____ By: _____

Attest: _____ (Secretary) Attest: _____ (Secretary)

CONTRACTING OUT

With the agreement of their client, many photographers wish to contract out assignments and accept an assignment fee or commission from the photographer who agrees to accept the job. This is usually done in a situation in which the original photographer has been servicing a valuable client and wants to retain them without providing a particular service. This may be a matter of the original photographer being insufficiently expert in the type of work needed, or unable to fulfill his obligation due to the loss of an employee or other subcontractor for whom a replacement cannot be found.

The contracted photographer who accepts the assignment agrees to provide a service to the client as specified by the original photographer and to be wholly responsible to the client (rather than to the original contracting photographer). This means that the original photographer signs the client to a contract that specifies the service, while the contracted photographer controls the production and disbursement of the photography and retains the copyright. Obviously, there has to be a special trust between the two photographers for this to work.

Because the client is the primary beneficiary of the arrangement, the original photographer needs to ensure that the client receives the service agreed in the contract. Therefore, the contract between the original photographer and the contracted photographer is as much a matter of assurance to the client as it is to the contracting photographer. When contracting out, keep in mind that a bad recommendation or reference reflects adversely on you, the original photographer.

This contract will relate to the contracted photographer the terms of the original contract and the services agreed within it. Additionally, the contract will specify how any fees or retainers, deposits, etc., are to be either passed on to the new photographer or to be held by the original contractor. Essentially, this is a contract in which the terms are set out for transferring the client's contract to another party.

INSURANCE

Neither contracting out nor subcontracting (such as work-for-hire agreements) exempts the original contractor from liability, so long as the original contractor remains responsible to the client. When the original contracting studio or photographer still holds the primary contract with the client, any liability for errors or omissions, property damage, or personal injury remains part of that contract. It is, therefore, important that you either arrange for appropriate coverage by your insurance or ensure that the subcontractor has the appropriate certificate of coverage. It is foolhardy to allow a third party to represent you on an assignment without insurance.

It is not uncommon for a contractor to sign a contract that requires appropriate insurance and then fail to purchase the coverage.

It is not enough to state within the subcontract or work-for-hire agreement that the subcontractor is required and obligated to properly insure against potential liability. After all, it is not uncommon for a contractor to sign a contract that requires appropriate insurance and then fail to purchase the coverage. It is therefore important that you not only *see* the actual certificate but also have a copy of it on file.

You may also be asked for a copy of your insurance certificate in order to operate at certain venues. When this is the case, a copy of both your own and the subcontractor's insurance certificate should be available. Consult your insurance broker with regard to this kind of coverage.

PHOTOGRAPHER–CONTRACTOR AGREEMENT

THIS AGREEMENT is made this _____ day of _____, 20__, between _____, an
_____ corporation (hereinafter called the "Studio"), and _____
_____, (hereinafter called the "Contractor").

WITNESSETH

 WHEREAS, the parties desire to provide this Agreement for the performance by the Contractor on behalf of the Studio and all the Studio's obligations under said General Contract in connection with the work hereinafter specified, or provided for.

 NOW THEREFORE, for and in consideration of the covenants and agreements herein contained and the referral of the photography the Parties agree as follows:

1. DUTIES OF THE CONTRACTOR. The Contractor shall furnish and pay for all labor, materials, tools, supplies, equipment, transportation, insurance, and services necessary to complete in a workmanlike manner all the work included in this Agreement, namely:

 Type of Contract: _____

 Division of Work: _____

 Scope of Work: _____

 Contract Amount: _____

 Special Conditions: _____

and shall do everything else necessary to fully perform.

 2. TIME AND MANNER OF WORK. That time is of the essence in this Agreement.

 3. DEFAULT AND REMEDIES. If the Contractor shall fail to complete the photography in a complete workmanlike manner due to the Contractor's tardiness, lack of equipment or supplies, and the Studio needs to defend itself against the client who is the subject of the photograph, then the Contractor shall be responsible to pay and will hold the Studio harmless from the amounts claimed, including court costs, attorneys' fees, filing fees, and expert witness fees.

 4. INDEMNIFICATION. The Contractor shall indemnify and save harmless the Studio from and against any and all loss, liability, damages, costs, attorneys' fees, or other expense incidental thereto of every kind and nature whatsoever on account of any claim or claims for death or injury to persons, if any, employed by the Contractor, his agents, or employees, or any of them; or for claim or claims for injuries or death caused by them or either of them; or for loss or damage to or destruction of property, real or personal, including loss of use thereof.

 5. RELATIONSHIP OF PARTIES. The Studio and the Contractor agree that the Contractor is an independent contractor. This Agreement is not an employment agreement or a subcontractor agreement, nor does it constitute a joint venture or partnership between the Studio and Contractor. Nothing contained herein shall be construed to be inconsistent with the intent of this Agreement, which is to be nothing more than a referral of photography from the Studio to the Contractor.

 6. OWNERSHIP. All images photographed under this Agreement are owned by the Contractor.

 7. DISPUTES. All disputes concerning questions of fact arising under this Agreement shall be decided by the Studio, subject to written appeal by the Contractor within seven (7) days to the Studio. In the event the dispute is not resolved by the Studio the settlement of the dispute shall be made in accordance with the Standard Form of Arbitration Procedure as issued by the American Arbitration Association.

 8. TERMINATION. In the event of the termination of the photography which is the issue of this agreement, this Agreement shall also be terminated upon written notice by the Studio to the Contractor.

9. GENDER. The word "he" when used herein shall include both singular and plural number and masculine, feminine, and neuter genders, as may be appropriate.

10. BINDING EFFECT. This Agreement shall be binding upon and inure to the benefit of the respective heirs, executors, administrators, successors, and assigns of the parties hereto.

11. ENTIRE AGREEMENT. This Agreement constitutes the entire agreement between the parties, and all previous agreements and negotiations, whether oral or written, relating to the subject matter herein are merged herein and, except as herein stated, are declared to be null and void. If there is any conflict between the provisions of this Agreement and the General Contract, the provisions more onerous to the Contractor shall control and anything herein required of the Contractor not required of the Studio by the General Contract shall nevertheless be the obligation of the Contractor.

12. EFFECTIVE DATE. It is the intention of the parties to this Agreement that all the provisions of the Agreement apply from the commencement of any work by the Contractor regardless of the date of signing of this Agreement.

IN WITNESS WHEREOF, the parties hereto executed this Agreement on the day and year first above written.

Studio: _____ Contractor: _____

By: _____ By: _____

Attest: _____ (Secretary) Attest: _____ (Secretary)

COLLABORATION WITH OTHER PHOTOGRAPHERS

Sometimes, an assignment or a contract requires us to seek the assistance of another photographer. When subcontracting or contracting out will not meet the terms of both parties, then a collaboration agreement is required. Just as in a work-for-hire contract or a subcontract, it is important that the respective obligations of the collaborators be clearly defined.

Collaboration between two photographers or photography studios in completing a commissioned job can potentially be complicated, as elements of the overall obligations may be less than clearly defined. However, the collaboration contract should clearly state what each of the parties to the agreement is responsible for. Additionally, the monetary rewards and liabilities must be clearly stated, as well as how the final product is to be presented. Which of the parties are responsible for which expenses and what the limitations are for each of the parties must also be covered in the contract.

Collaboration between two photographers or photography studios in completing a commissioned job can be complicated . . .

An area in which a very clearly defined contract is important is when a photographer works in collaboration with a school or university in which photography students are to participate in a planned exercise. The faculty may allocate students to the exercise who are not named at the time the arrangement is made. This can lead to a situation in which a student seeks to obtain reward for his or her work.

Any arrangement involving uncontracted individuals is legally hazardous unless there is an overriding contract in which the primary party to the agreement is responsible for all monetary liabilities in completing their obligations. Under such a contract, the photographer must be held harmless against any third-party claims by individuals assisting or otherwise party to completing the obligations of the agreement. This is especially important where copyright is concerned. When an individual who is not contracted provides copyrightable material to a primary source, the rights may belong to that individual and not to the photographer contracting with a collaborator.

Any contract with a collaborator should include the names of any and all possible persons who may be involved in the project, so as to protect the photographer against potential claims by anyone involved. The contract should clearly state that no persons other than those named may provide copyrighted material for the completion of the contract. The contract should also state that the remuneration required to fulfill the collaborator's obligations is the responsibility of the collaborating contractor.

COLLABORATION AGREEMENT

AGREEMENT entered into as of this _____ day of _____, 20___, between _____

_____ (hereinafter referred to as "Party 1"), located at _____,

and _____ (hereinafter referred to as "Party 2"), located at _____,

and _____ (hereinafter referred to as "Party 3"), located at _____

_____. Collectively, Party 1, Party 2, and Party 3 shall be referred to as the "Parties."

WHEREAS, the Parties hereto wish to collaborate on a _____ (hereinafter referred to as the "Event");

NOW, THEREFORE, in consideration of the mutual covenants hereinafter set forth and other valuable consideration, which the Parties acknowledge as sufficient and received, the Parties agree as follows:

1. DESCRIPTION. The Parties agree that the Event shall be described as follows: _____.

2. RESPONSIBILITIES. Party 1 shall be responsible for: _____

_____ and any other information that Party 1 feels is essential for his responsibilities under this Agreement. In addition, Party 1 shall also provide the following materials: _____.

Party 2 shall be responsible for: _____ and any other information that Party 2 feels is essential for his responsibilities under this Agreement. In addition, Party 2 shall also provide the following materials: _____.

Party 3 shall be responsible for: _____ and any other information that Party 3 feels is essential for his responsibilities under this Agreement. In addition, Party 3 shall also provide the following materials: _____.

3. FIRST COMPLETION DATE. If the Event is to be completed in stages, the Parties agree to complete their respective portions of the Event by _____, 20_____. The Parties agree that it is of the utmost importance that each Party upholds their responsibility and obligation and that time is of the essence for this Event and this Agreement.

4. CONTRACTS AND LICENSES. The Parties agree to mutually enter into any contracts necessary to complete the Event. That should a contract be entered into that the Parties shall satisfy all required contractual obligations under that Contract. Each party shall fully inform the other parties of all negotiations of any contracts pursuant to this Agreement. The disposition of any right shall require a written agreement between all Parties hereto. Each party shall receive a copy of any contract, license, or other document relating to this Agreement.

5. COPYRIGHT, TRADEMARKS, AND OTHER PROPRIETARY RIGHTS. To the extent possible, any materials created from the Event shall be copyrighted. The copyright shall include all the Parties, and once the Event is complete the work shall be considered one work. All trademarks, rights to photography or their subjects, titles, and similar ongoing rights shall be owned by all the Parties hereto. Further, the Parties agree that they shall have the right to participate in any sequels to the Event. A sequel is defined as an Event closely related to the Event in question which is the subject of this Agreement, and is similar in style and format to the Event, and is directed toward the same audience as that for the Event.

6. INCOME AND EXPENSES. Net proceeds are defined as gross proceeds, Event fees paid from the Event to the Parties, and any further proceeds from the sale or license of Event rights throughout the world as a result of the Parties' participation (including but not limited to serializations, condensations, and translations), including advances, minus reasonable expenses. Each party shall provide verification for expenses to the other party within ten (10) days of a written request. Unless otherwise provided, the Parties' expenses shall be reimbursed from the first proceeds received, including but not limited to advances.

Net proceeds from the Event, whether such proceeds occur before or after the initial Event date, shall be divided equally between the Parties.

To the extent possible, all net proceeds shall be distributed to the Parties directly. If direct payment is not possible and one Party is designated to collect such net proceeds, then that Party shall make immediate payment to the other Parties of such amounts as are due hereunder.

7. CREDIT. If there is a credit line for the Event, credit shall be published as follows: Party _____ shall be first and then Party _____ and then Party _____. The color and type size for such credit shall be the same for all the Parties.

8. ARTISTIC CONTROL. Each Party shall have artistic control over his or her portion of the Event. The Parties shall share ideas and make their work in progress available to the other parties for discussion and coordination purposes. No Party shall at any time make any changes in the portion of the Event created by another Party unless permission is expressly given by the other Party.

9. WARRANTY AND INDEMNITY. Each Party warrants and represents to the other that their respective contributions to the Event are original (or that appropriate releases have been obtained and paid for) and do not libel or otherwise violate any right of any person or entity, including but not limited to rights of copyright or privacy. The Parties each indemnify and hold the other harmless from and against any and all claims, actions, liability, damages, costs, and expenses, including reasonable legal fees and expenses, incurred by the other as a result of the breach of such warranties, representations, and undertakings.

10. ASSIGNMENT. The Parties agree that, due to the personalized nature of the Event, this Agreement shall not be assignable by any party hereto.

11. DEATH OR DISABILITY. In the event that any Party dies or suffers a disability that will prevent completion of his or her respective portion of the Event, the other Parties shall have the right to complete that portion or to hire a third party to complete that portion and shall adjust the credit to reflect the revised arrangements. The deceased or disabled Party shall receive payments pursuant to Paragraph 6 pro rata to the proportion of his or her work completed and shall receive payments pursuant to Paragraph 6 after deduction for the cost of revising the responsibilities. The active Parties shall have the power to license and contract with respect to the Event, and approval of the personal representative, heirs, or conservator of the deceased or disabled Party shall not be required. If all Parties are deceased, the respective heirs or personal representatives shall take the place of the Parties for all purposes.

12. ARBITRATION. All disputes arising under this Agreement shall be submitted to binding arbitration in the county of the disputing party and shall be settled in accordance with the rules of the American Arbitration Association. Judgment upon the arbitration award may be entered in any court having jurisdiction thereof.

13. TERM. The term for this Agreement shall be the duration of the Event, plus any renewals or extensions, should any be applicable.

14. COMPETITIVE EVENTS. The Parties agree not to take part in another Event that would be considered a competing Event so as to possibly diminish the net proceeds from the sale of this Event.

15. BALANCE OF TERMS. This Agreement shall be binding upon the Parties hereto, their heirs, successors, and assigns. This Agreement constitutes the entire understanding between the Parties. This Agreement can only be modified by a written instrument signed by all Parties. The Parties shall not do any act which would interfere with the terms of this Agreement. A waiver of any breach of any of the provisions of this Agreement shall not be construed as a continuing waiver of other breaches of the same or other provisions hereof. This Agreement shall be governed by the laws of the State of _____.

IN WITNESS WHEREOF, the Parties hereto have signed this Agreement as of the date first set forth above.

Party 1: _____

Party 2: _____

Party 3: _____

COAUTHORSHIP

You will have noted that this book is written as a collaboration between Norman Phillips and Christopher S. Nudo. While a collaboration contract between us would be a safeguard against one of us pirating the work of the other, it is not as important as a collaboration contract would be for two photographers working on such a project.

In the case of this book, the respective expertise of the two collaborators is totally dependent on their mutual respect and individual special contributions. There are no photographic images included, so the possibility of one or the other claiming rights over such elements does not exist. For two photographers, or a photographer and a writer, collaborating without a contract is fraught with possible legal problems. Therefore, the respective roles of the collaborators need to be spelled out in clear terms.

The contract we propose refers to the two individuals involved as the photographer and the coauthor. Although it is expected that the collaborators have a mutual respect for each other's work and expertise, the contract states such and immediately implies an understanding by each of their contributions. However, the contract goes beyond *implying* an understanding and, in fact, creates a document that warrants their partnership in the intended project.

The contract defines the respective responsibilities and the date the work is to be completed. The contract further states that if there is not already an agreement with a publisher, such an agreement or contract will be sought. The contract also deals with the issues of copyright, an extremely important issue for the photographer. Proprietary and trademark rights are also covered.

In creating a coauthored book, there may well be some ego involved. This can affect the way the credits for the work are to be displayed when the book is published. It may be that one or the other has a greater name recognition and that one of the two authors will logically be the most prominent when the book is advertised, since this is likely to result in greater sales. In this case, ego will be secondary to sales potential.

The contract goes beyond implying an understanding and creates a document that warrants their partnership in the intended project.

You will note the importance of Paragraph 9 in the proposed contract. Failure to warrant that neither party has plagiarized or stolen the material that constitutes their contribution to the project is a protection for both against suit by an owner of an original work. It holds each harmless in the event of any such action, should one or the other fail to obtain either a release or otherwise purchase the right to publish any part of the book.

COAUTHORSHIP AGREEMENT

AGREEMENT entered into as of this _____ day of _____, 20___, between _____ _____ (hereinafter referred to as the "Photographer"), located at _____ _____, and _____ (hereinafter referred to as the "Coauthor"), located at _____,

WHEREAS, the parties hereto wish to collaborate on a book (hereinafter referred to as the "Book");

NOW, THEREFORE, in consideration of the mutual covenants hereinafter set forth and other valuable consideration, which the parties acknowledge as sufficient and received, the parties agree as follows:

1. DESCRIPTION. The parties agree that the Book shall be described as follows:

2. RESPONSIBILITIES. The Photographer shall be responsible for creating photographs. Such photographs shall be captioned with the Subject of said photograph, whether or not it is color or black and white, the format and size of the photograph, and any other information that the Photographer feels is essential for his responsibilities under this Agreement. In addition, the Photographer shall also provide the following materials: _____

_____.

The Coauthor shall be responsible for writing the text, which shall be specific to the agreed subject matter. Further, the Coauthor shall write text specifically including the following: _____. In addition, the Coauthor shall also provide the following materials: _____.

3. FIRST COMPLETION DATE. The Parties agree to complete their portions of the Book by _____ _____, 20_____, or by the date for delivery of the manuscript as specified in a Publishing Contract entered into pursuant to Paragraph 4. If such a Publishing Contract requires preliminary materials prior to the date for delivery of the manuscript, the party responsible for same shall provide it to the publisher.

4. CONTRACTS AND LICENSES. The Parties agree to enter into a contract with a publisher; both the Photographer and Coauthor agree to seek such a contract. The Photographer and the Coauthor shall satisfy all required contractual obligations under the Publishing Contract. Each Party shall fully inform the other Party of all negotiations for such a Publishing Contract or with respect to the negotiation of any contracts pursuant to this Agreement. The disposition of any right shall require written agreement between both Parties hereto. Each Party shall receive a copy of any contract, license, or other document relating to this Agreement.

5. COPYRIGHT, TRADEMARKS, AND OTHER PROPRIETARY RIGHTS. The Photographer and Coauthor agree that the Book shall be copyrighted. The copyright shall include both the Photographer and the Coauthor and, once the Book is complete, the work shall be considered one work. All trademarks, rights to photography or their subjects, titles, and similar ongoing rights shall be owned by both the Photographer and Coauthor who shall have the right to participate in any sequels. A sequel is defined as a book closely related to the Book that is the subject of this Agreement, which is similar in style and format to the Book and is directed toward the same audience as the Book.

6. INCOME AND EXPENSES. Net proceeds are defined as gross proceeds from the sale or license of book rights throughout the world (including but not limited to serializations, condensations, and translations), including advances, minus reasonable expenses. Each Party shall provide verification for expenses to the other Party within ten (10) days of a written request. Unless otherwise provided, the parties' expenses shall be reimbursed from the first proceeds received, including but not limited to advances.

Net proceeds from the sale or license of publishing rights, electronic publishing (as hereafter defined), and nonpublishing rights in the Book (including but not limited to audio, merchandising, motion picture, stage play, or television rights to the Book), whether such sale or license occurs before or after initial publication of the Book shall be divided equally

between the Photographer and the Coauthor. For purposes of this agreement, electronic rights are defined as rights in digitized form that may be stored on and retrieved from electronic media including but not limited to computer disks, CD-ROMs, computer databases, and network-attached storage devices.

To the extent possible, all net proceeds shall be distributed to the Photographer and Coauthor directly. If direct payment is not possible and one of the Parties is designated to collect such net proceeds, then that Party shall make immediate payment to the other Party of such amounts as are due hereunder.

7. AUTHORSHIP CREDIT. The credit line for the Book shall be as follows wherever authorship credit is given in the Book or in promotion, advertising, or other ancillary uses: first the _____ and then the _____. The color and type size for such authorship credit shall be the same for both Parties.

8. ARTISTIC CONTROL. Each Party shall have artistic control over his or her portion of the Book. The Parties shall share ideas and make their work in progress available to the other Party for discussion and coordination purposes. Neither Party shall at any time make any changes in the portion of the Book created by the other Party unless permission is expressly given by the other Party.

9. WARRANTY AND INDEMNITY. The Photographer and Coauthor each warrant and represent to the other that the respective contributions of each to the Book are original (or that appropriate releases have been obtained and paid for) and do not libel or otherwise violate any right of any person or entity, including but not limited to rights of copyright or privacy. The Photographer and Coauthor each indemnify and hold the other harmless from and against any and all claims, actions, liability, damages, costs, and expenses, including reasonable legal fees and expenses, incurred by the other as a result of the breach of such warranties, representations, and undertakings.

10. ASSIGNMENT. The Parties agree that, due to the personalized nature of the Book, this Agreement shall not be assignable by either Party hereto.

11. DEATH OR DISABILITY. In the event that either Party dies or suffers a disability that will prevent completion of his or her respective portion of the Book, or of a revision thereof or a sequel thereto, the other Party shall have the right to complete that portion or to hire a third party to complete that portion and shall adjust the authorship credit to reflect the revised authorship arrangements. The deceased or disabled Party shall receive payments pursuant to Paragraph 6 pro rata to the proportion of his or her work completed or, in the case of a revision or sequel, shall receive payments pursuant to Paragraph 6 after deduction for the cost of revising or creating the sequel with respect to his or her portion of the Book. The active Party shall have the sole power to license and contract with respect to the Book, and approval of the personal representative, heirs, or conservator of the deceased or disabled Party shall not be required. If all Parties are deceased, the respective heirs or personal representatives shall take the place of the Parties for all purposes.

12. ARBITRATION. All disputes arising under this Agreement shall be submitted to binding arbitration in the county of the disputing Party and shall be settled in accordance with the rules of the American Arbitration Association. Judgment upon the arbitration award may be entered in any court having jurisdiction thereof.

13. TERM. The term for this Agreement shall be the duration of the copyright, plus any renewals or extensions thereof.

14. COMPETITIVE BOOKS. The Parties agree not to produce works that would be considered a competing Book so as to possibly diminish the net proceeds from the sale of this Book.

15. BALANCE OF TERMS. This Agreement shall be binding upon the Parties hereto, their heirs, successors, and assigns. This Agreement constitutes the entire understanding between the Parties. This Agreement can only be modified by a written instrument signed by both Parties. Neither Party shall do any act which would interfere with the terms of this Agreement. A waiver of any breach of any of the provisions of this Agreement shall not be construed as a continuing waiver of other breaches of the same or other provisions hereof. This Agreement shall be governed by the laws of the State of _____.

IN WITNESS WHEREOF, the Parties hereto have signed this Agreement as of the date first set forth above.

Photographer: _____ Coauthor: _____

19. EMPLOYEES

In the previous chapter, we discussed contracting out, subcontracting, independent contractors, and collaborative agreements. What we have not covered so far is contracts of employment that should be used for the employment of workers who are paid wages. Employing someone to whom you will be paying wages results in a contract between you and the employee, even if it is verbal. However, a verbal contract of employment is open to dispute, and the employee may well have the law on their side in any dispute between you. Therefore, a written contract of employment is recommended. Each state has its own laws, and you will need to know them before writing up a contract.

HIRING AND EMPLOYMENT CONTRACTS

Once you have ascertained that a candidate is suitable for the position you wish to fill, you should write a letter detailing your offer to the prospective employee. Once this has been done, and the offer is accepted, you should have the new colleague sign off on the contract that has largely been outlined in your offer letter.

Where the contract refers to the new employee's photography, it should be stated that there is a required minimum technical standard to be maintained, which shall be discussed at regular intervals.

It should specify that critiques will be conducted after the employee has completed assignments in order to ensure that these standards are maintained. The contract should also refer to the standards of conduct that your studio requires.

Employing someone to whom you will be paying wages results in a contract between you and the employee, even if it is verbal.

It should also spell out vacation and medical privileges and any healthcare coverage and other job benefits you will be providing. If you are going to allow personal days you must say how many. Additionally, as noted in the following section, the contract should provide for regular performance reviews of the employee's work (see pages 121–22 for more information on performance reviews).

EMPLOYMENT AGREEMENT

THIS AGREEMENT is effective this _____ day of _____, 20_____ by and between _____ a(n) _____ (*state*) corporation (hereinafter referred to as the "Company") and _____ (hereinafter referred to as the "Employee").

WHEREAS, the Company wishes to assure itself of the services of the Employee for the period provided in this Agreements; and

WHEREAS, the Employee is willing to serve as a Photographer on a permanent basis for said period.

NOW THEREFORE, in consideration of the mutual covenants herein contained and upon the other terms and conditions hereinafter provided, the parties hereby agree as follows:

1. EMPLOYMENT. The Employee is employed as a photographer.

2. BASE COMPENSATION. The Company agrees to pay the Employee during the term of this Agreement a salary at the rate of $_____ per annum, payable in cash not less frequently than twice a month.

3. BENEFITS.

(A) Participation in Retirement and Medical Plans. The Employee shall be entitled to participate in any plan of the Company relating to pension, profit-sharing, employee stock options, other retirement benefits, medical coverage or reimbursement, disability, or any other health or welfare plan that the Company may adopt for the benefit of its employees.

(B) Participation in Other Employee Benefits. The Employee shall be eligible to participate in any fringe benefits which the Company in its discretion makes available to other employees.

(C) Vacation. The Employee shall be entitled to any annual paid vacation in accordance with the policies as periodically established by the Company.

4. TERM. The term of employment under this Agreement shall be for the period commencing _____ and ending _____. The Agreement shall automatically renew for a period of not less than one year as long as neither party as given written notice to the other of their intent to terminate the Agreement.

The Company shall have the right to conduct job performance evaluations of Employee at any time after six (6) months of the date of this Agreement. If the Company at that time determines in its sole discretion that the Employee's performance is not satisfactory, it shall have the right to terminate this Agreement with thirty (30) days' notice to the Employee

5. LOYALTY AND NONCOMPETITION.

(A) The Employee shall devote his full time and best efforts to the performance of his employment under this Agreement. The Employee shall use his best efforts to uphold the standards that are set by the Company. During the term of this Agreement and for a period of one year following any termination of the Agreement of employment, the Employee shall not, at any time or place, either directly or indirectly, engage in any business or activity in competition with the business affairs or interests of the Company. Directly or indirectly engaging in any business or activity in competition with the business affairs or interests of the Company, shall include engaging in business as owner, partner, agent, or employee of any person, firm, or corporation engaged in such business.

(B) In the event of violation by the Employee of the aforementioned provisions, the Employee will be subject to damages and injunctive relief necessary for the Company to enforce these provisions of the Agreement.

6. EXPENSES TO ENFORCE AGREEMENT. In the event any dispute shall arise between the Employee and the Company as to the terms or interpretation of this Agreement, whether instituted by formal legal proceedings or otherwise, including any action taken by the Employee in defending against any action taken by the Company, the Company shall reimburse the Employee in the event the Employee prevails in his claim against the Company for all costs and expenses, including reasonable attorneys' fees arising from such dispute, proceedings, or actions. Such reimbursement shall be paid within ten (10) days of the Employee furnishing to the Company written evidence, which may be in the form, among other things, of a cancelled check or receipt, of any costs or expenses incurred by the Employee. Any such request for reimbursement by the

Employee shall be made no more frequently than at sixty (60) day intervals.

7. SUCCESSOR AND ASSIGNS.

(A) This Employment Agreement shall inure the benefit of and be binding upon any corporate or other successor of the Company which shall acquire, directly or indirectly, by merger, consolidation, purchase, or otherwise, all or substantially all of the assets of the Company.

(B) Since the Company is contracting for the unique and personal skills of the Employee, the Employee shall be precluded from assigning or delegating his rights or duties hereunder without first obtaining the written consent of the Company.

8. AMENDMENTS. No amendments or additions to this Agreement shall be binding unless in writing and signed by both parties, except as herein otherwise provided.

9. APPLICABLE LAW. This Agreement shall be governed in all respects whether as to validity, construction, capacity, performance, or otherwise, by the laws of _____, except to the extent that Federal law shall be deemed to apply.

10. SEVERABILITY. The provisions of this Agreement shall be deemed severable and the invalidity or unenforceability of any provision shall not affect the validity or enforceability of the other provisions hereof.

IN WITNESS WHEREOF, the parties have executed this Agreement on the day and year first hereinabove written.

CORPORATION

By:_____

Its:_____

EMPLOYEE:

PERFORMANCE REVIEWS AND WARNINGS

The contract should state that there will be regular reviews of the employee's performance, directed at enhancing the employee's standard of work, and that these will be made in writing. Any bonuses or rewards that will be contingent on these reviews should also be specified. This prevents issues that need to be addressed from being left to fester, creating serious situations that may lead to a lawsuit. Keep in mind that ours is a unique profession and an employee (especially one whose duties include creating photography) may require continued coaching and critique. Using written reviews is not only a good practice, it is also very good legal protection. These reviews will record any deficiencies that may ultimately lead to dismissal. You should not refrain from legitimate criticisms; if there is legitimate reason to terminate the employee and it is not recorded and the employee is not notified, it might lead to a lawsuit. These documents will then be used in the event that the dismissed employee applies for unemployment benefits, which can increase your unemployment contributions.

Tardiness and other issues that affect your business should also be recorded and discussed with the employee. Timekeeping might even be included in the contract of employment. Then, should these times be disregarded, you should record each violation and advise the employee after two or more incidents. Tardiness or failure to show up for work undermines your business and is grounds for dismissal; the fact that you have kept a record and warned the employee protects you against a lawsuit for unfair dismissal. Depending on how lenient your state law is in this matter, it may also prevent your unemployment contributions from increasing. The

PERFORMANCE REVIEW

This Performance Review is pursuant to the Employment Agreement dated _____ by and between
_____ (hereinafter the "Company") and
_____ (hereinafter the "Employee").

The Employee understands and acknowledges that any determination based upon this review could be used as a cause for termination of the above mentioned Employment Agreement and Employee's employment with Company.

REVIEW:
Employee's ability to start work or be at assignments as scheduled: _____

Employee has been warned of tardiness on the following occasions by: _____
_____ (a copy of said tardiness notice is attached).

Company Standard towards photography: _____

This review is done as of this _____ day of _____, 20____.

By:_____
Its:_____

EMPLOYEE WARNING

This Warning is pursuant to the Employment Agreement dated _____ by and between _____ (hereinafter the "Company") and _____ (hereinafter the "Employee").

The Employee is receiving this warning due to the following reason(s): _____

This Warning has been hand delivered to the Employee on _____ day of _____, 20___.

I THE UNDERSIGNED DO BY WARRANT THAT I DELIVERED A COPY OF THIS WARNING TO EMPLOYEE ON THE DATE STATED ABOVE.

warning to the employee should be in writing as well as verbal.

When an ex-employee makes a claim for unemployment it is not always the best course of action to dispute the claim, unless of course the reason for dismissal is for theft or other equally objectionable behavior. When you are requested to reply to the request for information with regard to a claim, providing copies of your records may, however, prevent an increase in your contributions while not denying the employee's benefits.

The forms above and on page 121 are examples of the kind of performance review and warning forms that you should provide.

WITHHOLDING TAXES AND FICA

This is not a book about accounting, but photographers, for whatever reason, are among the worst when it comes to handling withholding taxes and FICA (social security tax) deductions. Photographers who are having difficulty making ends meet are the ones who get into the most trouble, because the taxes they withhold from employees' wages (and also their social security taxes) often become part of their working capital.

There are serious consequences if money due to the Internal Revenue Service is not paid on time or not paid at all. Penalties and interest can be excruciating—and if left too long, they can be fatal to your business.

Additionally, the IRS has the ability to prevent you from operating a business in the future if you are a habitual miscreant.

You should not regard income tax and FICA withholdings as part of your working capital. Ideally, these funds should not be placed in your general account—especially if you are in the beginning stages of your business or are traveling close to the wind. Our advice is for you to set up a separate account and place the withheld funds in it for safekeeping.

This special account can be set up with a small float, perhaps $200, so that it never runs dry and the government's money is always safe. This will protect you from the serious matter of having the IRS paying you a very unpleasant visit.

Discuss your policies with your accountant to ensure you are fully compliant with the law and good business practices.

WORKERS' COMPENSATION

Additionally, workers' compensation insurance may be obligatory in your state. If you employ one or more people (even part-timers) and do not have it, you will be in violation of the law. Worse still, if you do not have this insurance and an employee is injured, you will find yourself responsible for paying his or her medical bills for the injury.

20. CONFIDENTIALITY AGREEMENT

Photographers frequently become involved with prospective clients, typically corporations, who have a project requiring photography but who have only a vague idea of what they want as a final image. Sometimes, however, after the photographer has invested a considerable amount of time consulting with the client and developing an idea, the client takes that idea elsewhere to get the project completed for less. As a result, the original photographer, who created the basis for a successful project, ends up excluded from the assignment. This denies the photographer his or her right of reward for the work done to develop the idea.

When a client (or prospective client) approaches you with a project and wants your ideas as to how you would achieve the end product, it should be clear that you are making an important investment in the completion of the project. Therefore, your time, creativity, and professional expertise need to be protected. This is when a nondisclosure agreement is appropriate.

When asking the client to sign this form, explain that you will be applying your expertise and experience as well as your creativity, which is one of your most valuable assets. Therefore, the client's word that he will not disclose your ideas will not provide you with the protection you require; it has to be a legal agreement. If the client declines the agreement, then you should not proceed with the development of the idea(s) needed to achieve his objectives.

The client's word that he will not disclose your ideas will not provide you with the protection you require; it has to be a legal agreement.

It is important to remember that buyers frequently put out assignments to bid, and one of their techniques is to explore the various options they have before assigning the job. Too frequently, after much time and creative thinking, the assignment goes somewhere else and is actually expedited as a result of the creative work that someone else did.

The following is the recommended nondisclosure agreement. You can modify it according to the project, but you should not change the legal wording.

CONFIDENTIALITY AGREEMENT

This Confidentiality Agreement (this "Agreement") is made effective as of _____, 20_____, between _____ (hereinafter referred to as the "Photographer") whose principal place of business is _____ and _____ (hereinafter referred to as the "Recipient") whose principal place of business is _____.

In this Agreement, the party who owns the Confidential Information will be referred to as the "Photographer" and the party to whom the Confidential Information will be disclosed will be referred to as the "Recipient."

WHEREAS, the Photographer has developed certain valuable information, concepts, ideas, or designs, which the Photographer deems confidential (hereinafter referred to as the "Confidential Information"); and

WHEREAS, the Recipient is in the business of using such Confidential Information for its projects and wishes to review the Confidential Information; and

WHEREAS, the Photographer wishes to disclose this Confidential Information to the Recipient; and

WHEREAS, the Recipient will not disclose this Confidential Information, per the terms of this Agreement.

1. CONFIDENTIAL INFORMATION. The term "Confidential Information" means any information or material which is proprietary to the Photographer, whether or not owned or developed by the Photographer, which is not generally known other than by the Photographer, and which the Recipient may obtain through any direct or indirect contact with the Photographer. (A) Confidential information includes without limitation: photographs, including negatives, digital images, and prints; business records and plans; financial statements; customer lists and records; trade secrets; technical information; products; inventions; product design information; pricing structure; computer programs and listings; source code and/or object code; copyrights and other intellectual property; and related information and other proprietary information. (B) Confidential information does not include: matters of public knowledge that result from disclosure by the Photographer; information rightfully received by the Recipient from a third party without a duty of confidentiality; information disclosed by operation of law; information disclosed by the Recipient with the prior written consent of the Photographer; and any other information that both parties agree in writing is not confidential.

2. PROTECTION OF CONFIDENTIAL INFORMATION. The Recipient understands and acknowledges that the Confidential Information has been developed or obtained by the Photographer by the investment of significant time, effort, and expense, and that the Confidential Information is a valuable, special, and unique asset of the Photographer which provides the Photographer with a significant competitive advantage and needs to be protected from improper disclosure. In consideration for the disclosure of the Confidential Information, the Recipient agrees to hold in confidence and to not disclose the Confidential Information to any person or entity without the prior written consent of the Photographer. In addition, the Recipient agrees that: (A) the Recipient will not copy or modify any Confidential Information without the prior written consent of Photographer; and (B) that the Recipient shall not disclose any Confidential Information to any employees of the Recipient, except those employees who are required to have the Confidential Information in order to perform their job duties in connection with the limited purposes of this Agreement. Each permitted employee to whom Confidential Information is disclosed shall sign a nondisclosure agreement substantially the same as this Agreement at the request of the Photographer. (C) If it appears that the Recipient has disclosed (or has threatened to disclose) Confidential Information in violation of this Agreement, the Photographer shall be entitled to an injunction to restrain the Recipient from disclosing, in whole or in part, the Confidential Information. The Photographer shall not be prohibited by this provision from pursuing other remedies, including a claim for losses and damages.

3. RETURN OF CONFIDENTIAL INFORMATION. Upon the written request of the Photographer, the Recipient shall return to the Photographer all written materials containing the Confidential Information. The Recipient shall also deliver to

the Photographer written statements signed by the Recipient certifying that all materials have been returned within five (5) days of receipt of the request.

4. RELATIONSHIP OF PARTIES. Neither party has an obligation under this Agreement to purchase any service or item from the other party, or commercially offer any products using or incorporating the Confidential Information. This Agreement does not create any agency, partnership, or joint venture.

5. NO WARRANTY. The Recipient acknowledges and agrees that the Confidential Information is provided on an AS IS basis. The Photographer MAKES NO WARRANTIES, EXPRESS OR IMPLIED, WITH RESPECT TO THE CONFIDENTIAL INFORMATION AND HEREBY EXPRESSLY DISCLAIMS ANY AND ALL IMPLIED WARRANTIES OF MERCHANTABILITY AND FITNESS FOR A PARTICULAR PURPOSE. IN NO EVENT SHALL THE PHOTOGRAPHER BE LIABLE FOR ANY DIRECT, INDIRECT, SPECIAL, OR CONSEQUENTIAL DAMAGES IN CONNECTION WITH OR ARISING OUT OF THE PERFORMANCE OR USE OF ANY PORTION OF THE CONFIDENTIAL INFORMATION. The Photographer does not represent or warrant that any product or business plans disclosed to the Recipient will be marketed or carried out as disclosed, or at all. Any actions taken by the Recipient in response to the disclosure of the Confidential Information shall be solely at the risk of the Recipient.

6. LIMITED LICENSE TO USE. The Recipient shall not acquire any intellectual property rights under this Agreement except the limited right to use set out above. The Recipient acknowledges that, as between Photographer and Recipient, the Confidential Information and all related copyrights and other intellectual property rights, are (and at all times will be) the property of Photographer, even if suggestions, comments, and/or ideas made by the Recipient are incorporated into the Confidential Information or related materials during the period of this Agreement.

7. GENERAL PROVISIONS. This Agreement sets forth the entire understanding of the parties regarding confidentiality. Any amendments must be in writing and signed by both parties. This Agreement shall be construed under the laws of the State of _____. This Agreement shall not be assignable by either party, and neither party may delegate its duties under this Agreement, without the prior written consent of the other party. The confidentiality provisions of this Agreement shall remain in full force and effect after the effective date of this Agreement.

Photographer:_____(sign) Recipient:_____ (sign)
 _____(print) _____ (print)
Date: _____ Date: _____

21. STOCK PHOTOGRAPHY

Stock agencies differ in how they market a photographer's work. In many cases, agencies specialize in the type of work they make available to the publishing industry. Therefore, an important issue with work marketed by an agency is what the work may be used for and what limitations you may want to apply to its use. For example, you may wish to deny the agency the right to use your images for sexual material or tobacco advertising.

While no stock agency will allow you to market identical images through another agency, you may also want to retain the right to market your images separately from the agency. You might allow the agency to sell nonexclusive rights to any of your images, or you might agree to allow part of an image to be sold while limiting the entire image as another saleable item.

AGENCY AGREEMENT

Some agencies have a standard agency agreement that they require the photographer to sign. However, you may wish to modify such an agreement. You will be well advised to carefully review the agency agreement and ensure that all your important issues are adequately covered. This includes the agency use of subagents and how they maintain your interests as specified in the agreement. The agency agreement may also include the right of the agency to obtain an assignment or assignments for you in addition to selling the right to use individual images.

The agency agreement will also cover copyright issues, model releases, and captions to be applied to the use of your images. The agreement should not allow the agency to create duplicates of any image. This is important because agencies have been known to create duplicates in order to license the image to more than one user at the same time. Should you agree to this, you will automatically reduce the value of the image—plus the users of the image may seek redress if they are not aware that the image was not exclusive to them.

The agency agreement must be precise about payment for the licensing of images, and you will want the right to inspect the agency accounts to ensure that you are being fairly treated. You may also wish to have a periodic report from the agency as to their progress in licensing your work.

Additionally, you will want the agreement to define a termination date, ending the agency's right to license your work and permitting you to retrieve images so you can market them yourself if you so choose. This is covered in Paragraph 15 of our proposed agreement.

Many stock photography agencies publish catalogs of the work they represent. When your image is published in such a catalog it enhances the marketability of the agency, not just your particular image. Therefore, the agency will need to receive your written approval for such usage. If the agency wishes to feature your image on the cover, this should be subject to approval and accompanied by some kind of payment.

The agreement that we suggest provides you with the opportunity to control the terms on which you submit your images. The agreement also covers various other legal implications. Therefore, the precise legal wording is important and should not be altered. The following is the recommended agreement.

STOCK PHOTOGRAPHY AGREEMENT

This Agreement is entered into as of this _____ day of _____, 20___, by and between _____, whose principal place of business is at _____ (hereinafter referred to as the "Studio"), and _____, located at _____ (hereinafter referred to as the "Client").

WHEREAS, the Studio has photographers who are professional photographers who create and own stock photography; and

WHEREAS, the Client is familiar with the stock photography of the Studio and wishes to represent such work; and

WHEREAS, the parties desire to enter into this type of Agreement abiding in the obligations of this Agreement and to the mutual, covenants, and conditions herein.

NOW, THEREFORE, in consideration of _____ dollars ($_____) and other good and valuable consideration, the sufficiency which is hereby agreed and the mutual covenants of this Agreement, the parties hereto agree as follows:

1. PHOTOGRAPHS. The Client shall request from Studio, from time to time within the timeframe of this Agreement, to review Studio's photography (hereinafter referred to as the "Photographs") and the Studio shall have the right to accept such choices of any photographs chosen by the Client within _____ days for the Client's representation.

2. SCOPE OF CLIENT'S REPRESENTATION. With respect to Photographs chosen by the Client and accepted by the Studio pursuant to Paragraph 1, the Client shall have the right to license said Photographs for the following uses:

(A) The Client may market directly in the following areas _____.

(B) The Client may also market through the following listed Agencies in the following countries _____ _____. Additional agencies may be added by the written agreement of the Parties.

(C) The Client's license shall be nonexclusive in the Photographs. If the Client wishes to license exclusive rights, it shall request permission from the Studio, which shall be obtained in writing and may have additional consideration required by Studio.

(D) The Studio agrees not to market the Photographs directly, during the term of this Agreement, through any other Client in the areas listed in (A) and (B) above.

(E) This Agreement shall not apply to referral photography. In the event that the Client obtains a referral for the Studio for photography, it shall offer that referral to the Studio who is free to accept or reject the referral and any or all of its compensation without any obligation to the Client.

(F) The Client agrees to use their best efforts to license the Photographs of the Studio.

(G) The Client shall require all agents to act in accordance with the Client's obligations pursuant to this Agreement.

(I) Electronic rights are within the scope of the permitted uses granted by the Studio in this contract insofar as the grant of such rights is incidental to the grant of nonelectronic rights. For purposes of this agreement, electronic rights are defined as rights in the digitized form of works that can be written, stored, and retrieved from such media as floppy disks, CD-ROMs, DVDs, hard drives, memory cards, or other forms of removable memory.

3. LOCATION OF PHOTOGRAPHY AND CATALOGS. All Photographs chosen by the Client and accepted by the Studio shall be kept at the Client's location. In the event that the Client intends to publish one or more Photographs in a catalog, the Client shall obtain the Studio's written permission.

4. DESCRIPTION OF PHOTOGRAPHS. The Client shall place descriptions on the Photographs. These descriptions shall include information regarding the subject matter of the Photographs. The Studio shall assist in giving the Client infor-

mation to assist in the descriptions. The Client will be obligated to convey such information to its agents and will ensure the accuracy of the information.

5. COPYRIGHT NOTICE. The Studio shall place a copyright notice on all Photographs, which shall not be removed from the Photographs. Copyright notice in the Studio's name shall appear on all Photographs licensed by the Client.

6. MODEL AND PROPERTY RELEASES. The Studio shall identify to the Client which Photographs have model or property releases. If the Studio does not acknowledge the existence of model or property releases, and if the Client permits uses beyond the scope of a model or property release, or if the Client fails to convey accurate description information as required by Paragraph 4, the Client assumes full responsibility for uses of the Photographs that may violate the rights of any parties, and indemnifies and holds the Studio harmless against any resulting claims, damages, and expenses, including but not limited to court costs, expert witness fees, and attorneys' fees.

7. REPRODUCTION. Any reproduction of one or more Photographs which the Client desires to create must have prior written approval from the Studio. All reproductions, whether created by the Client, the Studio, an agent, or any other party, shall be the property of the Studio and, as stated in Paragraph 1, are included within the definition of Photographs. The Client shall pay any and all expenses to the Studio if such expenses are incurred by the Studio for the reproduction of the Photographs. At the Studio's option, any such expenses shall be charged against payments due under Paragraph 8.

8. PAYMENTS. The Client shall create a separate escrow account for the holding of all payments due to the Studio until payment is made. For Photographs sold from the Client's locations, the Studio shall receive _____ percent of gross billings. For Photographs sold from the Client's catalogs, the Studio shall receive _____ percent of gross billings. For Photographs sold by agents, the Studio shall receive _____ percent of the gross billings received by the Client. Gross billings shall be defined as all payments from licensing, any and all other fees and any interest earned. Gross billings shall be reduced by the reasonable cost of currency conversions. The Studio shall make all payments due the Client at the time of giving the transaction reports required by Paragraph 9.

9. TRANSACTION REPORT. Every _____ months ("Period") the Client shall give a report of transactions to the Studio by the _____ day of the following month after the close of the Period stated above. The transaction report shall disclose for that period each Photograph licensed, the person or entity using the Photograph, the license of rights, the date of receipt of payment, the gross billing, and any reductions in the gross billing.

10. RIGHT OF INSPECTION. The Studio shall have a right of inspection of the Client's ledger of account to verify the payments. Such right shall be exercisable when sent to the Client in writing and shall take place no sooner than one (1) day after the Client has received said notice. Additionally, the right of inspection shall not be at a time that creates interference with the Client's daily activities. If errors in any such accounting are found and such errors are in the Client's advantage, then the Client agrees to pay the Studio the error amount payable immediately.

11. TERM. The term of this Agreement shall be _____ years from the date of entering into this Agreement. It is agreed between the Studio and the Client that this Agreement shall automatically renew with the same terms and conditions, unless one party serves notice of intent not to renew within thirty (30) days of the expiration of this Agreement.

12. TERMINATION. The Studio shall have the right to terminate this Agreement: (A) if the Client fails to make payments per Paragraph 8; (B) if the Client fails to provide a Transaction Report per Paragraph 9; (C) if the Client otherwise defaults in its obligations hereunder. The Parties may terminate this Agreement by written notice in the event of the Client's or Studio's death or incompetency. This Agreement shall automatically terminate in the event either Party should file a petition in bankruptcy or be requested to assign assets for the benefit of creditors. In the event of termination of the Agreement, the Client shall immediately cease its any of the permitted uses of all Photographs, and all Photographs shall be returned as provided in Paragraph 15.

13. RETURN OF PHOTOGRAPHS. In the event of termination per the terms of Paragraph 14, the Client shall return the Photographs within _____ days to the Studio. The Studio shall have access to the Photographs at the Client's place of business between the hours of 9am and 5pm, Monday through Friday as long as the Studio has given the Client written notice of this time and intent prior to arriving at the Client's place of business.

14. INDEMNITY. The Parties agree to hold each other harmless against any complaint or petition that is filed as a result

of their independent business activities. Such indemnity includes but is not limited to the reimbursement of attorneys' fees, court costs, out of pocket discovery costs, and expert witness fees.

15. LITIGATION. Should any loss, damage, or infringement of any of the Photographs in the Client's care and possession occur, then the Studio shall have the right to a cause of action for the recovery.

16. RELATIONSHIP OF PARTIES. The Client and the Studio are not partners, nor do they have interest in any entity jointly. Their relationship is completely independent of one another.

17. ARBITRATION. All disputes arising under this Agreement shall be submitted to binding arbitration and shall be settled in accordance with the rules of the American Arbitration Association. Judgment upon the arbitration award may be entered in any court having jurisdiction thereof.

18. ASSIGNMENT. The parties agree not to assign the whole or any part of this Agreement without the written consent of the other party.

19. NOTICE. When written notice is required pursuant to this Agreement, it may be given by use of facsimile with proof of transmission sent by regular first class mail, or certified mail, return receipt requested, to the Party's address stated herein or any other address subsequently provided to the other Party as a place for notice.

20. JURISDICTION. This Agreement shall be governed by the laws of the State of _____.

Client: _____ Studio: _____

STOCK PHOTOGRAPHY INVOICE

There are times when the standard arrangement you have with a stock agency will need to be modified so that you may have the option of licensing images on a limited basis or allowing an agent to sell a license on special terms. Most agencies will usually get back to you with offers for a license if you do not have a specified rate or minimum for your images.

When you accept an offer or a series of offers and have agreed to the terms, you should invoice the agency in very precise terms. These will state the use, limitations, and territories that are included in the agreement. While many agencies like to have control of these aspects so that they may license images without delay when an opportunity occurs, it would be advisable to prearrange an invoice form that satisfies your criteria. The invoice we propose could be set up on the agency computer and generated when image licenses are sold.

Note that the invoice relates all of your concerns as to the use of your work. This includes the use and placement of the images and the individual fee for each image. The invoice we suggest carries all the terms by which you permit licenses to be sold. You should not readily surrender any of those we have included in the following recommendation. Of course, there may be instances where only one image per invoice is required, but there may also be occasions when a buyer wishes to use a number of your images.

If you are unable to arrange for a prearranged invoice to be set up, then you will want to be able to present one via fax or e-mail so as not to cause a lost sale due to delay.

A sample stock photography invoice follows on pages 131–32.

STOCK PHOTOGRAPHY DELIVERY MEMO

I have learned of numerous photographers delivering stock images with reckless abandon. This can lead to all kinds of complications. It is important that you present stock images with careful records. The images should be listed and valued and should also be insured by the agent or client in case of loss or damage.

When you accept an offer or a series of offers and have agreed to the terms, you should invoice the agency in very precise terms.

If you are sending the images via mail or special delivery, your memo that lists the work should state also that the use of the images is not permitted until you receive confirmation of delivery by signature. When delivering by hand, you will receive a signature on the spot.

Note that this delivery memo also restates your terms and conditions for the use of the work listed. We recommend the following form.

A sample stock photography delivery memo appears on page 133.

STOCK PHOTOGRAPHY INVOICE

Client: _____ Date: _____

Address: _____ Invoice no.: _____

SS/EIN no.: _____

Purchase order no.: _____

Per request of: _____ Telephone: _____

The Client agrees that they may only use the images identified below for the following use: _____
_____ and such as shall be limited by the fol-
lowing time period or number of uses_____.

If applicable, the use of the Images shall be further limited by: _____

Photo ID#	Description	Fee
_____	_____	_____
_____	_____	_____
_____	_____	_____
_____	_____	_____
_____	_____	_____

Total fee . $_____

Subtotal . $_____

Sales tax . $_____

TOTAL . $_____

All payments shall be payable to: _____

Subject to the following Terms and Conditions.

TERMS AND CONDITIONS

1. DELIVERY AND DEFINITION. The Photographer has delivered to the Client those Images listed on the front of this form. "Images" are defined to include transparencies, prints, negatives, or digital images in any form in which the images submitted can be stored, incorporated, represented, projected, or perceived, including forms and processes not presently in existence but which may come into being in the future.

2. GRANT OF RIGHTS. Upon receipt of full payment, the Photographer shall license to the Client the rights set forth above for the listed Images.

3. RESERVATION OF RIGHTS. All rights not expressly granted are reserved by the Photographer. Without limiting the foregoing, no advertising or promotional usage whatsoever may be made of any Images unless such advertising or promotional usage is expressly permitted above.

4. PAYMENT. Payment is due to the Photographer upon receipt of this Invoice. Overdue payments shall be subject to interest charges of 2 percent (2%) monthly.

6. COPYRIGHT NOTICE. Client agrees to place a copyright notice in the name of the Photographer adjacent to the Photograph(s) when reproduced. If such copyright notice, which also serves as authorship credit, is required hereunder but is omitted, the Client shall pay as liquidated damages triple the usage fee agreed to between the parties in addition to the stated usage fee on the front of this invoice.

7. ALTERATIONS. No alterations may be made to the image or any derivative by use of computer or any other means; this would include any changes, deletions, or additions to the image and its content. This prohibition shall include processes not presently in existence but which may come into being in the future.

8. OWNERSHIP AND RISK OF LOSS. The Photographer shall be the owner of the images, and ownership shall not transfer at any time from the Photographer unless expressly stated. The Client agrees to assume full responsibility and be strictly liable as an insurer for loss, theft, or damage to the Images. Delivery of Images from the Client to Photographer shall only be acceptable by commercial overnight courier which requires proof of receipt or personal delivery. Reimbursement for loss, theft, or damage to any Photograph(s) shall be in the amount of the value entered for that Photograph(s) on the front of this form. Both the Client and the Photographer agree that the specified values represent the fair and reasonable value of the Images. Unless the value for an original Image is specified otherwise on the front of this form, both parties agree that each original Image has a fair and reasonable value of $2,000 (two thousand dollars). The Client agrees to reimburse the Photographer for these fair and reasonable values in the event of loss, theft, or damage.

9. RELEASES. Client agrees to indemnify and hold harmless the Photographer against any and all claims, costs, and expenses, including attorneys' fees, arising when the uses exceed the uses allowed pursuant to this agreement and an action is commenced by a third party due to the Client's misuse.

10. ARBITRATION. All disputes shall be submitted to binding arbitration before _____ in the following location _____ and settled in accordance with the rules of the American Arbitration Association. Judgment upon the arbitration award may be entered in any court having jurisdiction thereof.

11. ASSIGNMENT. The Client shall not transfer or assign any rights or obligations hereunder without the consent of the other Photographer. Additionally, the Photographer shall have the right to assign monies due.

12. TOTAL AGREEMENT AND NONWAIVER. This Agreement constitutes the full understanding between the parties hereto. Its terms may only be modified by a written instrument signed by both parties. A waiver of a breach of any of the provisions of this Agreement shall not be construed as a continuing waiver of other breaches of the same or other provisions hereof. This Agreement shall be governed by the laws of the State of _____.

DELIVERY MEMO

Client: _____ Date: _____

Address: _____

Telephone: _____

QUANTITY	FORMAT	ORIGINAL	DESCRIPTION/FILE NUMBER	VALUE*
_____	_____	_____	_____	_____
_____	_____	_____	_____	_____
_____	_____	_____	_____	_____
_____	_____	_____	_____	_____
_____	_____	_____	_____	_____
_____	_____	_____	_____	_____
_____	_____	_____	_____	_____
_____	_____	_____	_____	_____

*Value is based upon loss, theft, or damage.

One signed copy of this form must be received by the Studio on or before the thirtieth (30th) day after the date set forth above. The signature of the Client shall be considered as the Client's acceptance of the accuracy of the information written above and that the photographs are suitable for reproduction. No objections of any type shall be the responsibility of the Studio if receipt of this form or the nonreceipt of this form by the Studio from the Client occurs after the thirtieth (30th) day.

Copyright and all reproduction rights in the photographs are the property of the Photographer. The Client acknowledges that the photographs shall not be displayed, copied, or modified. Any and all reproduction shall be allowed only upon the Photographer's written permission.

The Client agrees to assume full responsibility and be strictly liable for loss, theft, or damage to the photographs from the time of shipment by the Photographer. Reimbursement for loss, theft, or damage to a photograph shall be in the amount of the value entered for that photograph. Both the Client and Photographer agree that the specified values represent the value of the photographs. If no value is entered for an original transparency, the parties agree that a fair and reasonable value is $1,500 (one thousand five hundred dollars).

The Client agrees to insure the photographs for all risks from the time of shipment from the Photographer until the time of delivery to the Photographer for the values shown on the front of this form.

Acknowledged and Accepted: _____ (Company Name)

Date: _____

By: _____ (Authorized Signatory, Title)

22. PHOTOGRAPHER–AGENT CONTRACT FOR ASSIGNMENTS

One method of developing a market or obtaining assignments is to have an agent working for you. There are different types of agents, but all work to get you assignments. The terms that govern these arrangements should be specific and in writing.

In wedding photography, party planners and coordinators may introduce clients to photographers. In most of these cases, these planners and coordinators (who we'll refer to as agents) send the potential client to the photographer and it is up to the photographer to close the deal. In such an arrangement, the photographer retains the control he needs when doing business with the client. When the agent simply provides a referral and does not sign the contract with the client, then a simple exchange of letters may be adequate.

However, if the agent is the person who will close the deal, we would recommend a photographer–agent contract for assignments. This will clearly state the terms of the arrangement, covering payments, samples, limitation of territories (if any), and whether the agent has an exclusive or nonexclusive right in any given area. You might, for instance, restrict the agent's field of work to a particular market or exclude a certain list of potential or existing clients. Additionally, you may exclude rights for any electronic use and whether any of the assignments he produces may be electronic.

The duration of the contract is important, since an open-ended arrangement can lead to problems down the road—particularly if there is a period of inactivity and then you obtain an assignment within the agent's territory.

Commissions must also be stated in the contract, as an accounting requirement. A paragraph that refers to payment is equally important. The right to audit the agent's books and accounting should be incorporated, too. Without it you may lose control of the monetary side of the arrangement.

As in so many working relationships, there are times when modification is called for. Paragraph 14 of the proposed contract provides for amendments that may be merged with the original contract.

Paragraph 10 refers to the nonassignment of the contract. It is unwise to permit an agent to reassign his or her contract to another agent, as you will lose control of the terms of the contract. Additionally, if there was no such prohibition, you would have no idea who might be working on your behalf.

Note too that the contract has a governing law statement (Paragraph 15). You will need to require that any legal disputes between you and your agent are to be resolved in your state, not his or hers.

Samples provided by the photographer are to be loaned for the duration of the contract and returned when it ends. It is not uncommon for agents to mistreat samples, and photographers who do not have a contract with their agent have to cover the loss themselves. Samples cost money and should not be treated as gifts and neglected or abused by third parties. Therefore, the contract should make the agent responsible for the safekeeping of these examples of the photographer's craft.

Promotional expenses should also be agreed upon at the time of the contract, so that there are no disputes as to who must pay these expenses.

The contract we suggest also makes it clear that the agreement does not create a partnership, nor does it create an employment of the agent. The agent is an independent contractor. There are a number of reasons why this is important, not the least of which is taxation. If the contract fails to make this independent status clear, the photographer may be seen as a employer and be responsible for withholding income taxes and social security taxes as well as unemployment contributions.

The following is the recommended contract.

PHOTOGRAPHER–AGENT AGREEMENT

THIS AGREEMENT, is entered into this _____ day of _____, 20_____, by and between _____ (hereinafter referred to as the "Photographer"), with a principal place of business at _____, and _____ (hereinafter the "Agent"), with a principal place of business at _____ _____.

WHEREAS, the Photographer has a successful business in photography and is well respected in the community; and

WHEREAS, the Photographer desires to sell the Photographer's work to new markets with the assistant of an agent; and

WHEREAS, the Photographer desires to enter into this Agreement to have Agent represent the Photographer and his work in these new markets; and

WHEREAS, the Agent desires to represent the Photographer and his work;

NOW, THEREFORE, in consideration of the recitals above and the obligations and promises hereinafter set forth and other valuable consideration, the sufficiency and receipt which is hereby acknowledged, the parties agree as follows:

1. AGENCY. The Agent has the ability to generate business for the Photographer based up the Agent's years of experience and the Agent's relationships within the community. On behalf of the Photographer, the Agent shall act to obtain new assignments within the scope of this Agreement. The Agent shall be responsible for:

(A) Geographical area: _____

(B) Specifically, the Agent will be responsible for the following markets: _____ _____

The following are Additional categories which Agent may represent for on behalf of Photographer:

[] Advertising [] Corporate [] Book publishing

[] Magazines [] Other, specified as _____

The Agent agrees that this Agreement is for very specific rights and any rights not expressly identified are not transferred to the Agent but are retained by the Photographer.

2. BEST EFFORTS. When Agent is in the process of submitting the Photographer's work, which may result in the securing of assignments for the Photographer, the Agent agrees to use his best effort. The Photographer shall be ultimately responsible for the negotiation of the terms of any photography assignment.

3. SALES AIDS. The Photographer agrees to provide the Agent with Sales Aids for the purpose of assisting the Agent with the closing of any assignment. The rights, title, and interest which are not implied or expressly identified remain the property of the Photographer. Should the Agent have a loss or damage on any of the Sales Aids, the Agent shall take responsibility for their actions and pay the Photographer for said Sales Aid.

4. COMMENCEMENT DATE AND TERM. The commencement date shall be the date of this Agreement, which is the date first set forth above, and shall continue for a term of one year, unless terminated as provided in Paragraph 9.

5. COMMISSIONS. As part of the consideration for the Agent to enter into this Agreement, the Photographer shall pay to Agent based upon the following commission schedule:

(A) _____ percent of the assignment billing for those customers who have never been represented by another photographer or Agent.

(B) _____ percent of the billing, for house accounts in which the assignment is for a customer who was a customer of the Photographer prior to the term of this Agreement.

It is understood by both parties that no commissions shall be paid on any assignments in which the Photographer fails

to receive payment, regardless of the reason for the lack of payment.

6. BILLING AND PAYMENTS. The Photographer shall be responsible for all billings. Payments shall be made within fifteen (15) days in which Photographer receives payment. If a payment is late, the Photographer shall pay a late fee equal to five percent (5%) of the amount due.

7. PROMOTIONAL EXPENSES. Promotional Expenses shall be defined as advertising of any type including but not limited to direct mail, radio, and trade shows. The Parties have agreed that payment for such expenses shall be paid, _____ percent (___%) by the Agent and _____ percent (___%) by the Photographer including incidentals such as shipping, insurance, and similar marketing expenses.

8. ACCOUNTINGS. The Photographer shall provide the Agent with a quarterly accounting displaying all assignments for that period. The accounting shall include the clients' names, the fees paid, any expenses incurred by the Photographer, the amounts still payable to the Agent, and the sums already paid to the Agent.

9. TERMINATION. Either Party may terminate this Agreement by giving thirty (30) days written notice to the other party. If the Photographer receives assignments after the termination date from clients originally obtained by the Agent during the term of this Agreement, the commission specified in Paragraph 5(A) shall be payable to the Agent. If the Photographer receives assignments after the termination date from clients originally obtained by the Agent as defined in 5(B) during the term of this Agreement, the Agent shall not be entitled to a commission.

10. NO ASSIGNMENT. This Agreement shall not be assigned by either of the parties hereto. The death of either party shall terminate this agreement and all of its obligations hereunder. This Agreement shall not be binding on and inure to the benefit of the successors, administrators, executors, or heirs of the Agent and the Photographer.

11. DISPUTE RESOLUTION. All disagreements between the Parties under this Agreement shall be submitted to arbitration under the rules of the American Arbitration Association.

12. NOTICES. All notices shall be validly served upon a party if served to the parties at their respective addresses set forth above. For purposes of this Agreement, notice shall be deemed received on the send day following the mailing of the notice via first class United State Post Office Mail.

13. RELATIONSHIP OF THE PARTIES. The Agent is acting as an independent contractor. This Agreement is not an employment agreement, nor does it constitute a joint venture or partnership between the Photographer and the Agent.

14. TOTAL AGREEMENT. There are no oral or other written agreements that modify or amend this writing unless said writing is dated after the execution of this Agreement and expressly references this paragraph. This Agreement reflects the total understanding of the Parties.

15. GOVERNING LAW. This Agreement shall be governed by the laws of the State of _____.

IN WITNESS WHEREOF, the parties have signed this Agreement as of the date set forth above.

Photographer: _____ Agent: _____

Every photographer has potential to find work as a fine art provider. Many specialize in this field and others can produce images that have fine art potential. When you have the images and you seek to sell them, there are many ways in which you may do so. One is to have a gallery represent you. Alternately, you may sell them personally.

SELLING YOUR WORK YOURSELF

Should you decide to sell fine art without the assistance of an agent or gallery, you should be aware that it is possible for your work to be copied if your bill of sale does not clearly state that the work sold may not be reproduced in any form whatsoever. The bill of sale should also state that the price paid does not provide a release that allows the work to be reproduced, and that any reproduction thereof is at the discretion of the creator. The following is a recommended bill of sale.

PHOTOGRAPHER–GALLERY CONTRACT

Selling your work via a gallery requires a very specific document that describes: the scope of the agency; the

FINE ART BILL OF SALE

In consideration of the sum of $_____, paid to _____ (hereinafter the "Photographer") by _____, (hereinafter the "Purchaser"), and for other good and valuable considerations, the Photographer hereby sells, assigns, transfers, and sets over to the Purchaser all the rights, title, and interest (including all copyright interest) in and to the following described Fine Art Photographs:

The Purchaser shall have the absolute right to use the Fine Art Photographs in any form, in any medium and for any purpose whatsoever.

As an inducement for the Purchaser to purchase the aforesaid Fine Art Photographs from the Photographer, and in consideration of such purchase, the Photographer represents and warrants the Purchaser the following: (A) that the Fine Art Photographs are original; (B) that the Photographer is the only owner of the Fine Art Photograph(s); (C) that the Photographer has full power to sell the Fine Art Photograph(s) to the Purchaser; and (D) that the Fine Art Photographs have not been used or published in whole or in part.

For the aforesaid considerations, the Photographer agrees to hold the Purchaser harmless from and against any loss, damage, or expense (including court costs and reasonable attorneys' fees) that it may suffer or incur as a result of any breach or alleged breach of the foregoing warranties.

This Bill of Sale shall inure to the benefit of the Purchaser's subsidiaries, affiliates, licensees, successors, and assigns.

Agreed to on this _____ day of _____, 20_____

_____ _____

Photographer Purchaser

term of the agreement and required notice of termination of the agreement; how the work provided for gallery sale is to be exhibited; a list of exhibition expenses provided for in the agreement; and commissions, payments, and accounting.

The scope of the agency establishes the gallery's exclusive or nonexclusive right to sell the images and limits the area or region in which the gallery is permitted to sell the work. This is needed in the event that you are selling a limited edition of a work and want to sell copies in other areas or regions. This will be negotiated between you and the gallery and then written into the contract. If you do not have this in your contract, you may find that the gallery may claim that it has the right to sell universally. Then, if you sell copies or allow others to sell in other areas, the gallery may demand commissions on those sales or seek to have the contract deemed void.

Galleries need time to both advertise and promote your work, and the contract should allow reasonable time for this to take place. However, the term of the contract should be negotiated so that both parties are comfortable with the term, and that term should be written into the contract. It is not recommended that the term be open-ended. A 60-day notice of termination by either party should also be provided. Additionally, the death of the photographer or insolvency of the gallery should normally end the contract. However, it may be provided that, in the event of the death of the photographer, the works shall be returned to his or her heirs. If the gallery should become insolvent, then the work should be returned to the photographer at the gallery's expense.

> Galleries need time to both advertise and promote your work, and the contract should allow reasonable time for this to take place.

You should negotiate the space in which your work is to be exhibited, and that area should be described in the contract since you need to be assured that the gallery will not reduce your exposure and potential sales if the they decide to modify the space agreed. The contract should also provide you with artistic control over how your work is being presented and advertised.

In the suggested contract, the paragraph covering exhibition details how the expenses for the promotion and advertising are to be shared. This will ensure that you are not presented with unexpected charges that will reduce your income from the sale of your work. A list of expected expenses should be included in the contract. We suggest a very solid basis for an agreement of likely expenses below, but you may need to modify it according to individual circumstances.

The suggested contract also covers important general terms with regard to the insurance of the work to be exhibited, copyright protection, and what is required in the event of damage to the work provided to the gallery, and states that the contract is not assignable by the gallery.

The paragraph that refers to security interest protects the photographer against any claims by creditors of the gallery and states that the photographer shall have all the rights of a secured party under the uniform commercial code. This prevents creditors of an insolvent gallery from seizing the photographer's work.

Appendix A (following the contract) provides a record of the consignment of the work to be exhibited, and Appendix B provides an important statement of account and lists the work that remains unsold. The recommended contract appears on pages 139–41.

CONTRACT FOR THE SALE OF FINE ART PHOTOGRAPHY

The sale of most fine art photography is accomplished by a very simple exchange of the art and for the payment, followed by the issuing of a sales receipt. This is not the correct way to handle such sales.

In making this comment, I am aware that a lot of fine art photographs are sold at art shows, county fairs, and in similar circumstances. This may be acceptable if the value of the work sold is relatively low, but if the photographer has a significant reputation and his work is of a much higher value, he should seek to sell his work using the contract recommended below.

The ongoing issue of copyright, a risk of loss, and insurance of expensive photographs are all of importance to the photographer and should be covered as recommended. The suggested contract appears on pages 142–43.

GALLERY AGREEMENT

THIS AGREEMENT is entered into on this _____ day of _____, 20_____, by and between _____ (hereinafter referred to as the "Photographer"), with a principal place of business at _____ and _____ (hereinafter referred to as the "Gallery"), with a principal place of business at _____.

WHEREAS, the Photographer desires to have certain photographs displayed at the Gallery; and

WHEREAS, the Gallery desires to display the Photographer's photographs under the terms and conditions of this Agreement,

NOW, THEREFORE, in consideration of the above mentioned recitals and the mutual covenants hereinafter set forth and other valuable consideration, the receipt and sufficiency which is hereby acknowledged, the parties hereto agree as follows:

1. SCOPE OF AGREEMENT. The Gallery shall serve in an agency capacity to the Photographer for the purpose of showing and selling of the Photographer's works as described: _____ _____. This agency shall cover only Works that are described herein and shall not be construed as the licensing of reproduction rights (whether for an assignment, client, stock photography, or otherwise). The Gallery shall document receipt of all Works consigned hereunder, and such receipt shall be acknowledged by the signing and returning to the Photographer a receipt in the form attached and made part of Appendix A to this Agreement.

2. TERM AND TERMINATION. This Agreement shall be valid and binding for a term of _____ years. Either party may terminate this Agreement before the expiration of the term herein by giving the other Party thirty (30) days' written notice. In the event of the death of the Photographer, this Agreement will automatically terminate. If the Gallery becomes bankrupt or insolvent or should relocate to area which is not acceptable to the Photographer, then this Agreement shall automatically terminate.

3. EXHIBITIONS. The Gallery shall provide a solo exhibition for the Photographer. A schedule of the exhibition times and days shall be as follows: _____. Each exhibition shall be exclusively devoted to the Photographer. The Parties acknowledge and agree that the artistic control over the exhibition shall reside exclusively with the Photographer. This includes but is not limited to the quality of reproduction of such work for promotional or advertising used for the exhibitions. The expenses of the exhibition shall be paid for in the respective percentages shown below:

EXHIBITION EXPENSES	PHOTOGRAPHER	GALLERY
Transportation and packing .	_____	_____
Promotion .	_____	_____
Frames .	_____	_____
Installations .	_____	_____
Other miscellaneous expenses .	_____	_____

4. COMMISSIONS. _____ percent of the actual sales price of each work sold shall be earned by the Gallery.

5. PRICES. The Gallery shall sell the works at the retail prices shown on the Record of Consignment, subject to the Gallery's right to make customary trade discounts to such purchasers as museums and designers.

6. PAYMENTS. All payments from sales shall become due and payable from the Gallery to the Photographer immediately upon the sale of the Work. The Gallery agrees to have all payments processed and delivered to the Photographer with-

in thirty (30) days of any sale. All sales on credit shall be considered cash sales for the purpose of this Agreement, and payment to the Photographer shall be as outlined above.

7. ACCOUNTING. Each calendar quarter, the Gallery shall provide the Photographer with a written accounting. Each accounting shall state, for each work sold during the accounting period, the title of the work, the date of sale, the sale price, the name and address of the purchaser, the amounts due the Gallery and the Photographer, and the location of all works which are still on consignment with the Gallery. A final accounting shall be provided to the Photographer upon an event of termination of this Agreement.

8. INSPECTION OF BOOKS. Should the Photographer or one of the Photographer's agents have a desire to inspect the Gallery's accounting, then the Photographer shall make such request in writing to the Gallery, and the Photographer or agent shall have the ability to examine books and documentation during normal business hours of the Gallery.

9. LOSS OR DAMAGE. All loss or damage to any Works on consignment with the Gallery from the date of delivery to the Gallery until the work is returned to the Photographer or delivered to a purchaser shall be the responsibility of the Gallery. In the event of loss or damage that cannot be restored, the Photographer shall receive the same amount as if the work had been sold at the retail price listed in the Record of Consignment. If restoration is undertaken, the Photographer shall have the exclusive right to choose the restorer.

10. INSURANCE. The Gallery shall insure the Works for 100 percent (100%) of the retail price as agreed to and reflected on the Record of Consignment.

11. COPYRIGHT. The Gallery shall provide copyright notices on all reproductions of the Works used for any purpose whatsoever.

12. SECURITY INTEREST. Title to and a security interest in any Works consigned or proceeds of sale under this Agreement are reserved to the Photographer and are hereby granted from the Gallery to the Photographer. Should the Gallery be in default under this Agreement, the Photographer shall have all the rights of a secured party under the Uniform Commercial Code (UCC), and the Works shall not be subject to claims by the Gallery's creditors. UCC financing statements shall be executed by the Gallery and delivered to the Photographer such that the Photographer may perfect his or her security interest in the Works. In the event of the purchase of any work by a party other than the Gallery, title shall pass directly from the Photographer to the other party. In the event of the purchase of any work by the Gallery, title shall pass only upon full payment to the Photographer of all sums due hereunder. The Gallery agrees not to pledge or encumber any works in its possession, nor to incur any charge or obligation in connection therewith for which the Photographer may be liable.

13. ASSIGNMENT. This Agreement shall not be assignable by either party.

14. MODIFICATIONS. There are no agreements between the parties which have not been reduced to this Agreement. Any and all modifications of this Agreement must be in writing and signed by both parties. This Agreement constitutes the entire understanding between the parties hereto.

15. GOVERNING LAW. This Agreement shall be governed by _____ state law.

IN WITNESS WHEREOF, the parties hereto have signed this Agreement as of the date first set forth above.

Photographer: _____ Gallery: _____

By: _____

Its: _____

APPENDIX A
WORKS ON CONSIGNMENT WITH GALLERY

The following represent the Works of the Photographer which are on consignment with the Gallery:

Title Description Retail Price

1._____ _____ _____

2._____ _____ _____

3._____ _____ _____

4._____ _____ _____

5._____ _____ _____

Gallery: _____

By: _____

APPENDIX B
GALLERY ACCOUNTING FOR PHOTOGRAPHER

Date_____, 20___

This statement represents the accounting for the periods _____, 20___, through _____, 20___.

The following Works that were on consignment with the Gallery were sold during the above period:

TITLE	DATE SOLD	PURCHASER'S NAME AND ADDRESS	SALE PRICE	GALLERY'S COMMISSION	DUE PHOTOGRAPHER
_____	_____	_____	_____	_____	_____
_____	_____	_____	_____	_____	_____
_____	_____	_____	_____	_____	_____
_____	_____	_____	_____	_____	_____
_____	_____	_____	_____	_____	_____

Based upon the above accounting, the Photographer is due or has already been paid $_____ for this period.

On consignment with the gallery are the following Works of the Photographer:

TITLE **LOCATION**

1. _____ _____

2. _____ _____

3. _____ _____

4. _____ _____

5. _____ _____

Gallery: _____

By: _____

FINE ART PHOTOGRAPHY CONTRACT

This Agreement is entered into this _____ day of _____, 20_____, by and between _____ (hereinafter referred to as the "Studio"), whose principal place of business is at _____ , and _____ (hereinafter referred to as the "Client"), whose place of residence is at _____ .

WHEREAS, the Studio/Photographer has created a unique image which the parties agree to described as follows: _____ _____ (the "Photograph"); and

WHEREAS, the Studio has full right, title, and interest in the Photograph; and

WHEREAS, the Studio desires to sell the Photograph; and

WHEREAS, the Client desires to purchase the Photograph.

THEREFORE, it is AGREED as follows:

In consideration of the foregoing recitals and the mutual obligations, covenants, and conditions hereinafter set forth, and other valuable considerations the receipt and sufficiency which is hereby agreed and acknowledged, the parties hereto agree as follows:

1. The Studio warrants that this Photograph is unique inasmuch as the Studio does not have another image which it has sold, available for sale or will sell for the specific photography session from which this Photograph was taken. Nor will the Studio create another image which involves the same props and/or participants to create an image that would be so similar that the average person would confuse the new image with the Photograph. The warranties in this paragraph are hereby modified by the following if the Photograph is part of a limited edition.

2. If the Photograph is part of a limited edition:

 (A) _____ is the size of the edition;

 (B) _____ multiples are signed;

 (C) _____ are unsigned;

 (D) _____ are numbered;

 (E) _____ are unnumbered;

 (F) _____ proofs exist;

The master image has not been cancelled or destroyed by the Studio.

3. SALE. The Studio hereby agrees to sell and transfer all rights title and interest in the Photograph to the Client. The title shall pass to the Client and a bill of sale be delivered to the Client at such time as full payment is received by the Studio.

4. PRICE. The Client agrees to purchase the Photograph for the agreed upon price of $ _____, and shall also pay any applicable sales taxes.

5. PAYMENT. Payment shall be made in full upon the signing of this Agreement.

6. DELIVERY. The Client shall arrange for delivery to the following location: _____ _____ no later than _____, 20_____. Client shall pay all the expenses of delivery (including, but not limited to, insurance and transportation).

7. RISK OF LOSS AND INSURANCE. The risk of loss or damage to the Photograph and the provision of any insurance to cover such loss or damage shall be the responsibility of the Client from the time the Photograph is placed in the custody of the Client or delivery service hired by the Client.

8. COPYRIGHT AND REPRODUCTION. The Studio reserves all reproduction rights, including the right to claim statutory copyright, in the Photograph. The Photograph may not be photographed, sketched, painted, or reproduced in any man-

ner whatsoever without the express, written consent of the Studio. All approved reproductions shall bear the following copyright notice: © by (Studio's name) 20_____.

9. MISCELLANEOUS. This Agreement shall be binding upon the parties hereto, their heirs, successors, assigns, and personal representatives. This Agreement constitutes the entire understanding between the parties. A waiver of any breach of any of the provisions of this Agreement shall not be construed as a continuing waiver of other breaches of the same or other provisions hereof. This Agreement shall be governed by the laws of the State of _____.

IN WITNESS WHEREOF, the parties hereto have signed this Agreement as of the date first set forth above.

Studio: _____ Client: _____

24. PHOTOGRAPHER'S LECTURE CONTRACT

I have to admit that, having made nearly two hundred presentations of varying kinds, I have been only too willing to provide my services and insights either by a handshake or by accepting a very inadequate contractual agreement offered by the respective organization. I will admit that there have been perhaps as many as six occasions where there was a misunderstanding concerning both payment and expenses. On at least three of these, I was not happy with the way the disputes were resolved. This is all due to the relative inadequacy of the agreement by which I made my appearance. Very few organizations provide a reliable and comprehensive contract when acquiring a speaker for their programs.

Should you be asked to provide a lecture or presentation for any organization, it is recommended that you review the contract carefully. If it does not provide the same elements that we recommend in our lecture contract, you should request the organization provide you with a contract that matches ours.

> Should you be asked to provide a lecture or presentation for any organization, it is recommended that you review the contract carefully.

Many organizations seek speakers on terms that can result in the speaker actually losing money because too many incidental expenses are not included in the contract. For instance, at the time of writing this book, an average fee for a presentation of two to four hours was about $500 and did not include incidental expenses. This can readily reduce the value of the speaking fee to less than half.

Obviously, there are times when you may be prepared to sign such a contract for different reasons. Therefore, the recommended contract may be modified to meet your intentions. Our recommended contract may be negotiated with the sponsor or organization so as to ensure that you have a reliable understanding of what you are providing and what the organization is to provide in addition to payment.

Many lecturing photographers have videos, books, and other products for sale to those attending their programs. If you wish to sell such products at your programs, you will need to make sure that it is included in the contract. This will also mean you need to include any facilities that will be required for you to do so. Do not leave out any details. The sponsor may wish to limit your options, and you should make sure that they do not limit your potential.

Additionally, suppliers of photographic materials and services are often invited to provide financial support or even finance the entire program. Speakers are normally requested to supply the names of potential financial sponsors for the presentation. It is not recommended that these be included in the lecture contract, as this is only a recommendation to the organizer and is not substantive.

Review our proposed contract and use it as a model for any speaking engagement. The contract is also a good one for organizations to use when signing on speakers.

The following is the recommended contract.

LECTURE AGREEMENT

THIS AGREEMENT is entered into on this _____ day of _____, 20_____, by and between _____ (hereinafter referred to as the "Photographer"), with a principal place of business at _____ and _____ (hereinafter referred to as the "Promoter"), with a principal place of business at _____.

WHEREAS the Promoter desires to hire the Photographer based upon the past works of the Photographer; and

WHEREAS the Promoter wishes the Photographer to visit _____ so that the attendees of _____ may have contact with the Photographer; and

WHEREAS the Photographer desires to lecture for the Promoter;

NOW, THEREFORE, in consideration of the above recitals and the mutual covenants and agreements hereinafter set forth, and other valuable considerations, the receipt and sufficiency of which is hereby acknowledged, the parties hereto agree as follows:

1. LECTURE. On _____ the Photographer hereby agrees to perform the following: _____, located at _____ _____ between the hours of _____ and _____. The Photographer further agrees that as part of this Agreement, the Photographer will include _____ _____.

2. PAYMENT. As payment in full for the Photographer's lecture services, the Promoter agrees to pay the sum of $ _____. One half of the payment shall be paid to the Photographer upon the Photographer's arrival, and the balance shall be paid upon the completion of the lecture.

3. EXPENSES. In addition to the payments provided under Paragraph 2, the Promoter agrees to reimburse the Photographer for travel, food, hotel, and any other expenses detailed below:

Expenses: _____ Amount: $ _____.

The reimbursement for all expenses shall be made at the same time as the second half of the payment fee due at the end of the lecture.

The Promoter shall provide delivery of any and all airline tickets, rental car, and hotel reservations within one week prior to the lecture dates set forth above. Further, any other hospitality needs of the Photographer shall be as follows: _____.

4. INABILITY TO PERFORM. Should the Photographer not be able to lecture on the scheduled dates above due to an injury or illness or some other reason which is not an Act of God and not a fault of the Promoter, the Promoter shall have no duty to make any payments under Paragraphs 2 and 3 above. Should the Promoter be prevented from having the Photographer lecture due to Acts of God or other cause beyond the Promoter's control, the Promoter shall make payment to the Photographer for all of the Photographer's expenses that the Photographer actually incurred.

5. LATE PAYMENT. The Promoter agrees to pay to the Photographer a late charge equal to _____ percent (____%) of the total amount due in the event the Promoter does not make final payment as outlined in Paragraphs 2, 3, or 7 as additional liquidated damages. Said interest is to run from the date stipulated for payment in Paragraphs 2, 3, or 7 until such time as payment is made.

6. COPYRIGHTS AND RECORDINGS. All copyrights as they relate to recording, including but not limited to electronic transcription, tape recording, wire recording, film, videotape, or other similar or dissimilar methods of video and audio shall be retained by the Photographer. Only upon written consent of the Photographer shall any such recording be made, and the Photographer shall be entitled to additional compensation for such use.

7. INSURANCE AND LOSS OR DAMAGE. The Promoter agrees that it shall be strictly liable for any and all damage or loss of the works which the Photographer has agreed to share during the lecture time. Such liability shall cover the time in which the works leave the Photographer's studio and shall continue until they are returned to the Photographer's studio. The Promoter shall contract with a willing insurance carrier to provide wall-to-wall insurance benefits in the amount of $_____, which amount has been approved by the Photographer. Additionally, the Promoter shall reimburse the Photographer for any and all shipping expense, including the cost of wrapping and protecting such works.

8. FULL AGREEMENT. There are no valid oral or side agreements which supplement or modify this Agreement. This Agreement is the full understanding of both the Promoter and the Photographer. Any additions or deletions to this Agreement must be made in writing and must reference this paragraph and be signed by both parties to be binding.

9. GOVERNING LAW. This contract shall be governed by the laws of the State of _____ .

In Witness Whereof, the parties hereto have signed this Agreement as of the date first set forth above.

Photographer: _____ Promoter: _____

By: _____

Its: _____

Schedule of Photographs

TITLE	DESCRIPTION	SIZE	VALUE
1._____	_____	_____	_____
2._____	_____	_____	_____
3._____	_____	_____	_____
5._____	_____	_____	_____
5._____	_____	_____	_____
6._____	_____	_____	_____

25. BOOK PUBLISHING CONTRACT

As you read this book you may well wonder how we the authors and the publisher come to agreeable terms for its publication. Often the agreement is by a mutual consent that is then put in writing, mostly by the publisher. Many publishers have a standard contract that they use for all their productions. So, if you have a manuscript accompanied by photographic illustrations that you would like published, your obvious first task is to find a suitable publisher. Most publishers tend to specialize so, as a photographer, you need a publisher like Amherst Media (the publisher of this book) that specializes in books on photography.

When you have found the publisher that best suits your proposed book, you will want to know under what terms the publisher will agree to publish your work. If the publisher has a standard contract, you may want to review it before an agreement is finalized and an actual contract is presented for your signature. Most publishers have readily acceptable contracts, and you are not likely to find much with which to take issue. But, in order to appreciate what is involved, the contract that we recommend is a guide as to the issues with which you should be concerned.

Some publishers may make an up-front publication payment (an advance) and include in their contract a reduced royalty, or not pay royalties until a minimum number of copies are sold. Others may make no up-front payment and pay, instead, on all book sales. Most publishers pay royalties every six months after the book is published.

Most publishers have readily acceptable contracts, and you are not likely to find much with which to take issue.

The contract we are presenting here contains terms that are similar to the ones used by most publishers, even if the way the contract is written differs from ours. Never take contracts lightly; missing just one element may prove to be expensive.

Our recommended book publishing contract appears on pages 148–51.

BOOK PUBLISHING AGREEMENT

THIS AGREEMENT is entered into this _____ day of _____, 20___, by and between _____ (hereinafter the "Publisher"), with a principal place of business at _____, and _____ _____ (hereinafter the "Photographer"), with a principal place of business at _____.

WHEREAS, the Photographer desires to write a book in which the principal subject of the book is _____ _____ (hereinafter referred to as the "Book"); and

WHEREAS, the Publisher desires to publish the Book written by the Photographer; and

WHEREAS, the Parties shall work together as mentioned above, subject to the mutual obligations, covenants, and conditions herein,

NOW, THEREFORE, in consideration of the recitals above and the mutual covenants and obligations hereinafter stated, and other good and valuable consideration, the Parties hereto agree as follows:

1. PUBLISHER'S RIGHTS. The Photographer conveys, transfers, and grants to the Publisher the unpublished Book titled _____, certain limited, exclusive rights to publish the Book in the form of a _____ book, to be sold only in _____.

2. RIGHTS RETAINED BY PHOTOGRAPHER. All rights not expressly transferred to the Publisher are reserved to the Photographer, including but not limited to rights to works which can be stored and retrieved electronically from such media as computer disks, CD-ROM, DVD, hard drives, and tapes.

3. MANUSCRIPT. The Photographer shall deliver to the Publisher a complete manuscript on or before _____, 20_____, in a form and content agreeable to the Publisher. The manuscript shall be delivered in the following format: _____. The manuscript shall include any additional materials listed in Paragraph 4. If the Photographer fails to deliver the complete manuscript within sixty (60) days after receiving notice from the Publisher of failure to deliver on time, the Publisher shall have the right to terminate this Agreement and receive back from the Photographer all monies advanced to the Photographer pursuant to Paragraphs 4, 5, and 9.

4. ADDITIONAL MATERIALS. The following materials shall be provided by the Photographer: _____ _____. The cost of providing these additional materials shall be borne by the Photographer, provided, however, that the Publisher at the time of signing this Agreement shall give a nonrefundable payment of $_____ to assist the Photographer in defraying these costs, which payment shall not be deemed an advance to the Photographer and shall not be recouped as such.

5. AUTHORIZATION. The Photographer agrees to obtain all necessary authorizations for the use of materials which may be copyrighted by others. Any and all cost of providing these permissions shall be the responsibility of the Photographer. The Parties agree that at the time of signing this Agreement, the Publisher shall give a nonrefundable payment of $_____ to assist the Photographer in defraying these costs, which payment shall not be deemed an advance to the Photographer and shall not be recouped. All Permissions shall be obtained in writing, and copies shall be provided to the Publisher when the manuscript is delivered.

6. PUBLICATION TIME. The Publisher shall publish the Book within _____ months of the delivery of the complete manuscript. Failure to so publish shall give the Photographer the right to terminate this Agreement sixty (60) days after giving written notice to the Publisher of the failure to publish. In the event of such termination, the Photographer shall have no obligation to return monies received pursuant to Paragraphs 4, 5, and 9.

7. ROYALTIES. The Publisher shall pay the Photographer the following royalties: _____ percent (___%) of the suggested retail price on the first _____ copies sold; _____ percent (_____%) of the suggested retail price on the next _____ copies sold; and _____ percent (___%) of the suggested retail price on all copies sold thereafter. Discounts to the royalty rate shall apply in the following circumstances: _____

_____.

Royalties rates shall be based upon the total copies sold, including revised editions. The number of copies sold shall be modified by any and all copies which are returned. For purposes of royalty category, when a copy is returned, the category shall be the same royalty category in which the copies were originally reported as sold.

8. ANCILLARY RIGHTS. The following ancillary rights may be granted by one of the parties as indicated below and the proceeds shall be divided as indicated in the paragraph:

ANCILLARY RIGHT	RIGHT TO BE GRANTED		DIVISION OF PROCEEDS	
	(Photographer)	(Publisher)	(Photographer)	(Publisher)
_____	_____	_____	_____	_____
_____	_____	_____	_____	_____
_____	_____	_____	_____	_____
_____	_____	_____	_____	_____
_____	_____	_____	_____	_____

A defaulting party shall have no rights pursuant to Paragraph 8 if the defaulting party is in default under any of its obligations under this Agreement. All ancillary rights not set forth in this paragraph are retained by the Photographer.

9. ADVANCES. At the time of the execution of this Agreement, the Publisher shall pay to the Photographer a nonrefundable advance of $_____.

10. ACCOUNTINGS. The Publisher shall deliver a report to the Photographer detailing to date the number of copies printed and bound, the number of copies sold and returned for each royalty rate, the number of copies distributed free for publicity purposes, the number of copies remaindered, destroyed, or lost, and the royalties paid to and owed to the Photographer, every three months.

11. PAYMENTS. Within fifteen (15) days of the close of each accounting period as defined in Paragraph 10 above, the Publisher shall pay the Photographer all monies due.

12. PHOTOGRAPHER'S RIGHT TO INSPECT. Upon the giving of written notice, the Photographer shall have the right to inspect the Publisher's accounts to verify the accountings. If there are any errors in the reported accounting and such errors are found to be a disadvantage to the Photographer and such error represents more than 5 percent (5%) of the payment made to the Photographer pursuant to the accounting, then the cost of said inspection shall be paid by the Publisher, including but not limited to the published hourly photography rate of the Photographer at the time the Photographer has invested in the inspection.

13. CREDIT FOR AUTHORSHIP AND COPYRIGHT. The registration of copyright shall be the sole responsibility of the Publisher. All rights conveyed to the Publisher by the Photographer under this Agreement are expressly conditioned on the Publisher taking the necessary steps to register the copyright on behalf of the Photographer. The copyright notice shall be in the Photographer's name on all copies of the Book. The Photographer shall receive authorship credit as follows:

_____.

14. WARRANTY AND INDEMNITY. The Photographer warrants and represents that he or she is the sole creator of the Book and owns all rights granted under this Agreement, and that the Book is an original creation and has not previously been published, and that the Book does not infringe any other person's copyrights or rights of literary property, nor, to his or her knowledge, does it violate the rights of privacy of, or libel, other persons. The Photographer agrees to indemnify the Publisher against any final judgment for damages (after all appeals have been exhausted) in any lawsuit based on an actual breach of the foregoing warranties. In addition, the Photographer shall pay the Publisher's reasonable costs and attorneys'

fees incurred in defending such a lawsuit, unless the Photographer chooses to retain his or her own attorney to defend such lawsuit. The Photographer makes no warranties and shall have no obligation to indemnify the Publisher with respect to materials inserted in the Book at the Publisher's request. Notwithstanding any of the foregoing, in no event shall the Photographer's liability under this paragraph exceed $_____ or _____ percent of sums payable to the Photographer under this Agreement, whichever is the lesser. In the event a lawsuit is brought which may result in the Photographer having breached his or her warranties under this Paragraph, the Publisher shall have the right to withhold and place in an escrow account _____ percent of sums payable to the Photographer pursuant to Paragraph 11, but in no event may said withholding exceed the damages alleged in the complaint.

15. ARTISTIC CONTROL. The Publisher shall be the final determiner of the title of the Book, the price of the Book, and the method and means of advertising and selling the Book. Additionally, the Publisher shall provide _____ free copies of the Book to the Photographer. The method of printing and the publishing processes, including but not limited to the date of publication, the form, style, size, and paper shall be at the sole discretion of the Publisher. The Publisher shall have final power of decision over all the foregoing matters except the following, which shall be controlled by the Photographer:

_____.

16. CHANGES TO THE BOOK. The Photographer shall have the exclusive right to make changes to the manuscript. The Publisher shall be granted the right to make editing changes, however the Photographer shall have the right to review such changes.

17. RIGHT TO PURCHASE ADDITIONAL COPIES. In addition to the free copies provided to the Photographer, the Photographer shall have the right to purchase additional copies at a _____ percent discount from the retail price.

18. REQUEST FOR REVISIONS. Upon a request from the Publisher, the Photographer agrees to revise the Book.

19. SUCCESSORS AND ASSIGNS. This Agreement is not assignable by either Party hereto. Upon written request, the Photographer may assign his payments to a third party. This Agreement shall be binding on the Parties and their respective heirs, administrators, successors, and assigns.

20. INFRINGEMENT. Either Party may pursue any infringements of any rights hereunder, and both the Photographer and the Publisher may file an action for such infringement. Any recovery shall be shared equally after deducting the expenses of the action. If either party chooses not to join in the suit, the other party may proceed; however, any recovery shall be retained by the Party that brought the action and not shared equally.

21. TERMINATION. The Photographer shall have the right to terminate this Agreement by written notice if: (A) the Book is out of print and the Publisher does not place the Book in print within sixty (60) days of receipt of such notice. Out of print shall be defined as a time and place whereby the Book is not available for sale in reasonable quantities in normal trade channels; (B) the Publisher fails to meet any of its requirements and obligations as specified in this Agreement. The Publisher shall have the right to terminate this Agreement as provided in Paragraph 3. This Agreement shall automatically terminate in the event of the Publisher's insolvency, bankruptcy, or assignment of assets for the benefit of creditors. In the event of termination of the Agreement, the Publisher shall grant, convey, and transfer all rights in the Book back to the Photographer.

22. MATERIALS AND COPIES UPON TERMINATION. Within sixty (60) days of notice of termination of this Agreement, the Photographer may purchase the plates, offset negatives, or electronic media at the scrap value and any remaining copies at the lesser of cost or remainder value.

23. PROMOTION. The Photographer shall consent to all distinguished uses of his name and photograph for the promotion of the Book.

24. ARBITRATION. The Parties agree that binding arbitration shall be the means to all disputes arising under this Agreement. Arbitrations shall be heard in the following location: _____ and shall be settled in accordance with the rules of the American Arbitration Association. Judgment upon the arbitration award may be entered in any court having jurisdiction thereof.

25. NOTICE. All notices may be served in written form by the use of first-class mail addressed to the Photographer or Publisher at the addresses given at the beginning of this Agreement and shall be deemed received five (5) days after mailing. Said addresses for notice may be changed by giving written notice of any new address to the other party.

26. MODIFICATIONS IN WRITING. All modifications of this Agreement must be in writing and signed by both parties.

27. WAIVERS AND DEFAULTS. Any waiver of a breach or default hereunder shall not be deemed a waiver of a subsequent breach or default of either the same provision or any other provision of this Agreement.

28. GOVERNING LAW. The law of the State of _____ shall be the governing law of this Agreement.

IN WITNESS WHEREOF, the parties have signed this Agreement as of the date first set forth above.

Photographer: _____ Publisher: _____

By:_____ By:_____

Its:_____

CONCLUSION

Previously, I have suggested that photographers are among the least likely of businesspeople to regard the legal aspects of their professional life to be of great concern. I have personally been quite amazed at the naivete of some of my colleagues when it comes to the contractual aspects of their commitments to clients and their clients' commitments to them.

In you consider how much large corporations invest in legal protection for their assets and business practices, the small considerations we have covered in this book are but a pittance, but they are fundamental to good business practice. What we have provided in this book is a set of legal guidelines that you can either adopt or disregard. I would, however, seriously suggest to you that if you ignore the issues we have addressed, there may be a day in your future when you will regret missing the opportunity to protect your interests with some of the tools we have provided.

I can appreciate that, for the layperson, legal terminology and wording is not something that most of us relish—often because it can be quite challenging to determine its precise meaning. We might even think that lawyers deliberately create documents in a style that defies our comprehension so that we frequently need to consult them to explain their meaning. However, the law requires specifics that are not necessarily reader friendly.

If, like me, you are a fan of television programs like *Law & Order*, you will have some appreciation for how the law is interpreted—and you'll understand why you need to protect yourself in situations where, potentially, your lawyer might have to argue your case. The language used in the documents we provide has been prepared with such potential in mind. Therefore, when you are considering the use of any of these documents as part of your protective legal armor, you should consult your attorney for a comprehensive look at their meaning, if needed.

However, I sincerely believe that the documents and the explanations are adequate as a basis for protecting your best interests. At the very least, the content of this book will give you an in-depth understanding of what governs the way we do business in an ever more litigious business environment.

Additionally, what we have discussed will have made you aware of the rights of your clients and how you must act to protect those rights—because the protections are mutual and need to be respected. This mutual respect is good for business and good business is good for our bottom line.

—*Norman Phillips*

INDEX

TRADITIONAL PHOTO-GRAPHIC EFFECTS WITH ADOBE® PHOTOSHOP®, 2nd Ed.

Michelle Perkins and Paul Grant

Use Photoshop to enhance your photos with handcoloring, vignettes, soft focus, and much more. Step-by-step instructions are included for each technique for easy learning. $29.95 list, 8½x11, 128p, 150 color images, order no. 1721.

MASTER POSING GUIDE FOR PORTRAIT PHOTOGRAPHERS

J. D. Wacker

Learn the techniques you need to pose single portrait subjects, couples, and groups for studio or location portraits. Includes techniques for photographing weddings, teams, children, special events, and much more. $29.95 list, 8½x11, 128p, 80 photos, order no. 1722.

THE ART OF COLOR INFRARED PHOTOGRAPHY

Steven H. Begleiter

Color infrared photography will open the doors to a new and exciting photographic world. This book shows readers how to previsualize the scene and get the results they want. $29.95 list, 8½x11, 128p, 80 color photos, order no. 1728.

HIGH IMPACT PORTRAIT PHOTOGRAPHY

Lori Brystan

Learn how to create the high-end, fashion-inspired portraits your clients will love. Features posing, alternative processing, and much more. $29.95 list, 8½x11, 128p, 60 color photos, order no. 1725.

THE ART OF BRIDAL PORTRAIT PHOTOGRAPHY

Marty Seefer

Learn to give every client your best and create timeless images that are sure to become family heirlooms. Seefer takes readers through every step of the bridal shoot, ensuring flawless results. $29.95 list, 8½x11, 128p, 70 color photos, order no. 1730.

BEGINNER'S GUIDE TO ADOBE® PHOTOSHOP®, 2nd Ed.

Michelle Perkins

Learn to effectively make your images look their best, create original artwork, or add unique effects to any image. Topics are presented in short, easy-to-digest sections that will boost confidence and ensure outstanding images. $29.95 list, 8½x11, 128p, 300 color images, order no. 1732.

PROFESSIONAL TECHNIQUES FOR
DIGITAL WEDDING PHOTOGRAPHY, 2nd Ed.

Jeff Hawkins and Kathleen Hawkins

From selecting equipment, to marketing, to building a digital workflow, this book teaches how to make digital work for you. $29.95 list, 8½x11, 128p, 85 color images, order no. 1735.

PROFESSIONAL DIGITAL PHOTOGRAPHY

Dave Montizambert

From monitor calibration, to color balancing, to creating advanced artistic effects, this book provides those skilled in basic digital imaging with the techniques they need to take their photography to the next level. $29.95 list, 8½x11, 128p, 120 color photos, order no. 1739.

GROUP PORTRAIT PHOTOGRAPHY HANDBOOK

Bill Hurter

Featuring over 100 image images by top photographers, this book offers practical techniques for composing, lighting, and posing group portraits—whether in the studio or on location. $29.95 list, 8½x11, 128p, 120 color photos, order no. 1740.

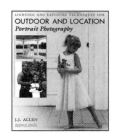

LIGHTING AND EXPOSURE TECHNIQUES FOR
OUTDOOR AND LOCATION PORTRAIT PHOTOGRAPHY

J. J. Allen

Meet the challenges of changing light and complex settings with techniques that help you achieve great images every time. $29.95 list, 8½x11, 128p, 150 color photos, order no. 1741.

THE ART AND BUSINESS OF
HIGH SCHOOL SENIOR PORTRAIT PHOTOGRAPHY

Ellie Vayo

Learn the techniques that have made Ellie Vayo's studio one of the most profitable senior portrait businesses in the U.S. $29.95 list, 8½x11, 128p, 100 color photos, order no. 1743.

THE ART OF BLACK & WHITE PORTRAIT PHOTOGRAPHY

Oscar Lozoya

Learn how master photographer Oscar Lozoya uses unique sets and engaging poses to create black & white portraits that are infused with drama. Includes lighting strategies, special shooting techniques, and more. $29.95 list, 8½x11, 128p, 100 duotone photos, order no. 1746.

THE BEST OF WEDDING PHOTOGRAPHY

Bill Hurter

Learn how the top wedding photographers in the industry transform special moments into lasting romantic treasures with the posing, lighting, album design, and customer service pointers found in this book. $29.95 list, 8½x11, 128p, 150 color photos, order no. 1747.

PHOTOGRAPHING CHILDREN WITH SPECIAL NEEDS

Karen Dórame

This book explains the symptoms of spina bifida, autism, cerebral palsy, and more, teaching photographers how to safely and effectively work with clients to capture the unique personalities of these children. $29.95 list, 8½x11, 128p, 100 color photos, order no. 1749.

PROFESSIONAL DIGITAL PORTRAIT PHOTOGRAPHY

Jeff Smith

Because the learning curve is so steep, making the transition to digital can be frustrating. Author Jeff Smith shows readers how to shoot, edit, and retouch their images—while avoiding common pitfalls. $29.95 list, 8½x11, 128p, 100 color photos, order no. 1750.

THE BEST OF CHILDREN'S PORTRAIT PHOTOGRAPHY

Bill Hurter

Rangefinder editor Bill Hurter draws upon the experience and work of top professional photographers, uncovering the creative and technical skills they use to create their magical portraits of these young subejcts. $29.95 list, 8½x11, 128p, 150 color photos, order no. 1752.

WEDDING PHOTOGRAPHY WITH ADOBE® PHOTOSHOP®

Rick Ferro and Deborah Lynn Ferro

Get the skills you need to make your images look their best, add artistic effects, and boost your wedding photography sales with savvy marketing ideas. $29.95 list, 8½x11, 128p, 100 color images, index, order no. 1753.

WEB SITE DESIGN FOR PROFESSIONAL PHOTOGRAPHERS

Paul Rose and Jean Holland-Rose

Learn how to design, maintain, and update your own photography web site—attracting new clients and boosting your sales. $29.95 list, 8½x11, 128p, 100 color images, index, order no. 1756.

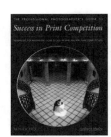

PROFESSIONAL PHOTOGRAPHER'S GUIDE TO
SUCCESS IN PRINT COMPETITION

Patrick Rice

Learn from PPA and WPPI judges how you can improve your print presentations and increase your scores. $29.95 list, 8½x11, 128p, 100 color photos, index, order no. 1754.

PHOTOGRAPHER'S GUIDE TO
WEDDING ALBUM DESIGN AND SALES

Bob Coates

Enhance your income and creativity with these techniques from top wedding photographers. $29.95 list, 8½x11, 128p, 150 color photos, index, order no. 1757.

PROFESSIONAL TECHNIQUES FOR
PET AND ANIMAL PHOTOGRAPHY

Debrah H. Muska

Adapt your portrait skills to meet the challenges of pet photography, creating images for both owners and breeders. $29.95 list, 8½x11, 128p, 110 color photos, index, order no. 1759.

THE BEST OF PORTRAIT PHOTOGRAPHY

Bill Hurter

View outstanding images from top professionals and learn how they create their masterful images. Includes techniques for classic and contemporary portraits. $29.95 list, 8½x11, 128p, 200 color photos, index, order no. 1760.

THE ART AND TECHNIQUES OF
BUSINESS PORTRAIT PHOTOGRAPHY

Andre Amyot

Learn the business and creative skills photographers need to compete successfully in this challenging field. $29.95 list, 8½x11, 128p, 100 color photos, index, order no. 1762.

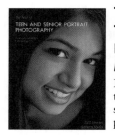

THE BEST OF TEEN AND SENIOR PORTRAIT PHOTOGRAPHY

Bill Hurter

Learn how top professionals create stunning images that capture the personality of their teen and senior subjects. $29.95 list, 8½x11, 128p, 150 color photos, index, order no. 1766.

PHOTOGRAPHER'S GUIDE TO
THE DIGITAL PORTRAIT
START TO FINISH WITH ADOBE® PHOTOSHOP®

Al Audleman

Follow through step-by-step procedures to learn the process of digitally retouching a professional portrait. $29.95 list, 8½x11, 128p, 120 color images, index, order no. 1771.

THE PORTRAIT BOOK
A GUIDE FOR PHOTOGRAPHERS

Steven H. Begleiter

A comprehensive textbook for those getting started in professional portrait photography. Covers every aspect from designing an image to executing the shoot. $29.95 list, 8½x11, 128p, 130 color images, index, order no. 1767.

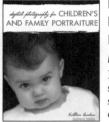

DIGITAL PHOTOGRAPHY FOR CHILDREN'S AND FAMILY PORTRAITURE

Kathleen Hawkins

Discover how digital photography can boost your sales, enhance your creativity, and improve your studio's workflow. $29.95 list, 8½x11, 128p, 130 color images, index, order no. 1770.

PROFESSIONAL STRATEGIES AND TECHNIQUES FOR DIGITAL PHOTOGRAPHERS

Bob Coates

Learn how professionals—from portrait artists to commercial specialists—enhance their images with digital techniques. $29.95 list, 8½x11, 128p, 130 color photos, index, order no. 1772.

THE BEST OF WEDDING PHOTOJOURNALISM

Bill Hurter

Learn how top professionals capture these fleeting moments of laughter, tears, and romance. Features images from over twenty renowned wedding photographers. $29.95 list, 8½x11, 128p, 150 color photos, index, order no. 1774.

FANTASY PORTRAIT PHOTOGRAPHY

Kimarie Richardson

Learn how to create stunning portraits with fantasy themes—from fairies and angels, to 1940s glamour shots. Includes portrait ideas for infants through adults. $29.95 list, 8½x11, 128p, 60 color photos index, order no. 1777.

PORTRAIT PHOTOGRAPHY
THE ART OF SEEING LIGHT

Don Blair with Peter Skinner

Learn to harness the best light both in studio and on location, and get the secrets behind the magical portraiture captured by this award-winning, seasoned pro. $29.95 list, 8½x11, 128p, 100 color photos, index, order no. 1783.

PLUG-INS FOR ADOBE® PHOTOSHOP®
A GUIDE FOR PHOTOGRAPHERS

Jack and Sue Drafahl

Supercharge your creativity and mastery over your photography with Photoshop and the tools outlined in this book. $29.95 list, 8½x11, 128p, 175 color photos, index, order no. 1781.

POWER MARKETING FOR WEDDING AND PORTRAIT PHOTOGRAPHERS

Mitche Graf

Set your business apart and create clients for life with this comprehensive guide to achieving your professional goals. $29.95 list, 8½x11, 128p, 100 color images, index, order no. 1788.

POSING FOR PORTRAIT PHOTOGRAPHY
A HEAD-TO-TOE GUIDE

Jeff Smith

Author Jeff Smith teaches surefire techniques for fine-tuning every aspect of the pose for the most flattering results. $29.95 list, 8½x11, 128p, 150 color photos, index, order no. 1786.

PROFESSIONAL MODEL PORTFOLIOS
A STEP-BY-STEP GUIDE FOR PHOTOGRAPHERS

Billy Pegram

Learn how to create dazzling portfolios that will get your clients noticed—and hired! $29.95 list, 8½x11, 128p, 100 color images, index, order no. 1789.

THE PORTRAIT PHOTOGRAPHER'S
GUIDE TO POSING

Bill Hurter

Posing can make or break an image. Now you can get the posing tips and techniques that have propelled the finest portrait photographers in the industry to the top. $29.95 list, 8½x11, 128p, 200 color photos, index, order no. 1779.

MASTER LIGHTING GUIDE
FOR PORTRAIT PHOTOGRAPHERS
Christopher Grey

Efficiently light executive and model portraits, high and low key images, and more. Master traditional lighting styles and use creative modi-fications that will maximize your results. $29.95 list, 8½x11, 128p, 300 color photos, index, order no. 1778.

PROFESSIONAL DIGITAL
IMAGING FOR WEDDING AND
PORTRAIT PHOTOGRAPHERS
Patrick Rice

Build your business and enhance your creativity with practical strategies for making digital work for you. $29.95 list, 8½x11, 128p, 200 color photos, index, order no. 1780.

CLASSIC PORTRAIT
PHOTOGRAPHY
William S. McIntosh

Learn how to create portraits that truly stand the test of time. Master photographer Bill McIntosh discusses some of his best images, giving you an inside look at his timeless style. $29.95 list, 8½x11, 128p, 100 color photos, index, order no. 1784.

DIGITAL INFRARED
PHOTOGRAPHY
Patrick Rice

The dramatic look of infrared photography has long made it popular—but with digital it's actually *easy* too! Add digital IR to your repertoire with this comprehensive book. $29.95 list, 8½x11, 128p, 100 b&w and color photos, index, order no. 1792.

THE BEST OF DIGITAL
WEDDING PHOTOGRAPHY
Bill Hurter

Explore the groundbreaking images and techniques that are shaping the future of wedding photography. Includes dazzling photos from over 35 top photographers. $29.95 list, 8½x11, 128p, 175 color photos, index, order no. 1793.

LIGHTING TECHNIQUES FOR
FASHION AND GLAMOUR
PHOTOGRAPHY
Stephen A. Dantzig, PsyD.

In fashion and glamour photography, light is the key to producing images with impact. With these techniques, you'll be primed for success! $29.95 list, 8½x11, 128p, over 200 color images, index, order no. 1795.

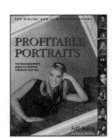

PROFITABLE PORTRAITS
THE PHOTOGRAPHER'S GUIDE TO
CREATING PORTRAITS THAT SELL
Jeff Smith

Learn how to design images that are precisely tailored to your clients' tastes—portraits that will practically sell themselves! $29.95 list, 8½x11, 128p, 100 color photos, index, order no. 1797.

PROFESSIONAL TECHNIQUES FOR
BLACK & WHITE
DIGITAL PHOTOGRAPHY
Patrick Rice

Digital makes it easier than ever to create black & white images. With these techniques, you'll learn to achieve dazzling results! $29.95 list, 8½x11, 128p, 100 color photos, index, order no. 1798.